CHATSWORTH

ALAN TITCHMARSH

CHATSWORTH

THE GARDENS AND
THE PEOPLE WHO MADE THEM

Foreword *by* The Duke of Devonshire

Photography *by* Jonathan Buckley

EBURY
SPOTLIGHT

Ebury Spotlight,
an imprint of Ebury Publishing
20 Vauxhall Bridge Road, London SW1V 2SA

Ebury Spotlight is part of the Penguin Random House group of companies whose addresses can be found at global.penguinrandomhouse.com.

© Smudger Enterprises LLP, 2023

Alan Titchmarsh has asserted his right to be identified as the author of this work in accordance with the Copyright, Designs and Patents Act 1988.

Photography © Jonathan Buckley 2023

Every effort has been made to fulfil requirements with regard to reproducing copyright material. The publisher and author will be glad to rectify any omissions at the earliest opportunity.

First published by Ebury Spotlight in 2023

www.penguin.co.uk

A CIP catalogue record for this book is available from the British Library

ISBN 9781529148213

Printed and bound in Italy by Printer Trento

Imported into the EEA by Penguin Random House Ireland, Morrison Chambers, 32 Nassau Street, Dublin D02 YH68

Penguin Random House is committed to a sustainable future for our business, our readers and our planet. This book is made from Forest Stewardship Council® certified paper.

Commissioning editor: Lorna Russell
Editor: Claire Collins
Design: Andrew Barron / thextension
Production: Rebecca Jones

Archive photography from the Devonshire Collections at Chatsworth. Additional archive images supplied by / used with kind permission of the following:

© National Trust Images / John Hammond (page 40)

incamerastock / Alamy Stock Photo / ICP (page 43)

Chronicle / Alamy Stock Photo (pages 47 and 278)

Burghley House Collection, Lincolnshire, UK / Bridgeman Images (page 62)

Country Life / Future Publishing Ltd (pages 75, 78 and 101)

Nancie Park (pages 78, 112, 227 and 235)

World History Archive / Alamy Stock Photo (pages 86 and 106)

Matthew Bullen (page 101)

© Bruce Weber (page 105)

Alan Titchmarsh (page 110)

The Devonshire Collections, Chatsworth © The Lucian Freud Archive. All Rights Reserved 2023 / Reproduced by permission of Chatsworth Settlement Trustees / Bridgeman Images (page 139)

Private Collection © David Dawson. All rights reserved 2023 / Bridgeman Images (page 140)

Trinity Mirror / Mirrorpix / Alamy Stock Photo (page 142)

Gary Rogers (page 145)

Jonathan Buckley (page 160)

© Katherine Anne Rose / Guardian / eyevine (page 160)

India Hobson (page 165)

Susan Morgan Jones (page 211)

With permission of Richard Long. All Rights Reserved, DACS 2023 (page 251)

IanDagnall Computing / Alamy Stock Photo (page 278)

© National Trust Images / Hawkley Studios (page 278)

© National Trust / Robert Thrift (page 278)

The Picture Art Collection / Alamy Stock Photo (page 278)

Original image: Chatsworth House Trust (endpapers)

For Stoker and Amanda
with affection and admiration

CONTENTS

FOREWORD · *10*

1 FIRST IMPRESSIONS · *16*

2 THE VIEWS AND THE LANDSCAPE · *26*

3 BESS OF HARDWICK · *40*

4 THE FORMAL GARDENS · *50*

5 LANCELOT 'CAPABILITY' BROWN · *62*

6 THE WATER · *72*

7 JAMES PAINE · *86*

8 THE FOLLIES · *94*

9 SIR JEFFRY WYATVILLE AND THE BACHELOR DUKE · *106*

10 THE GLASSHOUSES · *116*

11 SIR JOSEPH PAXTON · *130*

12 DEBORAH DEVONSHIRE · *136*

13 ARCADIA · *148*

14 TOM STUART-SMITH AND DAN PEARSON · *160*

15 THE ROCK GARDEN · *168*

16 Royalty and Chatsworth · *180*

17 The Arboretum and Pinetum · *190*

18 The 12th Duke and Duchess of Devonshire · *204*

19 The Ravine · *214*

20 Chatsworth Cricket Club · *224*

21 The Maze · *230*

22 Art Exhibitions in the Gardens · *238*

23 Sculpture · *244*

24 Shows and Fairs · *252*

25 The Kitchen and Cutting Garden · *260*

26 The Learning Centre · *270*

27 The Twenty-first Century · *272*

The Cavendish family: from Bess to Stoker · *278*

Acknowledgements · *282*

Bibliography · *284*

Index · *285*

FOREWORD

Alan Titchmarsh knows Chatsworth and its gardens very well. He and Alison have been coming to stay for many years, initially with my parents and, since we moved here in 2006, they have been our guests. Perhaps surprisingly, Alan has visited for all sorts of reasons, but never as a professional gardener. However, he has taken a keen and knowledgeable interest in the gardens, and must have walked around the whole 105 acres many times. He has known it through years of change and development.

My parents arrived at Chatsworth soon after my grandfather died in 1950. At that time, as was the case with similar estates virtually throughout Britain, this historic garden was in a state of neglect. My great grandmother Evelyn had made many improvements to the garden, but these mainly came to an end when her husband was made Governor General of Canada in 1916. Although they returned to Chatsworth after the Great War, there were other more important priorities at that time, and so the garden was more or less treading water, at best, for at least a generation.

My parents were both, in different ways, very enthusiastic gardeners. Despite his colour blindness, my father loved camellias. He also planted thousands of autumn crocuses (*Colchicum autumnale*) and even more spring-flowering crocuses, and on the mound outside the North Front door many other spring bulbs, where they remain as a living testimony to his hard work as a bulb planter.

My mother had a brilliant eye for landscape. Her planting of the Serpentine Hedge in the early fifties was a stroke of genius. Her push to clear large parts of the further garden of the 'wartime seedlings' (what we call 'trees growing in the wrong place') and acres of laurel, yew and pig holly was hugely important in itself and particularly influential on Amanda and me. Her love of the English cottage garden was a bigger challenge to integrate into the rather grand landscape of the Chatsworth garden. She worked without a design advisor and, although she gave credit behind the Serpentine Hedge to the crinkle-crankle wall at Hopton Hall (near Wirksworth), most of the rest of her introductions came entirely from her and from the Chatsworth gardeners with whom she worked.

Inevitably, since we have been at Chatsworth, and particularly since Dan Pearson and Tom Stuart-Smith appeared on the scene a few years ago, we have

The visitor's first view of Chatsworth House (previous spread) from the winding drive that approaches the River Derwent from the west.

Early spring (opposite) and the daffodils erupt to form a golden mantle below the majestic beech trees.

introduced a number of our own changes. The reinvigorated Trout Stream and the area near the Jack Pond reflect Dan Pearson's genius, especially with the semi wild, so-called 'natural looking' garden. Tom Stuart-Smith has wrought great improvements to Paxton's Rock Garden as well as his invention of a new area which we rather grandly call Arcadia, just to the east of the Rock Garden and the south of the Cascade, and stretching as far as the Grotto Pond.

Even before these two landscape superstars arrived we had been fortunate that, thanks to the spread of the dreaded *Phytophthora ramorum*, government grants were available to clear *Rhododendron ponticum*, one of its host species, to stop the spread of the disease. We would never have been brave enough to remove the 5 acres of rhododendron without this government directive and its supporting grant aid, but doing so has made a dramatic improvement to many different parts of the garden, especially the Ravine.

When we took over we were very lucky to have Ian Webster as head gardener, the most green-fingered man I have ever met and charming with it. His skill as a propagator is rightly legendary. It must have been a big change for him when we arrived but he put a very good face on it and made the garden a lovely place to be in. When Ian retired in 2011, Steve Porter was already his deputy and took on the role of head gardener – since then, he, Amanda and I have been

A lithograph by Newman & Co. from around 1840, showing James Paine's elegant three-arch bridge with the house beyond. Sir Jeffry Wyatville's 19th-century extension can be clearly seen to the left of the main house.

learning together. He is a proper gardener and we are but amateurs but, like Ian, Steve has made it very enjoyable to be involved outdoors. He has nurtured not only the garden but the garden and landscape teams and the amazing army of volunteers, with whose help the standards within the garden have improved enormously: it is really difficult now to find a plant in the wrong place.

As I write this foreword, we have moved out of Chatsworth and so Alan's book, with wonderful photographs from Jonathan Buckley, is a convenient punctuation point at the end of one set of likes and dislikes, before the next changes become apparent. William and Laura, our son and daughter-in-law are now ensconced with their young family: their imprint on Chatsworth will be exciting and different … of course.

To have Alan record the state of the garden as we leave it, as well as sharing stories of the people who have helped to shape it, is a great privilege for us. I hope his enthusiasm for the garden at Chatsworth will introduce many new people to what we consider to be a very special place.

<div style="text-align:center">

Duke of Devonshire
Chatsworth 2023

</div>

The private garden on the west front of the house, furnished with Wyatville's stone-sided raised beds. This image dates from the early 1900s, when the gardener could only dream of a ride-on mower …

CHAPTER 1

FIRST IMPRESSIONS

It was a large, handsome stone building, standing well on
rising ground, and backed by a ridge of high woody hills.
Pride and Prejudice, Jane Austen, 1813

No other estate of my acquaintance has such presence. Some houses are larger – the frontage of Wentworth Woodhouse in Yorkshire is said to be the longest in Europe; some are grander – nothing outdoes Blenheim Palace in Oxfordshire, gifted to the Duke of Marlborough by Queen Anne on behalf of a grateful nation in 1705 – and yet there is an indefinable quality about the setting of the 'Palace of the Peaks', which has always exerted a hold over me and caused my spirits to rise and my heart to flutter.

I sound like Elizabeth Bennet. Maybe it is because, as a dedicated Jane Austen fan, I recalled, on first seeing the house from that snaking road that approaches it through the rolling Derbyshire countryside, the effect that the first sight of Pemberley – itself situated in Derbyshire – had on the heroine of *Pride and Prejudice*. She journeyed by carriage with her aunt and uncle, the Gardiners, to that fabled residence – the country seat of Mr Darcy – across similar terrain until:

… the eye was instantly caught by Pemberley House, situated on the opposite side of a valley, into which the road with some abruptness wound. It was a large, handsome, stone building, standing well on rising ground, and backed by a ridge of high, woody hills; and in front, a stream of some natural importance was swelled into greater, but without any artificial appearance. Its banks were neither formal, nor falsely adorned. Elizabeth was delighted. She had never seen a place for which nature had done more, or where natural beauty had been so little counteracted by an awkward taste …

They descended the hill, crossed the bridge, and drove to the door …

… as did I on that day in 1989 when I first came to Chatsworth to make a programme for BBC radio.

There is a moment, on the journey north from London, when one is suddenly aware that the landscape has changed. Much of the journey is a relatively featureless sweep of sporadic industrialisation, interspersed with unremarkable

Looking across the valley to the northwest (*previous spread*), Lancelot 'Capability' Brown's landscape can be seen in all its 21st-century glory, with its sinuously modelled river. The site of the Great Conservatory is now occupied by the Maze, which can be seen in the foreground.

The west front of the house (*opposite*), with its gilded window frames that glint in the early morning sun. The urns on the parapet also have gilded finials that add to the opulence.

CHATSWORTH

agriculture. But then, beyond Chesterfield, the terrain alters; it becomes more undulating. There is a certain richness to the rolling landscape; it begins to cradle you in its sylvan embrace and there are copses and woods framing the view. The whole feeling is of William Blake's 'green and pleasant land', where sheep may safely graze and the greenwoods laugh. You have entered the Derbyshire Dales and the scenery is entrancing.

The roads are narrower now and more snaking – up hill and down dale, through overhanging oak and ash trees – until signs appear bearing names like Calton Lees and Edensor (which you have learned, over the years, to pronounce as 'Enzer'). The road rises in front of you, then dips, then swings around to the left and you are gazing upon Miss Bennet's view: you have arrived at the 'Palace of the Peaks'.

The house, garden and landscape have held me in their thrall ever since that day of revelations in the 1980s. As if to prove that my Austen imaginings were not fanciful, Chatsworth has played the role of Pemberley in a number of film and television adaptations, and Miss Austen is thought to have herself visited the house in 1811, while staying at the Rutland Arms in Bakewell. Her own feelings about the place would seem to have been shared by her heroine.

Elizabeth Bennet was daunted on entering the portals of Pemberley. I, too, passed through the massive front door of Chatsworth – heavy, oaken and twice as tall as I am – with awe and trepidation, until greeted by the then duchess, Deborah Devonshire, in the stone-floored hallway. It was flanked by gigantic equestrian portraits and decorated with log baskets, dog leads, water bowls, a basket of eggs and a seemingly endless phalanx of wellington boots.

The atmosphere was warm, and so was the welcome; both have persisted in the five decades during which I have been lucky enough to have been a frequent houseguest – first at the invitation of Deborah and Andrew Devonshire, and subsequently with Stoker (his given name of Peregrine has never been used in my hearing) and Amanda, the 12th Duke and Duchess, who have become valued and lasting friends. I will make every effort to temper my effusiveness in the pages that follow. It will not be easy.

Stand Wood, on the ridge behind the house, offers stunning views of the surrounding landscape, including the spire of St Peter's church at Edensor to the west, designed by Sir Gilbert Scott in 1867.

CHATSWORTH

In 2023, 'the House', as it is always known, and many other estate responsibilities, were placed in the hands of the next generation: William, Earl of Burlington and Laura, Countess of Burlington. After seventeen years of living in 'the House', the current Duke and Duchess have moved into the village of Edensor, from where they will continue to be involved with the garden and the estate. The transition will be an interesting one for both parties, but Lord and Lady Burlington will have the advantage – as did William's parents – of taking on an estate in good health; not something that could be said for Andrew and Deborah Devonshire in 1950, when punitive death duties led to years of financial difficulties and seemingly endless endeavours to save the house from disaster.

I have come to know William and Laura relatively recently. They are bright, intelligent and – just as important in my book – companionable. William's reputation as a fine photographer – using the name Bill Burlington – and Laura's experience in fashion (she is a contributing editor to British *Vogue* and a board member of Acne Studios in Stockholm), will stand them in good stead. The 12th Duke and Duchess have a well-deserved reputation for encouraging contemporary artists, sculptors, ceramicists and furniture makers; the Burlingtons are no less committed to the contemporary arts. It is quite likely that their tastes will differ from those of the previous generation, but that will only add to Chatsworth's reputation for moving forward and reflecting the changing tastes of society.

Daunting though the prospect may be, the new custodians have the advantage of the continued input of Stoker and Amanda, particularly in relation to the gardens and the estate – as well as the stability of Chatsworth, thanks to the existence of the Chatsworth House Trust and their own love and passion for the place. While the presence of a previous generation – all too willing to offer advice – can lead to tensions and, on occasion, challenging differences of opinion, I suspect that both parties are only too aware of the likely pitfalls, and are determined that these will be outnumbered by a common goal – that of maintaining the vibrant, lively high standards, both artistic and horticultural, that have come to be expected of the Palace of the Peaks.

The folk in this part of Derbyshire have a proprietorial feeling for their local 'stately home', and, particularly since Andrew and Deborah Devonshire's tenure,

FIRST IMPRESSIONS

that feeling has been cherished and respected by the Devonshire family. There is no sign of that mutual respect declining, and that, I firmly believe, is one reason why Chatsworth is so well loved by its visitors.

Visitor loyalty comes not only as a result of the admiration of a house's setting, architectural quality and contents, but also from the feeling of welcome that seems to emanate from its very stones. 'Vibes' is what we call them when we are examining a house with a view to moving in, and the same is true of stately homes that we can visit. Some are undeniably grand but remain cold and aloof. I've never felt that about this place.

While the intimidation I felt on approaching Chatsworth all those years ago has completely disappeared, my love, respect and admiration for the house, the 105 acres of garden, the estate – and for the family – have grown immeasurably; feelings due in no small part to the fact that the Devonshires, both past and present, actually enjoy sharing this special part of the Derbyshire Dales with visitors from the county, the country and indeed the entire world.

True enough, a steady stream of visitors is essential to provide the funds that will keep house and grounds in a good state of repair, but a visitor to a stately home can always tell when a mercenary air hangs about the place. Similarly, it is easy to see when inertia has taken hold and a house or estate seems becalmed in a dusty time-warp.

I am a great believer in atmosphere, both inside a house and out. The atmosphere at Chatsworth has every right to be intimidating simply by virtue of its scale – there are massive, newly re-gilded finials atop its roof, for goodness' sake, and gilded windows that dazzle in the westering sun – but at every turn there are reminders that this is a family home as well as a grand house. The garden and the immediate landscape are of a scale that complements the property, but which exude a kind of friendliness. There are no 'Keep Off The Grass' signs, and when one visitor on a hot summer's day complained to the late Duchess that people were actually paddling in the waters of the great Cascade, her response was: 'Yes; isn't it lovely!'

Chatsworth is not an estate that is preserved in aspic. The 11th Duke and Duchess, faced with crippling death duties in the 1950s, battled for more than

CHATSWORTH

twenty years to get Chatsworth back into the black. They worked to set it on the road not only to recovery, but to success, thanks to good taste, determination, an eye for design and sound commercial sense.

The 12th Duke and Duchess moved in during 2006, since when much has been done to restore the acres of roof and the stonework that make up the very fabric of the house, ensuring its durability for the twenty-first century. Modern art, furniture, ceramics and sculpture now sit alongside furniture by William Kent and family portraits by John Singer Sargent and Pompeo Batoni. Outdoors there are new plantations being established. The Ravine has been revitalised, the part of the garden referred to as Arcadia has become a series of life-enhancing woodland glades and the Victorian Rock Garden has been totally cleared, augmented with more towering stone pinnacles, and replanted. These new landscape features have been created by such highly rated modern designers as Tom Stuart-Smith and Dan Pearson.

Contemporary sculpture decorates the landscape. (No, you won't like it all, but it brings to its setting an energy and vitality that is at the very least provocative, as if to prove that this is not an estate that is resting on its laurels, be they spotted or crowning the marble head of a Roman god in the Sculpture Gallery.)

Since the arrival of Sir William Cavendish and his wife, the indomitable Bess of Hardwick, in 1549, Chatsworth has played host to as rich a cast of family characters as you are likely to find anywhere in the world. They have been, in turn, loved, reviled, extravagant, parsimonious, reclusive and sociable, but they have all left their mark on the land. This book aims to reflect their characters through my own experiences of a part of England that is second in beauty only to my home county of Yorkshire. The Devonshires own part of that, too.

I told you they had good taste …

Is it fanciful to suggest that the house seems to change its mood with the passing hours? Here, as the early morning mist recedes, it seems almost bashful.

CHAPTER 2

THE VIEWS AND THE LANDSCAPE

FROM EVERY WINDOW THERE WERE BEAUTIES TO BE SEEN.
Pride and Prejudice, Jane Austen, 1813

There is a moment, on that winding journey westwards from the town of Chesterfield, with its gravity-defying crooked spire on the church of St Mary and All Saints, when the urban sprawl is left behind and a circular stone monument on the rough turf of the roadside verge informs you that you are entering the Peak District National Park. There are rolling fields now, and barren stretches of moorland alternating with dense deciduous woodland. A short while further on, the sign is joined by another, welcoming you to the Derbyshire Dales. It is at this point that you can heave a sigh of relief. You are almost there.

James Hilton, the author of *Goodbye, Mr Chips,* described an earthly paradise he called *Shangri-La* – the 'mystical harmonious valley' – in his 1933 novel *Lost Horizon*. Hilton offered a glimpse of utopia to a nation that had come through the Great War and the Great Depression, and for whom the vision of a hidden valley somewhere in the mountains of Tibet – where peace and happiness reign and where the residents live astonishingly long and contented lives – offered an escape from the dangers and the worries of a troubled world. There are parallels with today's turbulent times, but the 'mystical, harmonious valley' of the River Derwent really does exist.

You will come upon it as unexpectedly as Hilton's explorer, for it is surrounded – at a comfortable distance – by more prosaic environs: it has Sheffield to the north, Chesterfield to the east, Buxton to the west and Matlock to the south. While the last two are picturesque, the industrial heartland of Sheffield (famous the world over for its steel) and the town of Chesterfield (unremarkable except for its twisted spire that leans, says the guidebook, '9ft 6in from its true centre') offer no indication of the delights to come. It is only when dry stone walls quite suddenly replace double yellow lines, and woodland and moorland occupy the land previously clothed in brick and concrete, that the existence of this different world becomes apparent.

The Derbyshire Derwent runs from Swains Greave, 1900ft up on Ronksley Moor, where it rises 5 miles south of Holmfirth in Yorkshire, and flows east and

The sun rises over Stand Wood (*previous spread*) and its early morning rays highlight the work of Lancelot 'Capability' Brown on the western banks of the River Derwent.

The once intricately winding river – spanned by James Paine's bridge (*opposite*) – was straightened to some extent by Brown, in order to limit the frequency of flooding.

CHATSWORTH

then southwards through Derbyshire. It fills up the reservoirs where Dr Barnes Wallis tested his famous bouncing bombs, and whose chilly waters now cover the villages of Derwent and Ashopton, as well as Derwent Hall, once a home of the Duke of Norfolk.

The river will run for 60 miles before it slides, ignominiously, into the waters of the River Trent in the gloomy shadows of the M1 at Long Eaton, but in middle-age its journey takes it through one of Britain's most beautiful National Parks.

Now the names of the villages have a more rustic euphony, and at Nether End, the southern boundary of Baslow, you will enter the estate of the Dukes of Devonshire, as have countless others before you since 1549, when Bess of Hardwick (see pages 40–47) persuaded her second husband, Sir William Cavendish, to sell up his lands in Suffolk and move to her home county of Derbyshire.

The first house on the site was begun in 1552. Stand at the top of the Cascade and look down the sloping valley side towards the house, imagining the landscape at a time before Chatsworth existed. Bess might have said, 'Here, I think', as she gazed westwards across the river valley, standing on land that once belonged to her stepfather, Ralph Leche.

Bess and William continued to buy land to add to the Chatsworth Manor, which they had bought for £600, selling property in Hertfordshire along with land in Wales and Lincolnshire to help fund the acquisition. When it came to getting her own way, it seems Bess was rarely contradicted.

Today, the estate covers around 35,000 acres and the garden 105 acres, cultivated, enlarged, altered and adjusted over a period of almost 500 years.

Ask returning visitors to Chatsworth – and the locals who come here regularly – what they most like about the place, and the chances are that aside from the sheer spectacle of house, garden, water features and landscape, all of them will refer to the fact that the place is friendly; they feel welcome. More than 800 local people are employed on the estate – both in the house and the surrounding countryside – maintaining a standard of upkeep that is thorough and detailed, without being at all oppressive.

One of the finest examples of a 'Brownian' landscape – the trees grouped to show off the contours of the land and provide the perfect setting for the 'Palace of the Peaks'.

CHATSWORTH

The view westwards from the house is of parkland originally designed by Lancelot 'Capability' Brown (see pages 62–69), who is believed to have first visited the estate in 1758 and began, almost immediately, to create the Arcadian idyll so fashionable in the late-eighteenth century. Much of Brown's now mature work is in evidence today, and has been sympathetically augmented with additional tree planting over the succeeding centuries.

Idyllic though Brown's schemes might seem to have been, they were also eminently practical. Then, as now, landowners regarded livestock as an important contribution to the economy of an estate, and Chatsworth was no exception. Today, around 3,000 breeding ewes and 300 suckler cows occupy 5,000 acres of land surrounding the house, which encompasses parkland, moorland and improved grassland. The Environmental Stewardship Scheme ensures the responsible management of land, promoting diversity in terms of wildlife, and sustainability over the longer term. It matters to the Devonshires that their land is managed thoughtfully and with an eye to the future, not just for the family and the estate, but for nature and the landscape in general.

That responsibility extends to arable farmland in northeast Derbyshire, where around 2,700 acres are given over to wheat and barley, oats and oilseed rape, cultivated in such a way as to improve soil health and increase carbon capture. Throughout the Devonshires' 35,500 total acreage in Derbyshire, farmed field margins are seeded with wildflower mixes that provide habitats for birds, bees and beneficial insects.

Weather records have been kept at Chatsworth since 1761. It is interesting to note that in the fifty years between then and 1811, the average annual rainfall amounted to 28.4 in (72 cm). In recent years it has averaged 33 in (84 cm). Highest recorded temperatures, too, have risen: 38.1°C was recorded on 19 July 2022. Previous highs were experienced in 1911 at 34.4°C and in 2019 at 33.8°C.

The undulating nature of the Derbyshire Dales is certainly an advantage when it comes to the beautification of the landscape. In such terrain the planting of trees and the management of grassland has a head start. But although that beauty is enhanced by the lie of the land, it must still be managed mindfully.

An ancient oak at the southern end of the park, the undulating land surrounding it is suffused with wild daffodils – spring is coming.

THE VIEWS AND THE LANDSCAPE

THE VIEWS AND THE LANDSCAPE

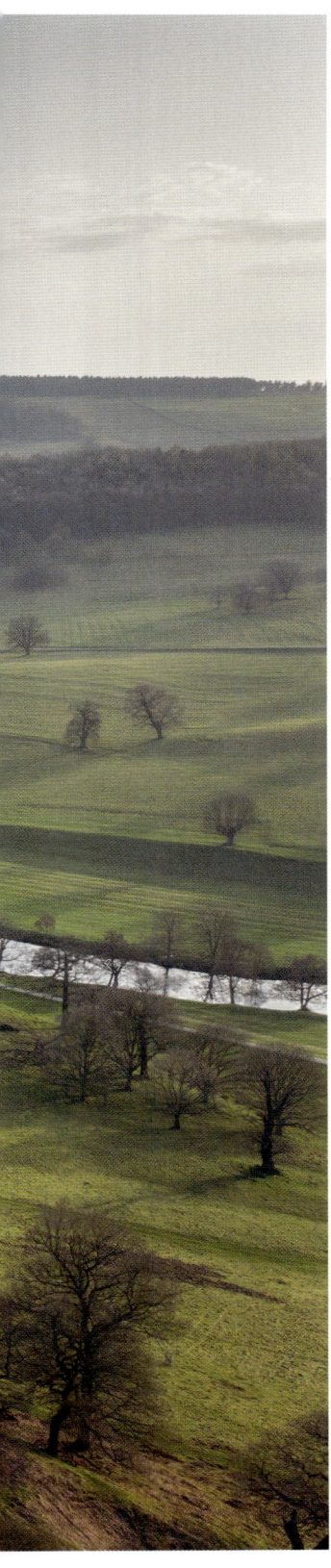

Woodland accounts for 4,000 acres of the Chatsworth Estate – a mixture of deciduous and evergreen forestry that has its part to play in the economy, as well as in the elegance of the landscape. At a time when there is much talk of carbon capture in the interests of ameliorating the effects of global warming and climate change, the Chatsworth woodlands sequester the equivalent of around 8,000 tonnes of carbon dioxide a year – outnumbering the carbon emissions from the estate by a factor of four to one – an enviable ratio.

The 1,300 acres of ancient woodland on the estate are augmented by the planting of around 90,000 trees every year. Between 2012 and 2022 almost 250 acres of new woodland were established.

As well as contributing to the economy of the estate, all this greenery provides the perfect setting not only for the house itself, but also for the houses, cottages, follies and other structures that pepper the landscape. Local stone has been used over the years, not only for the dry stone walls which crisscross the landscape, but also for the building of homes that shelter the local population.

The village of Edensor, nestling at the heart of the estate, was remodelled by the 6th Duke to the designs of his head gardener, Sir Joseph Paxton (see pages 130–135), in the mid-nineteenth century. In those days dukes were less accountable to local planning authorities. Today they are as strictly regulated as those of us with more modest portions of real estate. With so many of the buildings, monuments and structures at Chatsworth having listed status, and being located in a national park, the estate works closely with the local planning authority on proposed building and restoration projects.

Some architectural features on the estate date back to Bess of Hardwick's time: Queen Mary's Bower, reputedly built for Mary, Queen of Scots when she was at Chatsworth in the 1570s, but more likely created as a garden ornament, was much altered in the 1820s by Sir Jeffry Wyatville (see pages 106–113). However, the Hunting Tower, which stands on high ground to the east of the house, is much as it was when built for Bess in 1570. It offers astonishing views of what would have been a deer park to the east and of the softer, more welcoming landscape to the west, sloping down towards the river, as well as views of the rising ground where, today, Brown's landscape is seen in all its glory.

Even in winter the parkland trees have a sculptural quality, here looking south and southwest across the river.

Not far from the Hunting Tower on that wooded ridge, sitting beside its own moorland lake, is the Swiss Cottage. It was designed either by Paxton or his assistant John Robertson, and today its timber-decorated gabling and doors are painted in the distinctive livery of 'Chatsworth Blue'. You can stay here – or in the Hunting Tower – if you like. It is one of a number of houses and cottages on the estate that are available to rent, and if you yearn for a few days among the trees and the moors, away from the frantic life of town and city, there is nowhere finer to live your dream.

If self-catering is not to your liking, then the Cavendish Hotel, on the A623 – Church Lane – in Baslow will suit you better. Both the rented properties and the hotel are of a standard that will come as no surprise to those who are acquainted with the Devonshires' eye for detail. It is impossible to write about the standard of upkeep of the various forms of accommodation without sounding like an effusive tourist brochure, but stay in them and you will see that such praise is not misplaced.

Not surprisingly, the area around the house has been designed, right from its early years, with the views from its windows in mind. (Bess completed Hardwick Hall, 'more glass than wall', in 1599; so even at Chatsworth decades earlier she would have been keen to see out and let light in.)

Even in inclement weather houseguests and visitors can marvel at the landscape. To the south of the house, the Canal Pond, constructed in 1703,

The Hunting Tower, which stands on high ground to the east of the house, is much as it was when built for Bess in the 1570s. It offers astonishing views of what would have been a deer park to the east.

Chatsworth (*above*) in the 1720s, by the Flemish painter Peter Tillemans.

Another Flemish painter, Jan Siberechts, painted this overview (*opposite*) of the landscape in *c.* 1703 for the 1st Duke, when the elaborate formal parterre was in its prime. Statues, fountains and pools predominate.

THE VIEWS AND THE LANDSCAPE

Looking westwards down the Cascade (*opposite*) and across the valley towards Edensor, the evening sun casting long shadows.

The Canal Pond (*above*) runs due south from the house, now on level ground which, before its creation, was once referred to as the 'Great Slope'.

CHATSWORTH

is enhanced by the Emperor Fountain installed nearly 150 years later (see page 79). Beyond the Canal Pond the woodland creeps down towards the water, cradling the vista.

The gilded windows on the west front of the house gleam and sparkle in the setting sun, and from the inside they offer views over a terrace that supports a formal garden of Wyatville-designed, stone-encased clipped yew and box, centred by a circular pond. Until a few years ago, this terrace reflected the floor plan of Chiswick House, once the property of the Earl of Burlington (1st creation) and then the Dukes of Devonshire. Now, its very plainness connects it more readily to the landscape across the river.

Beyond the terrace, the ground drops 15ft or so, retained by a towering sandstone wall. Then the grassy slope runs more softly towards the wide but shallow Derwent. From the opposite bank, 'Capability' Brown's harmonious parkland rises steeply upwards from the gliding waters.

The north front of the house is embraced by a courtyard, where once a weeping ash tree was encircled by a lawn. The ash tree has been replaced by a Chinese tulip tree (*Liriodendron chinense*) but the lawn remains, occasionally acting as a platform for sculptures and artworks that change with the seasons.

The east front of the house looks out on one of Chatsworth's most spectacular features – the Cascade – the first iteration of which was completed in 1696. Flanked by verdant lawns and with a backdrop of woodland, it shimmers as its waters – fed by a moorland lake – tumble over steps that descend from the ornamental folly at its summit. To its left are the Rose Garden, the greenhouses and Paxton's Conservative Wall. Whichever window of the house you are standing by, there is sure to be a view that pleases you, surprises you, captivates you or makes you smile.

It seems to me that few, if any, English stately homes offer such a complete and comprehensive range of attractions. They are all features that remain true

This photograph, taken around 1900, shows how little the view across the river has changed in over a century.

to the spirit of the house, the working estate and the surrounding landscape. The Chatsworth Estate is comfortable in its skin and has no need to provide incongruous or inappropriate inducements to visit. Here you will find no safari park and no funfair, except the one that appears each September as part of Chatsworth's Country Fair. Yet, for every visitor, of whatever age, there is something of interest, something to marvel at; walks to be taken; sculpture to delight, or shock (sometimes even to repel); a model farm where small children from town and country can get close to sheep and cows and understand how the countryside works.

Duchess Deborah once encountered a group of schoolchildren from Sheffield watching a cow being milked in the farmyard. It was a revelation to most of them, who were clearly unsure where their milk came from. 'What do you think of that?' the Duchess asked one small boy. He wrinkled his nose and replied, 'I think it's disgustin'.'

Chatsworth's mission to demonstrate by example just how the countryside works continues …

Detail from an 18th-century copy of a lost 17th-century painting of Elizabethan Chatsworth, which shows what the house looked like before it was remodelled by William Talman in the 1690s, to be followed by Thomas Archer in the 1700s and and Sir Jeffry Wyatville in the 1800s.

737 ELIZABETH HARDWICK COUNTESS OF SHREWSBURY

CHAPTER 3
BESS OF HARDWICK

I hope sayd she (The Queen) that My Lady (Bess)
Hath knowne my good openon of her ... there ys no lady y[n]
thys land that i better loue and lyke.
Letter to Bess of Hardwick from her half-sister Elizabeth Wingfield, 21 October 1567,
quoting Queen Elizabeth I.

The twentieth-century Hollywood star Zsa Zsa Gabor famously declared, 'I am a marvellous housekeeper. Every time I leave a man, I keep his house.'

Elizabeth Shrewsbury, most often known as Bess of Hardwick, went one better: she built them. Granted, Bess cannot match Zsa Zsa when it comes to husbands: Zsa Zsa married nine times, Bess managed only four husbands, but after a shaky start, she certainly chose more profitably.

She was born Elizabeth Hardwick in 1521 or 1522, though sources frequently list her birthdate as 27 July 1527. Her parents, John and Elizabeth Hardwick, were classed as minor gentry: 'respectable, not especially prosperous', suggests one of Bess's biographers, Kate Hubbard.

There is much argument over the details of Bess's early life: where she was, her relationships with the nobility and gentry, and her degree of familiarity and experience within the Tudor Court. But there is no doubt at all over the fact that she rose to dizzying heights in her later years.

Her first marriage, around 1540, when she was twenty or twenty-one, was to thirteen-year-old Robert Barley. It was a marriage arranged to protect the estate of Robert's father, should he die before his son came of age. The legal age of consent at that time was twelve for girls and fourteen for boys, a fact that encouraged many estate owners, anxious to prevent their estates being taken over by the crown through 'the Office of Wards' upon their death, to marry off their young children and ensure the property remained within the family. Robert and Bess were thought to have met in the service of the Zouch family of Codnor Castle in Derbyshire. It is unlikely that the marriage was consummated, or even that the couple ever lived together, for Robert died shortly afterwards in 1554.

The inheritance plan foundered at first, but Bess entered into a court battle,

The indomitable Elizabeth Shrewsbury, better known as Bess of Hardwick, by the painter and goldsmith Rowland Lockey (*c.* 1565–1616).

which resulted in her claim being upheld and compensation being granted, though the wrangle took the better part of ten years. Surviving court documents reveal Bess's indignation and tenacity – an indication of her true character – and in 1553 she was granted £24 a year and £14 compensation for the delay. It hardly qualified her as landed gentry, but at least she now had her own annual income. She also had the advantage of being a widow: she owned her own goods and chattels, she could buy and sell land and property, enter into litigation and write a will. All of these factors combined to give her a valuable degree of independence.

It was Bess's second marriage that cemented her connection with Chatsworth. In 1547, in her mid-twenties, and the year Henry VIII died, she married the twice-widowed Sir William Cavendish who was many years her senior. Keen to remain in her native county, Bess persuaded her new husband to sell the lands he owned around Cavendish in Suffolk – having amassed them as one of the commissioners in Henry VIII's dissolution of the monasteries – and move to Derbyshire.

Bess's powers of persuasion – or William's love for her – must have been tested: Derbyshire was a wild and isolated place in those days, far away from the seat of power, and the chosen site was itself subject to flooding. They bought the manor of Chatsworth in 1549 for £600, and the building of the first house began in 1552. (I call it 'the first house', though there is evidence of previous building on the site – parts of a pre-Elizabethan arch have been found in the cellars beneath the northwest corner of the house.) The Hunting Tower, which still stands on the hill to the east of the house, and the original Queen Mary's Bower to the northwest, demonstrate a taste for elegant yet robust Elizabethan architecture.

The marriage propelled Bess into the higher levels of society in London, to a place at court and into motherhood. The Cavendishes' first child – a daughter, Frances – was born a year after they married, and Bess went on to have one child a year over the next seven years. Six of the Cavendishes' eight children survived into adulthood and it was them to whom the Chatsworth Estate would be bequeathed.

Ten years after their marriage, Sir William died, aged 49.

Due to wranglings with the Treasury, shortly before his death Sir William found himself hugely in debt – debts that passed to Bess and threatened her ability to hang onto the Chatsworth Estate.

A 19th-century engraving by John Whessell of Mary, Queen of Scots. She was imprisoned at Chatsworth in the late-16th century on the orders of Elizabeth I, and guarded by Bess and her 4th husband George Talbot, Earl of Shrewsbury.

Mary Queen of Scots.

Engraved on Steel by I. Whessell, from the Original in the Picture Gallery, Oxford.

CHATSWORTH

Bess was indomitable; there is more than a hint of Elizabeth I about her. The two had met when Bess was taken to the court of King Edward VI by William, who held the post of Treasurer of the Chamber. Bess was around ten years older than the teenage girl who would one day become Queen. They knew each other sufficiently well for Elizabeth to agree to become godmother to Bess and William's first-born son Henry. Their relationship in those early years seems to have been warm and friendly; perhaps that of two red-headed women warily acknowledging each other's strengths.

It is possible that Bess met her third husband at the coronation of Elizabeth I. Sir William St Loe was Chief Butler of England, Captain of the Guard to Queen Elizabeth I and, in common parlance, loaded. He paid off Bess's debts, and while he spent much of his time in London and retained his estates in the West Country, Bess was at 'my honest swete chatesworth' free of debt and able to indulge herself in improving her own estate so that it might rank with those at Longleat and Burghley. When her duties to St Loe took her away from it, she fretted and kept in touch with developments. By 1564, the house at Chatsworth was almost completed.

In 1565, St Loe died suddenly in London, just five years after their marriage. There is no real evidence to suggest that he was poisoned by his younger brother Edward who had, in 1560, attempted to poison Bess herself, but the siblings' strained relationship would explain why, rather than leaving his estate to his brother, or his two daughters by a previous marriage, St Loe left everything to Bess, making her one of the wealthiest women in the land. She had also been made a Lady of the Bedchamber to the Queen. Her position at court was established; her love of Derbyshire remained constant.

Still only in her mid-forties, Bess was now one of the most desirable widows in England, but Derbyshire would hardly offer much in the way of eligible husbands. In 1565, Bess decamped to London, but Chatsworth continued to preoccupy her, not least having to cope with various irregularities in the running of the house and estate by those she left in charge.

Her time at court paid off, and in the summer of 1567 she married her fourth and last husband, George Talbot, Earl of Shrewsbury, Lord-Lieutenant of

The new Hardwick Hall 'more glass than wall,' completed by Bess in 1597 and bearing her initials 'ES', for Elizabeth Shrewsbury, atop the parapets.

Yorkshire, Derbyshire and Nottinghamshire, Chief Justice in Eyre, Chamberlain of the Receipt of the Exchequer and Knight of the Garter, with estates in Yorkshire, Derbyshire, Nottinghamshire, Staffordshire and Shropshire, and castles, abbeys and mansions all over the land. He was most certainly a good catch, but it was possibly more of a dynastic manoeuvre than a love-match – two of George's children were then married to two of Bess's.

It was during this marriage that Mary, Queen of Scots was housed at Chatsworth, at the behest of Elizabeth I who wanted to protect Mary from the Scots who had forced her to abdicate in favour of her infant son James, but also to prevent Mary from usurping Elizabeth's own right to the throne.

For fifteen years, Mary was in the custody of the Shrewsburys, at Chatsworth and at their other houses, including Wingfield Manor in Derbyshire, and Sheffield Manor in Yorkshire. Bess and Mary spent much of their time engaged in embroidery – the Oxburgh Hangings, at Oxburgh Hall in Norfolk, are the most extensive examples of their work.

Mary's continued presence unsurprisingly put a strain on the marriage and, despite the intervention of Elizabeth I, who encouraged George and Bess to reconcile their differences, the two eventually separated.

In 1590, George Talbot died in the arms of his mistress – one of his servants – and Bess became the Dowager Countess of Shrewsbury.

It was time to begin work on what was to be her last building project: Hardwick Hall – 'more glass than wall'. The 'New Hall', replacing the old, was completed in 1597. Designed by Robert Smythson, it is the only house that still stands as a monument to Bess of Hardwick – now Elizabeth Shrewsbury. Her initials 'ES' are repeated on the house's parapet to make it clear to all who visit that this was the creation of one of the richest and most powerful women of the Elizabethan age.

Hardwick Hall remains in the Cavendish family no longer. It was ceded by the 11th Duke of Devonshire to the Treasury in 1956 as part payment of death duties, and passed to the National Trust in 1959.

Chatsworth House owes its very existence to Bess and her love of this part of Derbyshire. The current structure, replacing Bess's original, dates from 1687, with later additions, but without her foresight, perhaps the River Derwent would flow

through this part of the Derbyshire Dales unadorned by one of the finest houses in the land, home only to grazing cattle and grassy meadows peppered by oak trees below the rugged moorland.

Apparently, Bess was once told by a fortune teller that as long as she kept on building she would survive. She died on 13 February 1608, aged 81, and was buried in a vault at All Saints Church, Derby, since rebuilt and now designated Derby Cathedral, where her impressive memorial can still be seen.

Her estates passed to the children from her second marriage – the Cavendish line: her second son William, created the 1st Earl of Devonshire in 1618 (at a reported cost of more than £10,000), had bought the estate from his dissolute brother Henry in 1610, and thus began the tenure of the Cavendish family, created Dukes of Devonshire in 1694.

Bess of Hardwick's second son from her second marriage, William Cavendish, became the 1st Earl of Devonshire in 1618. The title cost him over £10,000 (roughly £1 million today).

CHAPTER 4

THE FORMAL GARDENS

Now in the middle of this great Parterre,
A Fountain darts her streams into the air.
The Wonders of the Peake, Charles Cotton, 1681

During the summer droughts of 2018 and 2022 a ghostly apparition was to be observed at Chatsworth. On the South Lawn – the close-mown greensward that surrounds the Sea Horse Fountain – the pattern of an elaborate formal garden, created at the end of the seventeenth century, appeared in astonishing detail. The curlicues and swirls of the 1st Duke of Devonshire's Great Parterre emerged in scorched silhouette. Even after three hundred years the grass, which was subsequently seeded into the thin layer of earth that had been raked over paths and elaborate gravelled shapes, betrayed its shallow root system. The turf on those areas that once were beds of deeper loam remained green far longer, and so the pattern emerged for all to see – until the rains came just a few weeks later when, like an evanescent wraith, the evidence of the South Lawn's former glory quickly disappeared.

George London designed a parterre to the west of the house (probably the one described by the diarist John Walker in 1677) and was joined by his partner Henry Wise to create the Great Parterre to the south, which was completed in 1690. London and Wise's reputation as the finest British exponents of the art of formal gardening remains unchallenged – not surprising since London had travelled to France to learn his craft from the master of the art at Louis XIV's gardens at Versailles: André le Nôtre. London and Wise were paid £500 for the work. Wise went on to design the Privy Garden at Hampton Court for William and Mary (restored and recreated there in 1996) and the similarities in design with the Great Parterre at Chatsworth are plain to see.

Hundreds of lime trees, box bushes, hollies, junipers and myrtles, along with orange trees and 12,000 hornbeams were supplied to Chatsworth by London and Wise's nursery at Brompton Park, now the site of the Kensington museums. Not only did they design the gardens, they supplied the plants in enormous quantity. Theirs was a profitable and highly successful business, allowing them to engage the Frenchmen Monsieurs Huet and Audias to supervise their plans on site.

Looking westward across the Salisbury Lawns in autumn (*previous spread*). Around 300 years ago these lawns and those on the left (to the south of the house) would have been elaborate parterres.

The end of the Wyatville-designed Broad Walk (*opposite*) has Blanche's Vase as a focal point. Blanche Cavendish was the wife of the 7th Duke of Devonshire and a favourite niece of the Bachelor Duke.

CHATSWORTH

The fountain, with its central figure of the Greek demigod Triton, son of Poseidon, accompanied by a quartet of sea horses (as opposed to seahorses), was carved by the Danish sculptor Caius Gabriel Cibber, who worked at Chatsworth from 1688–91. His CV must have been impressive: he had worked for Sir Christopher Wren at St Paul's Cathedral and also at Hampton Court.

When Charles Cotton wrote *The Wonders of the Peake* at the end of the seventeenth century, the Great Parterre was newly created. It lasted little more than thirty years before fashions changed and the French-influenced formal gardens of the seventeenth century, which graced the demesnes surrounding many a fine English country house, were swept away to be replaced by simpler, more fashionable – and more easily maintained – landscapes. The Great Parterre was expunged from the earth in 1728.

The engraving that can be found in *Britannia Illustrata*, the glorious two-volume masterpiece by the Dutch-born partnership of engraver Johannes Kip and draughtsman Leonard Knyff (real name Leendeert Knijff), which was first published in 1707, shows the Great Parterre at the height of its pomp. Allowing for a certain degree of landscaping hyperbole, you can see the elaborate nature of the gardens to the east, south and west of the house. The engraving shows the Cascade before the addition of the fountain house at its summit, which was completed in 1708. Below the engraving, in my edition of 1714, is the attribution:

Chatsworth House being ye Seat of his Grace Wm. Duke and Earl of Devonshire, Marquis of Hartington, Baron of Hardwick, Ld. Steward of her Maj.ties household, Chief Justice in Eyre of all her Maj.ties Forrests, Chaces Parks &
Trent North and Kt. Of the Most Noble Order of the Garter.

Devonshire was elevated from the Earldom to the Dukedom in 1694, by virtue of being one of the 'Immortal Seven' who invited William of Orange to take the throne of Great Britain in place of James II during the Glorious Revolution of 1688. But for the 1st Duke of Devonshire's quarrelsome nature, the formal gardens at Chatsworth might have remained no more than a dream. They owe their existence to a startling event that occurred at court during the reign of

The Kip and Knyff engraving of Chatsworth (*opposite top*), from the impressive two-volume *Britannia Illustrata*, dates from 1707 and shows the garden at its most formal and elaborate.

A portrait of William Cavendish, 1st Duke of Devonshire (1640–1707) from the studio of Sir Godfrey Kneller (*opposite below left*). The 1st Duke commissioned London and Wise to design and plant the Great Parterre to the south of the house.

The intricacy of the Great Parterre can be seen in this detail of Siberechts's painting of *c.* 1703 (*opposite below right*). Now only Triton and his sea horses remain.

CHATSWORTH

James II in 1685. The 4th Earl took offence at the presence of a certain Colonel Thomas Colepeper:

> … in The King's Presence Chamber and receiving from him an insulting look he took him by the nose, led him out of the room and gave him some despising blow with the head of his cane.

Colepeper did not take this lying down (although he may well have ended up lying down at the time of the incident). The Earl was fined £30,000. He declined to pay his dues and was briefly sent to prison, managing to extricate himself by signing a bond, which was eventually cancelled a few years later by the new King.

Liberated from his embarrassing, if short-lived, sojourn at His Majesty's Pleasure, and no doubt wishing to put the whole sordid episode behind him, the Earl left the seething atmosphere of court and high-tailed it to Chatsworth, where, after the fashion of his great, great grandmother, he concentrated his energies on rebuilding the house and landscaping the grounds. (Colonel Colepeper's fate was rather more ignominious: after a number of failed money-making schemes and devices, he died in penury in lodgings at Tothill Street, Westminster, but not before the Duke had once more encountered him in a London auction house in 1697 and 'caned him for being troublesome in the late reign', according to the delightfully named Cornish MP and diarist, Narcissus Luttrell. The Duke clearly made occasional visits to the capital; hopefully not only as a means of settling old scores.)

A century earlier at Chatsworth, Bess and William Cavendish had created small formal gardens to the south of the house with ponds and fountains, and the sloping ground to the east was terraced. Fishponds were excavated between the house and the river – Queen Mary's Bower (see page 96) stands in what remains of one of them. The majority of the balustrade along the west side of the South Lawn is Elizabethan – a rare survivor from Bess's time here.

There is a record of Bess ordering 'al kynde of earbes and flowres', which would have included roses, honeysuckle, pinks, irises and pansies – subjects for embroidery as well as creating a pleasant atmosphere – along with fruit trees to

The mown ride through the Salisbury Lawns in midsummer guides visitors to the Old Greenhouse.

THE FORMAL GARDENS

Deborah Devonshire's Serpentine Hedge (*opposite*), planted in 1953, and bronze in its late winter livery, runs parallel to the west of the Maze.

The Ring Pond (*left above*) 'where all roads meet', with the Strid Pond visible to the top right of the picture.

A bronze bust of the Bachelor Duke (*left below*) acts as a focal point at the end of the Serpentine Hedge.

THE FORMAL GARDENS

supply the kitchens. It was not until 1659 that any kind of parterre was first mentioned, and not until several decades later that the Great Parterre was completed.

Its commissioner, the 1st Duke of Devonshire, William Cavendish (Bess's great, great grandson) married Lady Mary Butler, daughter of the 1st Duke of Ormonde, and from that point until 1833, with the birth of the 8th Duke, Spencer Compton Cavendish, every duke would bear the name William – something that can make for confusion. It is easy to see why the Dukes of Devonshire are generally referred to by their number rather than their Christian names.

Today the formal areas of the garden at Chatsworth are more modest in extent. The Sea Horse Fountain serves as a reminder of the time when elaborate patterns of box and gravel, clipped yew and holly were the height of fashion, and there remain vestiges of formality on the private west lawns, where symmetrically placed raised stone kerbs, designed by Wyatville, support clipped box hedges.

In 1960, Deborah Devonshire, wife of the 11th Duke, recreated the floor plan of Chiswick House, an eighteenth-century villa once owned by the Cavendish family; 3,300 plants of golden box were used to replicate the floor plan on Chatsworth's west lawn. Alas, they succumbed eventually to poor drainage and waterlogging; now only the circular fountain (filled with water flowing from the Cascade) endures as a reminder of the dome of the Earl of Burlington's elegant Neo-Palladian villa, which was completed in 1729.

Duchess Deborah also planted a double row of pleached limes parallel to the pathways that run along either side of the South Lawn. Elegant though they were, those to the western side obscured the view of Lancelot 'Capability' Brown's landscape rising up from the River Derwent. The 12th Duke and Duchess had both avenues removed. The changes made by successive generations of a family will always give rise to controversy, and this particular refinement was no exception. I enjoyed it while it was there; I enjoy the wider view now that it has gone.

Duchess Deborah's opinion of the work of 'Capability' Brown was not so effusive as that of later generations. In a letter to her great friend, Sir Patrick Leigh Fermor, the famous travel author, she writes of a television interview in which, when asked about Brown's work at Chatsworth, she confessed that she

The Rose Garden, originally commissioned by Duchess Mary in 1939, has gone through various incarnations. It was recently seeded with cornfield wild flowers, but has now been replanted with roses by Tom Stuart-Smith.

'spoke my mind about how he buggered up our garden and how thankful I was he hadn't stopped up the river to make a soggy old lake (a miracle he didn't, now I come to think of it, a favourite trick of his) …'

Deborah's mother-in-law made her own relatively modest mark on the garden. The Rose Garden is an example of the kind of feature that was popular in the first half of the twentieth century, but which has since fallen out of favour. And yet, it perfectly suits the spot it still occupies in front of the structure which was until recently somewhat erroneously known as the 1st Duke's Greenhouse (see page 122).

Duchess Mary, wife of the 10th Duke, commissioned its creation in 1939. While it bears all the hallmarks of yesteryear, the planting scheme is set off well by the backdrop of the portico and orangery-style windows of the greenhouse, along with the towering statue-topped pillars and sentinels of Irish yew, which now list rather drunkenly at either side of the vista leading south.

Other views and vistas, while not perhaps as elaborate as those depicted in Kip and Knyff's time, still reflect a degree of grandeur that suits the house. Duchess Deborah's Serpentine Hedge, made from 1,500 beech saplings (*Fagus sylvatica*) and planted in 1953, is – seventy years on – at the height of its effectiveness: a tribute to the mathematical, trigonometrical and horticultural prowess of Denis Fisher and Bert Link (the Comptroller and Head Gardener of the time). It runs gently uphill due south from the Ring Pond, whose disc of lily-dappled water is disturbed by a single jet of water and gazed upon by herms or 'terms' designed by William Kent and brought to Chatsworth from Chiswick House. The hedge runs parallel with the Canal Pond and terminates in a pedestal bearing a bronze bust of the 6th Duke by Thomas Campbell.

Is formality a thing of the past? There is always the chance that one day the Great Parterre might, in some form, be reflected once more on the South Lawn. Triton and the cavorting sea horses that surround his fountain would, I think, smile at its return.

The view along the Broad Walk presented a more formal picture when this photograph (was taken by Francis Frith in 1897.

Chiswick House (*opposite top*), owned by the Earl of Burlington, depicted in a painting by Pieter Andreas Rysbrack.

Chiswick House floor plan (*opposite below left*) from the original presentation drawings by Richard Boyle and depicted in clipped golden box by Deborah Devonshire on the west lawn.

Before it became the Rose Garden in 1939 (*opposite below right*), the garden in front of the Old Greenhouse had an even more formal layout.

CHAPTER 5

LANCELOT 'CAPABILITY' BROWN

He was far too busy dashing around the country at the behest of every landowner worth his salt, changing the surroundings of all the big houses you have ever heard of, to spend a long time at Chatsworth ...
The Garden at Chatsworth, Deborah Devonshire, 1999

Deborah Devonshire was not on her own in being less than charitable about the alterations made to the landscape by Lancelot Brown, though she does concede that he 'was peerless as a designer of parks'.

The sobriquet 'Capability' was quite likely bestowed upon him posthumously as a result of his habit of suggesting to his landowning clients that their estates had 'great capabilities'. His detractors – and there were plenty of them – regarded him as a 'one-trick pony', considering that every one of his naturalistic-looking landscapes was very much like another. The poet Richard Owen Cambridge reputedly said to his face: 'Mr Brown, I hope I die before you do.' When Brown, suitably abashed by the compliment, asked his interlocutor why, he received the answer: 'Because I want to see heaven before you've improved it.'

Harsh? Definitely. Look closely at Brown's surviving work – around 150 landscapes – and you will discover an innate sensitivity to the genius of each landscape he 'improved'. And yet it is understandable that those who had enjoyed their formal gardens, heavily influenced by the Dutch and French styles, which predominated in Britain during the latter half of the seventeenth and early-eighteenth centuries, were a little miffed and less than charitable about his talents.

The popularity of parterres and intricately geometrical 'plats' was due in no small measure to the exile of King Charles II in France in the first half of the seventeenth century, when André le Nôtre was at the height of his powers at Versailles, and the arrival of William and Mary from Holland and the grandeur of the gardens at Het Loo, which they began to replicate at Hampton Court. Both the House of Stuart and the House of Orange brought their regal influence to bear on British soil.

And the man who is accused of sweeping it all away? An apprentice gardener from Northumberland.

Lancelot 'Capability' Brown (1716–1783) by Nathaniel Dance Holland. A kindly yet inquisitive gaze from Britain's most famous, and arguably most accomplished, landscape architect.

CHATSWORTH

Lancelot Brown was baptised on 30 August 1716 in the village church in Kirkharle, 12 miles west of Morpeth. The landscape there is rough and rolling moorland and meadow and, unless I am being fanciful, to stand within it you will somehow feel that its very soul is at the heart of Brown's work as a landscape architect, following on from those other giants and masters of the art: Charles Bridgman and William Kent.

Brown's beginnings were humble: his father was the land agent to Sir William Loraine of Kirkharle Hall, and his mother was a chambermaid in that household. Young Lancelot worked as an apprentice to the head gardener on Sir William's estate, taking up his seven-year apprenticeship at the relatively late age, for those times, of sixteen.

Lancelot was a hands-on gardener and learned his craft from the bottom up – planting, sowing, digging and hoeing. At twenty-three he moved to Boston in Lincolnshire, and eventually, in February 1741, at the age of 25, to Stowe in Buckinghamshire. There, as an undergardener on Lord Cobham's famous estate, he was able to flex his landscaping muscles as he worked under that other great figure of British landscaping, William Kent. A year later, Brown would become Stowe's Head Gardener on a salary of £25 a year and, newly married, find himself living in the West Pavilion.

Brown's work at Stowe can still be seen – most especially in the Grecian Valley, created under the watchful eye of Kent. Brown left Stowe in 1750, and by 1760 – when he accepted a commission from the 4th Duke of Devonshire to work at Chatsworth – his reputation as a creator of idyllic landscapes was assured and his earnings had escalated to a colossal £6,000 a year – equivalent to more than £850,000 today.

Brown's hand-written account book in the Lindley Library of the Royal Horticultural Society in London gives a detailed insight into his charges and the regularity of payments he expected from his illustrious clients. From the Duke of Marlborough at Blenheim to Lord Palmerston at Broadlands, it seems that he submitted a quarterly account that, in the majority of cases, amounted to a sum of £500 – the equivalent today of around £120,000 per annum.

There are no mentions of Chatsworth or the Duke of Devonshire in this

Chatsworth, painted in the early 1740s by Thomas Smith of Derby, a decade before Lancelot Brown's first visit. The Great Fountain – the Emperor Fountain's predecessor – reached a height of 28m. The old stables can be seen below the house and the river would appear to be in full spate.

account book. Only a few records of payments to Mr Brown can be found in the Chatsworth archives, but no plan and no details of the work he undertook. Perhaps one day, like the plan he drew up for the estate at Belvoir Castle, which was discovered among the muniments just a few years ago, something more comprehensive will come to light.

At the time he visited Chatsworth he would have arrived on horseback, travelling, there is little doubt, in some discomfort across the rugged landscape of the Peak District. Brown was an accomplished horseman who rode well (he needed to, to get around all his widespread commissions), though later in life he did allow himself the luxury of travelling by coach.

By the 1760s, Brown's career was at its height: dozens of workmen would be set to work, supervised at Chatsworth by his foreman Michael Millican, who would have been given detailed instructions during Brown's once- or twice-yearly visits, when areas would have been marked out, views and vistas delineated and detailed planting plans agreed upon. Trees were sourced locally wherever possible, though sometimes particularly fine specimens would be transported from further afield. The bulk of the planting would have been 'whips' – young trees a year or two old, with more mature oaks, beeches, planes and cedars being chosen for particularly telling spots.

Within a year the changes to the landscape were well underway, and incorporated James Paine's one-arch bridge to the south at Calton Lees, built in 1759, and his more famous three-arch bridge, completed two years later to facilitate the new approach to the west of the house, favoured by the 4th Duke. It sits at just the right angle to complement both house and landscape.

In 1761, Horace Walpole records that the Duke was making 'vast plantations ... and levelling a great deal of ground to show the river under the direction of Brown'. These 'vast plantations' comprised New Piece Wood and Calton Lees, which were created, according to Jane Brown's excellent biography of Brown – *The Omnipotent Magician* – with 71,500 thorns, 15,000 rowan, birch and spruce and 10,000 oaks.

Admitting his talent for creating beautiful parkland, and swallowing her criticism of his destruction of formal gardens, Deborah Devonshire concedes that the crowning of the distant hill with trees and effectively embracing the parkland:

... gives the comfortable feeling of an enclosed space and, because you cannot see through it, seems to be far more heavily treed than it is. Brown planted the wood in wedge-shaped compartments, so when one section is mature and ready to be felled another is growing and the line remains unbroken. All was planned to delight the eye from the house, making the best use of the contours in the wide expanse across the river.

Stand beside the balustrade alongside the house and gaze westward at the parkland beyond the River Derwent and I doubt that you will be less than awe-inspired by its beauty, even now, some 250 years after Brown's work was completed.

And do not lay at Brown's feet the destruction of that formal design shown in Kip and Knyff's engraving of 1707. Much of that had been swept away thirty years before Brown arrived.

As to Deborah Devonshire's relief that Brown did not turn the River Derwent into a serpentine lake, his contribution was, in reality, practical as well as artistically sensitive. In 1760 the river was not easily seen from the house. What's more, it was, quite naturally, comprised of a series of serpentine twists, which meant that after high rainfall it flooded and engulfed the surrounding land, making access difficult and often dangerous. Brown actually straightened it out to shift the floodwater more rapidly downstream. A one-trick pony? I don't think so.

The management of water – from moorland to drain, from culvert to canal, from pond to river, is a constant challenge at Chatsworth, and has been so since the days of Bess of Hardwick. Lancelot Brown played an important and practical role not only in the martialling of those natural resources, but also in the inclusion of livestock – sheep and cattle were every bit as important as serpentine lakes, from an economic as well as an aesthetic point of view.

The poet Thomas Gray was certainly impressed by what he saw when he visited Chatsworth in 1762, declaring:

James Paine's three-arch bridge, built in 1761, and seen here with its original ornamentation of Devonshire stags as well as the statues in niches above each pier.

[it] has the air of a palace, the hills rising on three of its sides to shut out the view of its dreary neighbourhood, & are covered with wood to their tops; the front opens to the Derwent winding thro' the valley, which by the art of Mr Brown is now always visible and full to its brim, for heretofore it could not well be seen (but in the rainy season) from the windows; a handsome bridge is lately thrown over it, & the stables taken away, which stood full in view between the house & the river, the prospect opens here to a wider track of country terminated by more distant hills; this scene is yet in its infancy, the objects are thinly scatter'd & the clumps and plantations lately made: but it promises well in time.

That promise is, today, fulfilled, and Brown's vision has come to fruition.

The 4th Duke died in 1764, and the landscape did not especially interest the 5th Duke, husband of the fabled Georgiana. But Lancelot Brown had almost twenty years ahead of him, during which time he would add significantly to his standing and his income.

Lancelot Brown's employer, the 4th Duke of Devonshire (1720–1764), painted by Thomas Hudson and displaying the fine aristocratic costume of the mid-18th century.

LANCELOT 'CAPABILITY' BROWN

In 1764, the year of the 4th Duke's death, Brown was appointed King George III's Master Gardener at Hampton Court. He planted the 'Black Hamburgh' grape vine, which survives to this day, and lived in the Wilderness House there. He bought a small estate in Fenstanton, Cambridgeshire – the only land he ever owned – in 1767.

And what of Lancelot the family man? Brown married Bridget 'Biddy' Wayet, whom he had met in Boston, in Stowe parish church in 1744. They had eight children. How often he saw them, thanks to his peripatetic life, is open to conjecture, since he travelled widely and was actively involved in designing both houses and landscapes until the very end of his life.

In Nathaniel Dance Holland's portrait of 1773, Brown has a kindly yet quizzical look. I like to think that he must have been a 'people person', able to converse happily with Kings and Queens, dukes and garden labourers. His early years as a gardener would have kept his feet firmly on the ground.

He died on 6 February 1783 at the age of 66, having collapsed the previous evening in Hertford Street, Mayfair, outside the house of one of his clients, Lord Sandwich. His fall, it is thought, led to an asthma attack. At the time of his death he had earned, in today's equivalent, around £500 million. From that you can deduct the wages he would have had to pay his foremen and his labourers, at the 260 different sites on which he worked, but that would still leave him the equivalent today of around £130 million. His legacy, I would argue, shows that he earned it.

The memorial fountain installed in the Cloister Garth at Westminster Abbey to mark the tercentenary of his birth, and dedicated on 29 May 2018 by the Dean of Westminster, bears the words of Horace Walpole:

> WITH ONE LOST PARADISE THE NAME
> OF OUR FIRST ANCESTOR IS STAINED;
> BROWN SHALL ENJOY UNSULLIED FAME
> FOR SO MANY A PARADISE REGAINED
> 1716–1783 LANCELOT 'CAPABILITY' BROWN
> HE SOUGHT AN IMAGE OF HEAVEN

At Chatsworth, I reckon, that image is pretty well accomplished.

CHAPTER 6
THE WATER

A Noble Palace, adorn'd with all the Embellishments of the most exquisite workmanship; delicate Gardens, beautified with all the Rarityes Curiosity can invent, in the midst of a most barbrous Country.
A Journey to Edenborough in Scotland, Joseph Taylor, 1903 edition

Thanks to its geography and the plentiful supplies of rain, Chatsworth is seldom short of water, and successive dukes have done their best to utilise both its nourishing and its aesthetic properties.

The River Derwent

In spite of his fondness for serpentine lakes, the course of the Derwent was adjusted by Lancelot 'Capability' Brown in the 1760s so that it was less sinuous and less inclined to flood. The river is, in a way, the beating heart of the Chatsworth Estate. It flows just a stone's throw to the west of the house, having started its journey at Ronksley Moor, five miles south of Holmfirth in Yorkshire, and will lose its identity some 60 miles downstream when it slides into the River Trent at Long Eaton in Derbyshire. At Chatsworth it expresses its happiest personality in landscape terms – gently gliding by – except when winter rains add to its load and the currents become more forceful. Trout are caught here, but the last recorded salmon was pulled from the river in 1836. Sheep graze its verdant banks. It acts as the perfect backdrop to the Chatsworth Country Fair at the beginning of September, when sheepdog trials can be viewed across its glinting waters.

The Cascade

There is something so refreshingly contemporary about the appearance of the Cascade that visitors are surprised at its history. Designed by a French hydraulics engineer, Monsieur Grillet, its first iteration was completed in 1696 and the house at its apex, reworked by Thomas Archer (who was responsible for designing the north front of Chatsworth House itself), was put in place in 1711. The credit for the decorations of the building must go jointly to Henri Nadauld and Samuel Watson.

Lancelot Brown's glorious 18th-century landscaping to the west of the house (*previous spread*) and the Canal Pond with the Emperor Fountain of the 19th century to the south.

The view westwards from Thomas Archer's Cascade House of 1711 down the Cascade itself (*opposite*), which was designed by the French engineer Monsieur Grillet and completed in 1696.

CHATSWORTH

Look closely and you will see a river god asleep on the roof, while two nymphs spill their pitchers of water to add to the flow, which is augmented by the outpourings of a pair of griffins and dolphins – thirteen spouts in all. It is wonderfully elaborate, and when the sun glints through the spume and spray it becomes especially enchanting.

William Kent (1685–1748) produced designs for remodelling the Cascade in the early part of the eighteenth century, and influenced the more natural plantings on the landscape surrounding the house, but it is unclear exactly what – if anything – remains of his activity. Perhaps the Salisbury Lawns, as they are called, immediately below the Cascade, are most likely the result of his influence – sweeping away the formal and replacing it with a calmer, more naturalistic feel.

The Cascade itself has outlived the influence of one of Britain's most-revered architects of both landscapes and buildings, as well as robust and elaborate furniture.

There are twenty-four sets of steps on the slopes of the Cascade – changed and added to in 1826 by the 6th Duke – and various reconstructions and restorations have taken place since, most notably in 1995–97, when local stone was carved and inserted to counter the effects of erosion from the water, which makes its way downhill from a nine-acre reservoir dug especially for the purpose high up on the moor. Listen carefully as you walk down hill – the water changes its tone with every set of steps.

Soon, comprehensive work will have to be undertaken once more to counteract the decades of erosion and leakage – even more extensive than that of the 1990s. The cost will be eye-watering, but this aquatic masterpiece's unique spectacle will then be assured for another century or more.

From the base of the Cascade, the water flows on through underground culverts to fill the circular pond to the west of the house, but only during the Cascade's working hours. It is turned off at night to conserve water. Watching it erupt from the ground each morning to tumble down the gigantic staircase once more never fails to delight.

Samuel Brailsford's survey of 1751 (*opposite top*) shows features of the park which were subsequently removed as part of 'Capability' Brown's landscape design, including multiple fish ponds, the Canal and the Kitchen Gardens.

The Cascade exterior (*opposite below left*) – a picture taken for a *Country Life* feature in 1900. The sprays on the Cascade House still work, though they are not turned on very often since they use a lot of water and this is a gravity-fed water system. As such, they are only operated when water supplies are plentiful. The Cascade is about to undergo a major restoration process.

A design produced by William Kent (1685–1748) for the remodelling of the Cascade in the early part of the 18th century (*opposite below right*). It is unclear just what remains today of his intervention in the landscape.

THE WATER

The Emperor Fountain (*opposite*) dates from 1844, and can reach a height of 60m, though it was once claimed to be capable of an astonishing 90m. That's just 6m short of the Elizabeth Tower, more commonly known as Big Ben.

The sinuous journey of the River Derwent (*above*) winding south past the house.

A black chalk drawing on paper, *c.* 1700, by Samuel Watson (*top*), of one of the elements of the Sea Horse Fountain carved by Caius Gabriel Cibber for the 1st Duke's parterre garden. This and similar drawings were of great importance in the project to restore the Sea Horse Fountain in 2015, when they were used by the conservators (of Cliveden Conservation) to carve replacements for the missing marine legs of several of the sea horses.

The Sea Horse Fountain (*top right*) remains the one constant on the South Lawn, having survived for more than three hundred years.

The girls of Penrhos College (*right*) who occupied the house during World War II. The Canal Pond froze regularly until the 1990s.

THE WATER

The Sea Horse Fountain

A part of the formal gardens that once adorned the land to the south of the house, the Sea Horse Fountain – now one of only three remaining, after others were removed and ponds filled in – is now marooned in its surrounding lawn. It is all that remains of those seventeenth-century glory days. Carved by Caius Gabriel Cibber (1630–1700) – father of the actor, playwright and poet laureate Colley Cibber – Triton the sea god blows his conch shell at its centre, while four mythical marine beasts – half horse, half fish – cavort around him. Until recently, they exhibited the kind of infirmity that might be expected of any three-hundred-year-old equine, with an occasional limb missing and a liberal coating of lichens, but their very survival is, in itself, a miracle, bearing in mind the sweeping away of most of Chatsworth's formal embellishments in the mid-eighteenth century. Happily, they were fully restored in 2015.

The Canal Pond and Emperor Fountain

To look at it now, you would scarcely imagine that the land here was once referred to as the 'Great Slope', which hid from view the prospect southwards towards Rowsley. The 1st Duke took it upon himself to improve the view, levelling the ground and adding the water not only to reflect the sky, but also the south front of the house, which is why the Canal Pond is raised very slightly above the ground on its southern end.

Constructed between 1702 and 1703, the Canal Pond is 287m long, but less than a metre deep. A 'plug hole' at the end farthest from the house allows excess water to escape. Impressive in the extreme when at its full height of 60m (and once said to have reached 90m), the Emperor Fountain, erupting from a cairn of boulders, is guarded by a pair of bearded river gods on the edge of the bank nearest the house. They were sculpted by Henri Nadauld – the man who created the decorations for the house at the top of the Cascade.

The Emperor Fountain's predecessor – the Great Fountain – reached a height of 28m, but when a visit by Czar Nicholas I of Russia was arranged in 1844, the 6th Duke – always known as 'the Bachelor Duke' – felt that something even more spectacular was needed: a fountain that would be even higher than

'The Bachelor Duke' – William Spencer Cavendish (*right*), 6th Duke of Devonshire (1790–1858) by Sir George Hayter.

THE WATER

that of the Czar's own at Peterhof. Joseph Paxton was charged with the construction of its replacement. Fed by the Emperor Lake more than 120m above the garden, the water is channelled through a 40cm iron pipe – gravity alone being responsible for its impressive height. New nozzles were manufactured in 2014 – one the same diameter as the original and another slightly narrower, which ensures that the fountain continues to reach heady heights. Having myself been allowed to turn the huge iron key, which opens the valve to allow the water through, I can testify to its power as it thunders upwards to the sky.

In 2022, the pipe that feeds the fountain fractured and flooded parts of the garden – it was, after all, almost 200 years old – but repairs were made and the Emperor Fountain is once more capable of impressing all who see it.
And the opinion of the Czar? A sweet chestnut tree to the northwest of the house bears a plaque indicating that it was planted by him in 1816, when he was Grand Duke Nicholas, heir to the throne of Russia, but he never did return to Chatsworth as the Czar. In 1844 he met the 6th Duke and Paxton at Windsor and in London, and he invested them both with the Order of Knighthood of Saint Vladimir (an honour founded by Catherine the Great) – a ceremony involving the bestowing of elaborate insignia and sable coats. Perhaps he asked about his tree, but he never journeyed to Derbyshire to see it, or to admire the fountain named in his honour. Ah well; his loss is our gain.

The Grotto Pond

Georgiana, the first wife of the 5th Duke and a passionate collector of minerals, was responsible for the creation of the stalactite-filled grotto up the slope to the southeast of the house. The grotto is surmounted by a rustic bandstand which was added by the 6th Duke and is not open to the public, but the spot is still worth visiting, since the pond in front of it offers glorious reflections of the surrounding trees – especially when at their most spectacular, clad in the autumn livery of red, gold and amber. The pond itself is fed by the higher Morton Pond and was excavated around 1700 – pre-dating the grotto by around a century.

The Grotto Pond in autumn. A perfect place to reflect … and to observe reflections.

CHATSWORTH

The Aqueduct (*left*) in Stand Wood, designed by Sir Joseph Paxton for the 6th Duke.

Morton Pond (*right*) feeds the Grotto Pond lower down the slope. This is one of the quietest and calmest parts of the garden.

THE WATER

The Aqueduct

Moorland lakes are responsible for feeding all the water features at Chatsworth, including the rather striking Aqueduct, which appears to lurch out of the undergrowth like some prehistoric beast, and over whose craggy, broken-off end cascades a 25m cataract of foaming water. It was built by Joseph Paxton for the 6th Duke in 1839, and retains an impressive air of theatricality, as though it had been especially constructed for a James Cameron disaster movie. The Bachelor Duke wrote: '… nothing can be more beautiful than the icicles formed by the dripping from those arches in fantastical shapes during the winter.'

Quebec

Until 2008, the area below the Canal Pond was swamped by *Rhododendron ponticum*. The sound of running water could be heard among the undergrowth, but there was nothing picturesque about it. Known as Quebec – a name given to the area, it is thought, by the 9th Duke who was Governor General of Canada in the early twentieth century – the small cascade was a part of the 1st Duke's garden: an overflow from the Canal Pond. Now it tumbles over rocks in full view, down slopes adorned with bluebells in spring, where seats made from convoluted branches – like something out of an Arthur Rackham fairy-tale illustration – offer somewhere to rest and take in the glorious view over 'Capability' Brown's landscape across the valley. This particular spot offers one of the finest prospects of the parkland.

There is little new planting here at the moment, though young trees are being added – trees of North American origin as befits an area known as Quebec. Future plans may include more comprehensive plantings of shrubs and perennials that suit the terrain. And to think that for years it lay beneath a thicket of dense undergrowth …

The Cascade Pond is fed through aqueducts from the Emperor Lake high up in Stand Wood, the water then making its way down the hillside to power the spectacular Emperor Fountain.

CHAPTER 7
JAMES PAINE

> IT HAS BEEN USUAL FOR THOSE WHO HAVE PUBLISHED THEIR LABOURS, TO GIVE SOME ACCOUNT OF THEMSELVES, AS WELL AS OF THEIR WORKS ... IN CONFORMITY TO THIS CUSTOM, THE AUTHOR THINKS IT SUFFICIENT TO SAY, THAT HE BEGAN THE STUDY OF ARCHITECTURE IN THE EARLY PART OF HIS LIFE ...
> *Plans, Elevations and Sections, of Noblemen and Gentlemen's Houses*, James Paine, 1767

Born in 1717 – most probably in or near Andover in Hampshire, where records show he was baptised on 9 October – James Paine's early life is hard to document, but we do know that his father was a carpenter and that three of his siblings survived into adulthood. We also know that he went on to study at the St Martin's Lane Academy – the precursor of the Royal Academy – which was founded in 1735 by William Hogarth of *The Rake's Progress* fame, and recognised as being involved in the encouragement of the Rococo style of which Paine would become a great exponent.

Among those he encountered at St Martin's was the architect Isaac Ware, and it is likely that Ware's friendship with the 3rd Earl of Burlington was the reason – along with a prodigious talent – that in 1737, at the age of nineteen, Paine was appointed Clerk of Works, supervising the building of Nostell Priory near Wakefield in Yorkshire for the owner and friend of Burlington, Sir Rowland Winn.

It is sometimes stated that Nostell Priory was designed by Paine himself, though as a relative unknown at the time, his talents and connections would have been unlikely to result in such a commission. The house had, in reality, been designed by Colonel James Moyser, a gentleman architect and part of Lord Burlington's circle.

Here is our first connection with Chatsworth: some eleven years later, in 1748, the 4th Duke of Devonshire married Lord Burlington's teenage daughter, Charlotte Boyle – Burlington's only surviving child. Upon Burlington's death in 1753, all of his lands and property passed to her and became a part of the Devonshire estates. Charlotte would die the following year at the tragically young age of 23.

By 1745, Paine's expertise – and reputation – had grown sufficiently for him to

The architect of Chatsworth's stables and bridges, James Paine (1717–1789), with his son, painted by Sir Joshua Reynolds.

be put in charge of the interior decoration at Nostell Priory – work for which he is now rightly famous.

It is not surprising that Thomas Chippendale, born in Otley, just 20 miles away, was commissioned to provide the furniture; the largest collection of Chippendale furniture in any one house still resides there. Chippendale was born a year after Paine – in 1718 – and it is almost certain that the two knew each other well and that Paine recommended the young cabinet maker to Sir Rowland Winn, as well as encouraging Chippendale to move to London. It was in St Martin's Lane – that powerhouse of the artistic community – that Chippendale would open his workshops in 1754.

After seven years of working at Nostell Priory, Paine began to take on his own commissions. While living in Pontefract, just 4 miles from Nostell, he was commissioned to design Heath House close by, and also the Mansion House at Doncaster. Other local commissions followed.

His private life was transformed, too. In 1741 he married Sarah Jennings, whose late father George Jennings had been a member of the Pontefract gentry and a friend of Sir Rowland Winn. James and Sarah had one son, also called James, but Sarah died shortly afterwards and Paine married Charlotte Beaumont in 1748. They had two surviving daughters (another two died in infancy), one of whom, Mary, married the artist Tilly Kettle.

Paine had returned to London in 1746, and in that year was made Clerk of Works at the Royal Mews in Charing Cross. Over the next ten years, Paine's reputation grew, and his commissions for the nobility and gentry – among them the Earl of Darlington, at Raby Castle, and the Earl of Northumberland, at Alnwick Castle – were ever increasing.

It was thanks to his appointment in 1754 as Clerk of Works at His Majesty's Stables at Newmarket, Suffolk, that Paine had met the Marquis of Hartington, son-in-law of the late Earl of Burlington. Before acceding to the Dukedom in 1755, Lord Hartington had been Master of the King's Horse, and the two would clearly have encountered each other among the thoroughbreds. So it was that in 1756, Paine was commissioned to design, at Chatsworth, one of the grandest eighteenth-century stable blocks in the country.

West Front of the Great Stables at Chatsworth.

James Paine Arch.t / T. Morris Sculp.t

The elaborately decorated archway makes an impressive entrance to the building, which is constructed of sandstone with a Westmorland slate roof. A clock is surmounted by a domed lantern above the arch, which gives onto a courtyard around which the stables, with accommodation above, are arranged.

The Bachelor Duke tells us in his *Handbook of Chatsworth* of 1844–5:

These have been unaltered by me: they were built by my grandfather. They contain about eighty stables for horses. In the days of breeding, training &c., there were accommodations suitable to each department, neglected in these degenerate times … I have added a new coach-house, to shelter the carriages of my visitors from the elements … I have always admired the exterior of the building and fancied something Florentine in the quality of its architecture.

Since eighty horses are no longer kept by the present Duke and Duchess, the stables and carriage house now comprise a restaurant and shops – all carefully incorporated into Paine's grand building. Think of him while you enjoy your meal, or when you cross one of his two bridges over the Derwent – the three-arch bridge to the west of the house and the single-arch bridge at Calton Lees.

Paine's designs for the stable block at Chatsworth from his book *Plans, Elevations and Sections, of Noblemen and Gentlemen's Houses* of 1767.

CHATSWORTH

A committed exponent of the Palladian style, Paine's antipathy to the work of those neoclassical champions, the Adam brothers, is made clear in his writings, as is his opinion of Lancelot 'Capability' Brown. In spite of working alongside him at Chatsworth, Paine states:

… what surprising genius's then must those be who are born architects? How much above every other order of men? But, as nothing is impossible with the great Author of nature, so we have seen a genius of this kind, who, after having been from his youth confined against his nature, to the serpentine works of horticulture, emerge, at once, a compleat architect, and produce such things, as none but those who were born with such amazing capability, could possibly have done …

And yet in his book of 1767 he shows at least some generosity of spirit:

… in justice to Mr. LANCELOT BROWN, who was employed by His GRACE, in laying out the improvements near the house, it would be an omission not to say, that he has executed his part in a masterly manner, and has by his skill, contributed towards making it perhaps one of the noblest places in EUROPE.

In other words, provided Brown stuck to landscaping, Paine was prepared to concede that he was among the most skillful exponents of the art. But when he overstepped the mark designing houses and buildings, Paine's feathers clearly were ruffled.

A glance at the portrait of Paine painted by his friend Sir Joshua Reynolds – showing James and his son – seems to reveal, if appearances are anything to go by, a sturdily built man with an unflinching gaze. A man who was firmly committed to his own ideas of what constituted fine architecture.

Paine produced one two-volume work during his lifetime. The first part of *Plans, Elevations and Sections, of Noblemen and Gentlemen's Houses* published in

Horses and a carriage in front of Paine's stable block c. 1900 – the age of elegance.

1767, and the second in 1783. He was appointed High Sheriff of Surrey in 1783 – he had bought the lease to Sayes Court near Chertsey in 1773, and went on to become a Justice of the Peace.

With the rise of the Adam brothers and their promotion of neoclassicism – architecture heavily influenced by Greek and Roman antiquities – rather than his own preference for the Palladian style, based on the work of the sixteenth-century architect Andrea Palladio, Paine's practice declined.

In 1789 he retired to France, and died later that same year. He was seventy-two. The list of Paine's surviving works is long and impressive, and while many of his commissions were remodelled and adjusted by those who followed – as whims were pandered to and fashions changed – there are still many surviving examples of his fine architecture. Take a look at New Wardour Castle in Wiltshire – a grand villa-based house of exceptional elegance and presence, so much so that when it was converted into apartments, the designer Jasper Conran plumped for what he considered to be the best one.

Paine also designed the existing bridges over the Thames at Richmond and Chertsey. Far away from the buzz of these outer London river crossings, the stables and bridges at Chatsworth remain elegant monuments to the remarkable talents of a man who knew what he liked and was not afraid to say so.

Not all the horses housed in the stable block were of aristocratic pedigree. Working horses found a home here, too.

CHAPTER 8
THE FOLLIES

> ... I HAD SEEN IT BEFORE, BUT IT IS MUCH IMPROVED BY THE LATE
> DUKE, MANY FOOLISH WATERWORKS BEING TAKEN AWAY, OAKS &
> ROCKS TAKEN INTO THE GARDEN & A MAGNIFICENT BRIDGE BUILT.
> *Journal of the Walpole Society*, Horace Walpole, 1768
> (quoted in *A History of Chatsworth*, Francis Thompson, 1949)

Each succeeding Earl, and latterly Duke, has made his mark on the garden when it comes to ornament. The current Duke and Duchess have a predilection for contemporary – twentieth- and twenty-first-century – sculpture, from Dame Elisabeth Frink to David Nash. Their predecessors exercised their artistic whims on a somewhat grander scale, before the imposition of that thing called 'planning permission'. For almost 500 years the owners of the Chatsworth Estate have bequeathed their own follies and extravagances to succeeding generations. Many of them have survived the ravages of time, as well as changes of taste.

The Hunting Tower

Standing imperiously atop the towering 400ft hill to the east of the house, the five-storey, four-domed Hunting Tower built of 'coursed sandstone with ashlar dressings' was completed around the year 1582 for Bess of Hardwick. It was probably designed by the Elizabethan architect Robert Smythson, who also created Bess's new Hardwick Hall. Its proximity to the adjacent Stand Wood has meant that it is also known, less romantically, as the Stand Tower.

Back in Elizabethan times it would most likely have been a place for celebratory banquets or hunt lunches, as well as a vantage point from which the ladies of the household could watch the activities of the huntsmen, the horses and the hounds as they pursued deer in the valley below. Today it is elegantly furnished in a twenty-first-century style. You can rent it for a few days' holiday and imagine yourself back in the first Elizabethan era, with the merciful addition of running water, power and heating, and the kind of creature comforts that Bess and her houseguests could not even have dreamed of. Gaze westwards through the diamond-pane windows and you will have the finest of all views of 'Capability' Brown's landscape beyond the River Derwent.

The Elizabethan Hunting Tower (previous spread) dates back to the time of Bess of Hardwick. Its views westwards over the valley, particularly in autumn, are spectacular.

Duchess Georgiana was responsible for the Grotto (opposite), seen here in spring, flanked by a carpet of rich blue camassias and a blossoming crab apple.

CHATSWORTH

Queen Mary's Bower

More legend surrounds Queen Mary's Bower than any other feature on the Chatsworth Estate. It is true that Mary, Queen of Scots was incarcerated at Chatsworth, under the care of Bess's fourth and last husband, George Talbot, Earl of Shrewsbury, at various times between 1569 and 1584, but opinions vary as to her use of the building known as 'Queen Mary's Bower'. Francis Thompson, Chatsworth's librarian for much of the twentieth century, had no such doubts, remarking:

Close to the house and actually within its garden-walls, itself surrounded by water and with only one means of approach, as an outdoor prison it was ideal. Nowhere could she have been more secure from that sudden attempt at rescue of which her guardians lived in constant dread.

The bower we see today likely bears only scant similarity to how it would have appeared in Bess's day. It was heavily restored by Sir Jeffry Wyatville in the 1820s, and the surrounding landscape was altered even earlier by 'Capability' Brown and his foreman Michael Millican, but its transformation and restoration do not detract from the romantic legend – to all except herself – of Mary's Derbyshire banishment from the court of Elizabeth I.

The Grotto

The Grotto was built by my Mother; and I respected its exterior when the addition was made of a natural cavern, formed of crystals of copper ore that were discovered in Ecton mine, on the borders of Staffordshire ...

These are the words of the Bachelor Duke, referring to Georgiana Spencer, wife of the 5th Duke who was, in the words of Deborah Devonshire, 'Famous for her charm, gambling debts, enormous hats and electioneering prowess.'

The inside of the Grotto is decorated with stalactites but it is not open to the public. The external view of the structure, topped by its rustic bandstand and flanked by a reflective pond (see page 81), must suffice as fuel for our imaginings of life at the court of the infamous Georgiana, four times great aunt of Diana, Princess of Wales.

The Grotto Pond disgorges its water into the Trough Waterfall which flows onwards to the Ravine. A rustic bandstand sits atop Duchess Georgiana's 18th-century creation.

THE FOLLIES

THE FOLLIES

Georgiana died in 1806 at the age of forty-eight. The eighteenth-century traveller Louis Dutens wrote of her: 'She changed the hours, and set the fashions. Everybody endeavoured to imitate her, not only in England, but even at Paris. Everyone enquired what [Georgiana] did, and how she dressed, anxious to act and dress in the same style.' How curious that he could, 200 years later, have been talking about her four times great niece …

Paine's Mill

Aside from the stables and his one-arch and three-arch bridges over the River Derwent, James Paine was also commissioned by the 4th Duke to design a handsome yet practical folly in the form of a working mill. Built between 1759 and 1762, close to the river at the southern end of the park towards Calton Lees, the mill last ground corn – for the miller Wilfred Johnson – in 1950. It is now derelict, with only traces of its machinery in evidence, but we have to thank Duchess Deborah for its survival as a handsome ruin, since it was severely damaged by a falling beech tree in a gale that wreaked havoc in Yorkshire and Derbyshire during the winter of 1962. She stopped it from being totally demolished, and it serves as a reminder of Paine's ability to invest even modest and practical buildings with good proportions and elegance.

Paxton's Coal Hole

It is the middle of the nineteenth century and you have a large greenhouse to heat. What do you use for fuel? Coal, of course. Where do you keep it? In a coal hole. You can see the massive and beautifully constructed Coal Hole at Chatsworth to the northeast of the Maze where the Great Conservatory stood, and marvel at the operation involved in bringing the coal into the garden, from the Manchester, Buxton, Matlock and Midland Junction Railway at Rowsley, transported along the tunnels, which sadly became repositories for garden rubbish after the demolition of the Great Conservatory in 1920. Amends were made in 2003 when the Coal Hole and tunnels were cleared out, and their sturdy and handsome construction revealed. They are now lit and open to visitors, who can marvel at the degree of manual labour needed to keep Victorian greenhouse plants warm.

James Paine was commissioned by the 4th Duke to design a handsome yet practical folly in the form of a working mill. Now a ruin, it emerges through the mist on a June morning.

CHATSWORTH

Flora's Temple

It is only fitting that Flora, the Roman goddess of flowers, should have a place in the garden. She was sculpted by Cibber, the man responsible for the Sea Horse Fountain (see page 79) in around 1690, and she stands in a temple dating from the 1st Duke's garden, built in 1693. It originally stood beside the Bowling Green to the southwest of the house. It is now a splendid focal point at the north end of the Broad Walk, to which spot it was moved in 1750. The stonework was restored and the pillars renewed in 1993, when statue and temple were united – Flora having started her life in Flora's Garden beyond the parterre on the south terrace, before being moved to the Rose Garden in 1813. She looks rather splendid – and no doubt enjoys being more sheltered from the elements than earlier in her life.

Two skeleton trunks of Camellia 'Captain Rawes', planted along the Conservative Wall by Paxton around 1850, reside nearby, having finally succumbed to old age at the start of the new millennium.

Summer House

To the south of the Kitchen and Cutting Garden (alongside the serpentine path as you descend from the Trout Stream) you will come across Chatsworth's ugliest folly, and one that would probably be more at home amid the exotic excesses of the garden at Biddulph Grange in Staffordshire. Also known as Luttrell's Seat (Henry Luttrell, described as 'a wit and poet', was a friend of Duchess Georgiana), it was erected by Georgiana's son, the 6th Duke, in a style he described as, 'Saracenic; the columns are of Aberdeen granite, and the rude central capital of serpentine came with me from Palermo, and is the cause of this manner of decoration.' I share Duchess Deborah's opinion: 'a hideous building'. The interior contains a Latin inscription from Virgil. I have never dallied here long enough to read it, but then my knowledge of Latin – strictly botanical – would probably not be up to the task.

Queen Mary's Bower (*opposite top*) dates from the time of Bess of Hardwick, but has been much altered in the intervening centuries. For many years it has been asserted that Mary, Queen of Scots, was held captive here, at the behest of Queen Elizabeth I.

Paine's Mill (*opposite below left*), built between 1759 and 1762, seen here prior to its partial demolition by a falling tree in 1962. It was milling flour until the 1950s.

Flora's Temple (*opposite below right*), pictured before its rightful occupant was moved under cover and out of the bracing Derbyshire air.

THE FOLLIES

Flora's Temple (*opposite*), with the goddess having finally taken up residence.

The Summer House (*above left*) – also known as Luttrell's Seat – is a strange and rather eerie shelter bearing a Latin inscription by Virgil. Not the garden's most handsome structure, but a curiosity nevertheless.

A section of the chimney pipe (*below left*) from the Great Conservatory, which runs through the garden to a chimney in Stand Wood.

Game Larder

The year is 1909. You have a large estate. You host weekend house parties (contrary to the opinion of a certain fictional Dowager Countess of Grantham, the term 'weekend' was in widespread circulation from 1878). Your guests come to shoot pheasants and partridges. You need somewhere cool and airy to hang the birds – along with venison and rabbits – until the meat is considered mature enough to eat. So you build a game larder; a handsome one. This is the octagonal building adjacent to the car park. Duchess Deborah preferred live birds to dead ones: she used the Game Larder as a hen house, from which she would collect the eggs every day. In 2016 the building – now devoid of poultry – became a Landscape Interpretation Centre, where the story of the estate's development over the centuries, and its current aspirations, are explained. It is useful and informative … but I do miss the hens …

Golden Gates

As entrance gates go, the Golden Gates are pretty impressive: fashioned from elaborately sculpted and partially gilded wrought iron, and topped with two-dimensional vases whose finials are gilded after the fashion of those atop the house itself. They stand at the north end of the park, just south of Baslow between two gatehouses. They are for authorised access only, so you will likely have to drive past them for a couple of miles before you come to the public entrance further south. They were created for the Bachelor Duke (the 6th Duke) in the 1830s and, even though you cannot normally enter through them, you can stop to marvel at their craftmanship on a walk through the park. They have been known for the last 100 years as the Golden Gates. A more fitting entrance to a ducal estate is hard to imagine.

The Golden Gates (*above*), the 'Sheffield entrance', created for the Bachelor Duke in the 1830s. Even if you come from Sheffield, you will have to drive past this ceremonial ducal entrance rather than through it.

Deborah Devonshire (*opposite*), feeding her hens. They were given a home in the Game Larder behind her. Pictured here not in her usual daytime attire, she was photographed by Bruce Weber.

CHAPTER 9

SIR JEFFRY WYATVILLE AND THE BACHELOR DUKE

He spoke the oddest dialect, if I may so call it, and at first I feared that it would be a stumbling block with royalty, which, however, took to being amused by and imitating it – perfectly, never ill-naturedly ... 'You enter the house (thee ouse) by the sub hall (sub awl)' ... It was singular in a man of so much justice, that, depriving so many words of their Hs – he did not, as is customary in such cases, confer them upon others: it was not 'henter the ouse'.

Handbook of Chatsworth, 6th Duke of Devonshire, note added, 1844–5

Jeffry Wyatt may have dropped his 'h's, but he also dropped a 't' and added a 'ville' to his name in 1824, with the express permission of King George IV, to distinguish himself from the Wyatt family of architects of which he was a part, presumably so that when he departed this life, history could readily identify his work from theirs.

The original portrait of Wyatville by Sir Thomas Lawrence, on which John Henry Robinson based his engraving, was commissioned by George IV in 1828 – the same year that the King bestowed upon him a knighthood – and remains in the collection of the present King at Windsor Castle. It shows a confident yet kindly looking man of sixty-two. His reputation is now assured: there is a view of the castle over his right shoulder and his hands are resting on a plan of his proposed works there.

His greatest commissions – of more than a hundred that are documented – were for additions and 'improvements' to Windsor Castle under three sovereigns – King George IV, King William IV and Queen Victoria – and for Chatsworth, where the 6th Duke – the Bachelor Duke – was a devoted admirer.

In his introduction to the 6th Duke's *Handbook*, John Martin Robinson makes the point:

Wyatville was a competent architect whose work could, however, be a little dry, and dead if left to his own devices; he needed a strong client to work with and spark off. The triumph of the additions and alterations at Chatsworth lies in the Duke's own contribution, insisting that the new work should harmonise externally with the 1st Duke's architecture without being too reticent.

An engraving of Sir Jeffry Wyatville (1766–1840). His collaboration with the Bachelor Duke created much of the Chatsworth we see today.

CHATSWORTH

Jeffry Wyatt – as he was when he started work at Chatsworth in 1818 – came to meet the Bachelor Duke as a result of the Duke's admiration of work Wyatt had undertaken for Lady Bath at Longleat, as well as for the 6th Duke of Bedford at Woburn Abbey. The relationship would continue until Wyatville's death 22 years later.

He was born on 3 August 1766 in Burton upon Trent, to Joseph and Myrtilla Wyatt. His mother died at his birth, and Jeffry was brought up by his stepmother Mary Fortescue. It seems that it was not a happy childhood. At sixteen he ran away to sea – or at least he attempted to – endeavouring to join Admiral Kempenfelt's flagship the *Royal George*. But he was not taken on. The ship sank off Spithead in 1782, thus sparing a man destined by fate for greater things.

Jeffry's father died when he was eighteen, at which point he began a seven-year stint under his architect and engineer uncle Samuel Wyatt who, in his younger days, had been Clerk of Works for Robert Adam at Kedleston Hall in Derbyshire. This left Samuel with a taste for the neoclassical architecture that Chatsworth's architect of the stables and bridges, James Paine – that champion of Palladian architecture – had fought against half a century earlier.

In 1792, Jeffry moved to London to work for his other architect uncle – Samuel's brother James – and in 1799, he set up his own practice at Avery Row in Brook Street (150 years later to be the home of Colefax and Fowler with Nancy Lancaster's famous 'buttah yellah' drawing room on the first floor). At first, Wyattville was in partnership with the builder John Armstrong; later, he worked independently. Over the decades that followed he not only designed new buildings, but made alterations to existing houses – many of them with an aristocratic pedigree.

The work expanded at quite a pace, and Wyatville's contacts among the nobility and gentry proved enormously useful. From 1800 to 1811 he worked on the new stables and orangery, as well as the interior decorations at Longleat. He remodelled interiors at Badminton House in Gloucestershire between 1809 and 1813, and made alterations to the Sculpture Gallery at Woburn Abbey in 1816 (returning to build a greenhouse there in 1836).

From 1818 onwards, Wyatville would periodically work for the Bachelor Duke until the end of his days in 1840 – more than twenty years of creation and

The Wyatville Lodges, near the north entrance. Wyatville's contribution to the house was extensive – he redesigned the west front and added a new north wing.

SIR JEFFRY WYATVILLE

A Design for the Entrance to the Court

innovation, adjustment and remodelling, and much of the house we see today is thanks to his intervention, albeit under the sensitive and guiding hand of his patron.

In the words of the architectural historian John Martin Robinson: 'Between them Wyatville and the 6th Duke of Devonshire made Chatsworth the greatest country house in England, a pre-eminence which it has retained ever since.' He added: 'In my view almost everything which makes the neoclassical part of Chatsworth interesting is due to the 6th Duke of Devonshire himself.'

There is no doubt that the combination of their talents – competent neoclassical architect and cultured aristocrat with impeccable taste – resulted in the creation of a masterpiece.

Wyatville's contribution to the house was extensive – he redesigned the west front and added a new north wing. This housed a great dining room, a vast kitchen, a dairy and staff accommodation and includes a theatre, topped by a Belvedere, and the Sculpture Gallery. Wyatville added lodges and estate buildings for the Duke. He redesigned the Library (my favourite room in the house, if not the country), and many other rooms were remodelled in the neoclassical style during the two decades he worked here.

In 1826, the arrival of Joseph Paxton at Chatsworth (see page 131) would complete the soon-to-be famous triumvirate, whose union would add even more prestige to the estate.

Aside from his work on the house, Wyatville also designed parts of the garden: the Broad Walk, running down the east side of the house, is his, and it met with the Duke's approval: 'Sir Jeffry Wyatville's first great hit out of doors was the invention of the broad gravel walk that is of so much use and ornament here.'

It still is, and provides a visual 'breathing space' between the house and the rising ground to the east. At its southernmost end is a gigantic vase dedicated to Blanche, Countess of Burlington (the favourite niece of the Bachelor Duke, who died just two months after Wyatville in 1840, at the tragically early age of 28).

Wyatville's Orangery was constructed in 1827, to house those plants acquired when the Duke was, in his own words, 'bit by gardening'. He noted that, 'Among the orange trees here, four came from the Empress Josephine's collection at Malmaison.

Sir Jeffry Wyatville's bookplate discovered in a 'book box' bought by the author at auction.

I believe they are the only survivors, for Lord Ailsa's and Lord Ailesbury's died, and Lord Londonderry's were burnt.'

This last remark is an indication of the friendly rivalry that existed between the stately homes of England when it came to the quality and breadth of their plant collections.

Wyatville worked with Paxton, designing the West Garden with its central pond, and where eight 'ingenious architectural parterres' – in reality giant stone 'flower baskets' – enclose clipped yew and box.

Lest we should get carried away, there were those, in the generations that followed, who were not quite so enamoured of Wyatville's contribution to the house. Duchess Deborah confessed:

When I first knew the family, all Wyatville's work was condemned as a monstrous addition to the classical square block of the house. There was much talk of pulling the whole thing down, and if that was thought to be a bit drastic, then at least the Belvedere and the theatre at the furthest end of it should go. Had it not been for the Second World War of 1939–45, which put a stop to any flights of fancy, it is quite possible that at least some of the building would have gone.

The Bachelor Duke with his nieces and nephews, by the Belgian artist Charles-Louis Baugniet. His favourite niece, Blanche, died tragically young at the age of 28. She is commemorated in the vase at the end of the Broad Walk.

The girls of Penrhos College, evacuated to Chatsworth during World War II, walk out through Wyatville's north entrance arch.

The north wing, in the eyes of some, perhaps remains a bit of an eyesore; to others, it is a fine example of late-Georgian neoclassical architecture. One thing is certain: it is there to stay.

While the work at Chatsworth continued, Wyatville's most high-profile commission was for the work he undertook at Windsor Castle, primarily under George IV and subsequently William IV and Queen Victoria. Parliament originally approved £300,000 for the improvements – in reality they cost over £1 million – equivalent to £100 million today, but then that figure did include furniture …

Over the space of four years, 700 workmen were involved at Windsor, with another seventy in London preparing timber and stone. The reason Wyatville gave for such an escalation in cost, compared with his original estimate, was that as soon as work began he discovered that much of the existing structural fabric was rotten and needed replacing. That, he explained, only became evident once the work began.

Wyatville resided in the Winchester Tower at Windsor from 1824, and used it for the rest of his life – living above the shop, the late Duke of Edinburgh might have called it. Wyatville's wife, Sophia Powell, who bore him a son and two daughters, pre-deceased him in 1810.

Cottage Lodges for the Buxton Entrance – at Chatsworth

It was in his house at Lower Brook Street, London, that he died on 10 February 1840, aged 73. On 25 February, fifteen days later, he was accorded the rare distinction of being buried in St George's Chapel, Windsor.

In his book, *The Wyatts: An Architectural Dynasty*, John Martin Robinson explains:

Wyatville retained his 'provincial character' to the end of his life … He remained unaffected, jolly, good-humoured and plain speaking. His manner matched his appearance, for contemporaries remarked on his 'low stature and inelegant personal form.'

His epitaph I will leave to the 6th Duke: 'A delightful man, good, simple like a child, indefatigable, eager, patient, easy to deal with, ready to adopt a wish if practicable, firm to resist a faulty project.'

Edensor Lodges – a watercolour by Sir Jeffry Wyatville. While Paxton and Robertson were responsible for the architecture of the majority of the village, Wyatville designed these two *cottages ornés* at the Buxton entrance.

E.L.S. 161-6. Sir Joseph Paxton's Greenhouse, Chatsworth House.

CHAPTER 10
THE GLASSHOUSES

*... A LARGE CONSERVATORY, THE MOST STUPENDOUS &
EXTRAORDINARY CREATION IMAGINABLE ... THE WHOLE IS ENTIRELY
OF GLASS. THE FINEST & RAREST PLANTS & FLOWERS ARE IN IT ...
& THE EFFECT IS VERY LOVELY.*
Journal, Queen Victoria, 1843

Alas, the famous 'Great Stove' that so impressed Queen Victoria, when she arrived with Prince Albert to spend the weekend at Chatsworth, on Friday 1 December 1843, is no more. But the low walls that supported it are there for all to see and to understand the kind of spectacle it must have presented when the Queen and the Prince Consort rode through it in their carriage. It may seem perverse to begin a chapter on the glasshouses at Chatsworth by describing one that no longer exists, but its ghost lingers still among the breezes that caress the Maze that occupies its former site. The fact that it was the precursor of Sir Joseph Paxton's grandest creation, the Crystal Palace, home of the Great Exhibition of 1851, make the very memory of its existence a potent one.

The Great Conservatory

Chatsworth's Great Conservatory with its 'ridge and furrow' roof took four years to build, and was completed in 1840. Paxton is credited with its design, though Decimus Burton (designer of the Palm House at the Royal Botanic Gardens in Kew, who had worked for the 6th Duke of Devonshire at Chiswick House and Devonshire House in London) was brought in as 'architectural-design consultant' at the insistence of the Duke himself. Indeed, the drawings for the conservatory are all signed 'DB'. That Paxton and Burton worked together on the project is beyond doubt, but the relationship was not a happy one, and in 1841 Burton protested to the Duke that he was given little credit for being what he considered himself as – the primary architect:

Now as it was a commission of which I feel justified in being unusually proud – I am very desirous that the error should be cleared up ...

Looking across the Salisbury Lawns (*previous spread*) towards the Old Greenhouse with the Display Greenhouse of 1970 behind.

The Great Conservatory or Great Stove (*opposite*), a Victorian 'palace of glass' designed by Sir Joseph Paxton and Decimus Burton.

THE CONSERVATORY AT CHATSWORTH ILLUMINATED.

The Duke clarified the situation, but not effusively, in 1845:

This extraordinary monument of Mr Paxton's talent and skill in the execution of which he was cordially met and assisted by Mr Decimus Burton.

From this we can deduce what? That Paxton was the designer and that Burton had a greater input in terms of architectural construction? Or was it simply that Burton was miffed that Paxton's name and not his was coupled with the structure that received so much approbation? I suspect a bit of both.

The vital statistics of this palace of glass were noted by the Queen during her visit, three years after its completion, in a breathless letter to her uncle, King Leopold of the Belgians: 'The conservatory is out and out the finest thing imaginable of its kind. It is one mass of glass, 64 feet high, 300' long and 134' wide.'

The Duchess of Sutherland, Mistress of the Robes to Queen Victoria, remarked that nothing could match it, save St Peter's in Rome.

Even Charles Darwin was impressed, writing in 1845 that he was 'transported with delight', adding that '[a]rt beats nature there'.

It was, at the time, the largest glass building in England; it cost £33,099 to build (nearly £4 million in today's money) and covered three-quarters of an acre. Two carriages could pass on its main thoroughfare. A hidden staircase led to an upper gallery from which visitors could gaze down upon a tropical landscape of rocks, pools and palm trees.

The interior of the Great Conservatory (*above*) showed off its grandeur even at night, when it was illuminated to the delight of guests.

The Lily House (*opposite top*), was created in 1850 to house the giant water lily *Victoria regia*, which first flowered in this country in 1849 and which was named after the Queen. Built at Barbrook near the old kitchen garden, the greenhouse is, alas, no more.

Queen Victoria and the Prince Consort arriving at Chatsworth to great fanfare in 1843 (*opposite below left*). Her diaries reveal her admiration for the Great Conservatory which she described as 'the most stupendous & extraordinary creation imaginable'.

The sad post-war state of the Great Conservatory (*right*). Having suffered during the necessary economies of World War I it was finally demolished in 1920.

THE GLASSHOUSES

Eight coal-fired boilers were housed underground, the fuel being delivered through a tunnel by rail wagons (see page 99). The 6-inch diameter hot-water pipes ran around the glasshouse for a total length of 7 miles – in winter, 300 tonnes of coal were needed to maintain the temperature.

The Great War of 1914–18 sounded the death knell for this remarkable structure, built primarily from timber rather than cast iron, which was used only for the main supports. Coal was by then in short supply and needed for more vital objectives than that of maintaining a Duke's collection of hot-house plants. In the chilly winter weather of those four years, many of the Great Conservatory's horticultural specimens perished. Fortunately, some smaller plants had been moved to other glasshouses, and so survived this period. By the end of the war the structure itself was in a sorry state of repair. In 1920 it became a victim of country house economies and was pulled down. It stood as a monument to Paxton's and Burton's genius for just eighty years. Walk around inside its walls and imagine you are a part of Queen Victoria's house party. What an experience it must have been.

The Conservative Wall

Stand and stare at Paxton's 'Case', or Conservative Wall, and ask yourself what it reminds you of. A Victorian railway station? Indeed. Among Paxton's many accomplishments and involvements was his directorship of the Midland Railway in 1848 – travelling by rail, on platforms and in waiting rooms across the country, his architectural influence spread far and wide. 'The Case', as it is sometimes called, was constructed in 1848, a few years after the 'Great Stove' was completed. The taller section was added in 1850 by John Robertson, who worked with Paxton on the designs for those quaint cottages in the village of Edensor nearby.

The Conservative Wall faces south, to make the most of the sunlit hours, and protects an array of plants both in beds and growing against the wall. There are 'Peregrine' peaches, nectarines, apricots and cherries, along with wall-trained *Chimonanthus* whose translucent yellow flowers scent the air in winter. Two plants of *Camellia reticulata*, 'Captain Rawes', which were planted in Paxton's time, finally succumbed at the age of more than 150 years in 2000 and 2002. Their skeleton trunks can be seen in Flora's Temple. It seemed heartless to discard them.

The Case, originally called the Conservative Wall, was constructed in 1848 and is home to peaches and nectarines, as well as tender climbers. Facing south, it makes the most of the warming sunlight.

CHATSWORTH

Snake Terrace

As you walk from the Display House to the Old Greenhouse, take a moment to look beneath your feet at the pattern in the stonework. Designed by Denis Fisher, when he was Comptroller of Chatsworth (being of a certain methodical turn of mind, he also designed the Serpentine Hedge and the pattern for the Maze), its stone was recycled from Paxton's old Lily House. At its centre you'll spot the Cavendish family crest – a serpent – picked out in pebbles brought from the beach at Eastbourne, whose long association with the family dates back to the eighteenth century. The Devonshires were prime movers in developing the town as a tourist destination.

The Old Greenhouse

This elegant structure, which gives on to the Rose Garden, houses part of Chatsworth's collection of camellias. The original was built in the 1690s, at the same time as the parterre to the south of the house, and stood further to the northeast (it is clearly visible on Kip and Knyff's engraving, but at that time it had flat-topped windows and more bays). Known for centuries as the 1st Duke's Greenhouse, the current structure (built 1748–50) was recently and more accurately renamed the Old Greenhouse, as in truth, nothing remains of the 1st Duke's creation. Despite its chequered past, with its honey-coloured columns it makes an elegant backdrop to the formal garden in front of it, with its pillars and arch-topped orangery windows, seen through the vertical framework of the Irish yews.

The Vinery

Originally built in the mid-nineteenth century to house the 6th Duke's collection of orchids – collected and gathered from all over the globe – the Vinery is sometimes known as Paxton's Glasshouse, although it in fact dates from soon after his death. Its north end now houses white-fleshed peaches and a display offering information about Joseph Paxton. There are more camellias here, too, but the stars of the show are the grape vines for whose fruit Chatsworth has won many prizes over the years: the variety 'Muscat of Alexandria'.

The Old Greenhouse is home – as it has been for many years – to a wide range of camellias, some of which have lasted as long as two hundred years.

THE GLASSHOUSES

The fabled 'Muscat of Alexandria' grape (*opposite*), almost ready for harvesting in the Vinery. By far the finest flavoured of all grapes, but also the most difficult to grow well.

The Vinery (*above*) dates from 1868, when it was used to house the 6th Duke's collection of orchids.

THE GLASSHOUSES

This is the queen of grapes: a fruit so aromatic and so mouth-watering that it puts other grapes to shame. But it is tricky to grow; a demanding mistress, as the gardeners who tend it will tell you – there are up to three of them ministering to its needs at any one time at the height of the season. Pruning, thinning, ventilating and watering take time and skill. Around 500 bunches are produced each year from vines that were planted as long ago as 1920. As well as being eaten in the house, they are occasionally sold in the farm shop, and the family are exploring the possibility of making a dessert wine too. All I can tell you is that the first time you taste one you will realise their superiority over the common herd of grapes. Yes, they contain pips, but oh that sweet and succulent flesh … and that fragrance …

The Display Greenhouse

Built in 1970 and positioned to the north of the Old Greenhouse, the aluminium-alloy structure has no internal supports (hence the arrangement of struts and hawsers on the outside). It was inspired by the then quite new and ground-breaking glasshouse at Edinburgh Botanic Garden, and houses a wide range of ornamental plants in three sections: tropical (not open to the public in order to conserve heat and humidity), Mediterranean and temperate. Although even its mother would not call it beautiful, the house offers a kaleidoscope of the kind of tender plants that have been grown at Chatsworth from the 1st Duke's time to the present day. Citrus fruits, the loquat, *Brugmansia* (angel's trumpet), a multitude of climbing plants hanging from the rafters like floral lace, and the night-flowering cactus – *Epiphyllum oxypetalum* – which, on a recent visit, I was lucky enough to see in full bloom.

It flowers rarely, perhaps once a year, and even then each flower opens for one night only. We walked – resplendent in evening dress – from the house across the moonlit lawns by the light of a torch at 11pm. The door of the greenhouse was eased open, the light switched on, and there in the glow of its feeble rays shone a host of white starburst blooms – each one fully 25cm across. The plant itself – growing directly in a bed of earth – must have been 3 metres tall and the myriad of flowers studded the flattened stems like fireworks. I had seen the

Known as the 'Display House', the newest glasshouse in the garden was built in 1970 and comprises three distinct sections: tropical, Mediterranean and temperate.

CHATSWORTH

image of the flower in Robert Thornton's *Temple of Flora*, published in 1810 – in the moonlit background of the botanical painting, a church clock shows the hands at midnight – but this was the first time I had seen the flower in reality. The sight – and scent – are unforgettable.

Growing here, too, is a plant that has taken the family name of Cavendish around the world. In 1831, a dwarf variety of banana – a strain of *Musa acuminata* – was imported by the 6th Duke from Mauritius. The talented Mr Paxton managed to get it to fruit. He gave some offshoots to a visiting missionary, John Williams, who left these shores intent on providing sustenance to Pacific Islands recently devastated by a hurricane. In Samoa, the plant thrived – so much so that offshoots were sent to other Pacific Islands. Alas, Mr Williams fared less well. At Erromanga in the New Hebrides the welcome was less than cordial and he was killed and eaten by the locals. He can take modest posthumous comfort from the fact that, 200 years on, *Musa acuminata* 'Dwarf Cavendish', accounts for the majority of the seven billion bananas eaten in the UK every year, not to mention half of those eaten in the rest of the world.

Paxton's other great success grows in the tropical end of the Display House: the giant water lily. With leaves up to 6 feet across, and 30cm-wide white flowers that fade to pink, in Paxton's time it had a greenhouse all to itself. The gardeners at Kew, rather ignominiously, had failed to get it to flower. In 1849 it bloomed for the first time in cultivation at Chatsworth. John Lindley had named the flower *Victoria regia* in 1837, although today it bears the name of *Victoria amazonica* – due to the complex registration rules of botanical nomenclature – but at least the Queen is commemorated in the first part of its name. Astonishingly, it is an annual and grows to full size each year from a seed the size of a pea. It was Paxton's seven-year-old daughter Annie who was placed on a leaf to demonstrate the plant's wondrously buoyant properties. Mrs Paxton's reaction is not recorded.

The night-flowering cactus pictured in Robert Thornton's *Temple of Flora*, published in 1810. The church clock and the Moon indicate its time of flowering.

CHAPTER 11
SIR JOSEPH PAXTON

Mr Paxton is quite a genius, for he plans out all the
buildings, as well as laying out his gardens ...
Journal, Queen Victoria, 1843

Joseph Paxton gave the following account of his arrival at the Palace of the Peaks:

I left London by the Comet Coach for Chesterfield; arrived at Chatsworth at half past four o'clock in the morning of the ninth of May 1826. As no person was to be seen at that early hour, I got over the greenhouse gate by the old covered way, explored the pleasure grounds and looked round the outside of the house. I then went down to the kitchen gardens, scaled the outside wall and saw the whole of the place, set the men to work there at six o'clock; then returned to Chatsworth and got Thomas Weldon to play me the water works and afterwards went to breakfast with poor dear Mrs Gregory and her niece. The latter fell in love with me and I with her, and thus completed my first morning's work at Chatsworth before nine o'clock.

It was no flash in the pan; Mrs Gregory's niece, Sarah Bown, married Paxton the following January. She was twenty-six; he was twenty-three. The daughter of a prosperous farmer, she came with a dowry of £5,000 (more than £600,000 today). Paxton was earning £70 a year (the equivalent of £8,742).

He had been spotted by the 6th Duke when he was working at the Horticultural Society's gardens next door to Chiswick House, which the Duke owned. He stood out as a man of great energy, determination and zeal. Paxton was poached.

Three days after Paxton's arrival at Chatsworth, his employer travelled to Russia to represent King George IV at the coronation of Czar Nicholas I. It was then that the Duke would have seen the fountains at Peterhof, which inspired the Emperor Fountain at Chatsworth – constructed by his head gardener some eighteen years later.

Paxton was born on 3 August 1803, at Milton Bryan in Bedfordshire, close to the estate of the Duke of Bedford at Woburn. One of seven children, Joseph's father died when he was a boy and he was brought up – somewhat unhappily – by an elder brother.

A 33-year-old Joseph Paxton, painted by the English portrait artist Henry Perronet Briggs in 1836, ten years after his arrival at Chatsworth.

By the age of fifteen, he was working as a garden boy at Battlesden Park in Bedfordshire. Other jobs followed until, in 1823, he moved to work at the Horticultural Society's gardens at Chiswick.

To be made head gardener to the Duke of Devonshire at the age of twenty-three would undoubtedly have boosted his self-confidence. He did not let his new employer down.

With Sarah supporting him – and she was a formidable woman, running the household and organising his affairs, as well as bringing up eight children: two sons and six daughters – Paxton was able to give his ambitions full rein.

With Wyatville's north wing almost completed, he and Paxton set about designing the West Garden. His work did not stop there. Paxton created the Aboretum and Pinetum (a comprehensive collection of conifers), which still survive. He imported large trees to create instant effect – something of a novelty in its day.

Over the years that followed – and he worked at Chatsworth as head gardener until 1858, a total of thirty-two years – he supervised the construction of the Rock Garden, the 'Great Stove', the giant waterlily house, the Emperor Fountain and numerous other glasshouses and installations. He was instrumental in moving part of the village of Edensor to improve the view from the park, and, with John Robertson, for the designing of numerous picturesque cottages and estate buildings that replaced those which had been demolished. They stand today as reminders of a man with a vivid imagination.

His relationship with the Bachelor Duke was such that Paxton was allowed to take on other projects outside the estate – a testament, perhaps, to his ambition, as well as to his energies. The breakneck speed at which he lived his life would eventually catch up with him, but for now he launched himself into the design of parks in Liverpool and Birkenhead – later on in Halifax and Glasgow. He published a monthly magazine, the *Horticultural Register*, accompanied by the *Magazine of Botany*, and numerous books. He became a director of the Midland Railway and, courtesy of steam trains, he spread his influence far and wide.

As the Duke's right-hand man he was invaluable. From employer and head gardener, their relationship developed into that of close friends. The Duke wrote to him: 'I had rather all the flowers in the garden were dead than you ill.'

The North Nave. *South Nave Looking North.*

They made trips abroad together – to Paris, to Switzerland, to Italy, Athens and Constantinople – collecting plants and looking at gardens for ideas and inspiration.

Their work at Chatsworth attracted a host of admirers – it became a Mecca for those keen to see perhaps the most impressive gardens and arboreta in the country. Princess Victoria would visit with her mother, the Duchess of Kent, in 1832 – much preparation was undertaken so that she would not be disappointed. She was not, and returned eleven years later as Queen, along with the Prince Consort, to admire the grandeur of the three-year old Great Stove and its tropical denizens.

Paxton's efforts especially impressed one member of the royal house party who remarked: 'I should have liked that man of yours for one of my generals.' He was the Duke of Wellington.

In 1850, after much to-ing and fro-ing and meetings with Prince Albert, it was decided that Joseph Paxton should be the designer of the building that would house the Great Exhibition of 1851, to be built in Hyde Park. It was later moved to Sydenham where it became known as the Crystal Palace. In October 1851, as the exhibition closed, Paxton was knighted for his efforts. A few years later – in 1854 – he would become Liberal MP for Coventry. This responsibility, combined with his widespread travel for the railway company, began to take its toll on his health.

Interior views of Paxton's most famous creation, the Crystal Palace, which housed the Great Exhibition of 1851 in Hyde Park and which led to Paxton's knighthood.

Not exactly 'the back of an envelope', but perhaps the Victorian equivalent - doodles on a blotter. Paxton's early sketches of what would come to be known as the Crystal Palace.

During his trips abroad and all around the country, mixing with high society, MPs and fellow directors of the Midland Railway (he was a natty dresser with a fine line in waistcoats and cravats, and favoured a white top hat), Sarah would remain at Chatsworth, holding the fort and becoming more and more resigned to a lonely existence. Those early days of their marriage, when Chatsworth alone was the centre of their universe, were the ones she treasured and sorely missed.

SIR JOSEPH PAXTON

Now her husband would be away for months at a time – in Sydenham or Paris or London – designing houses and gardens for the nobility and gentry, including Mentmore Towers for Baron Mayer de Rothschild – one of the grandest surviving Victorian country houses in England. 'Sir Joseph Paxton, architect' he now styled himself, though he had no formal training in that sphere.

Sarah would write to him regularly, begging him to come home. Her letters are in the archive at Chatsworth and make for poignant reading: 'You would not regret a visit to Chatsworth if only to see the rhododendrons and the great beauty of the place,' she wrote. 'Our beautiful flowers will bloom and die and you will never see them.' Perhaps the most heart-breaking comment came with the line: 'O Fame, would that I could break your trumpet.'

On 18 January 1858, after suffering a stroke several years earlier, the Bachelor Duke died in his sleep at Hardwick Hall. Paxton knew it was time to relinquish his post as head gardener, but not before arranging the funeral of his friend and mentor. Sarah did finally join him in London and Sydenham, but never with much relish. He was allowed to keep his house at Chatsworth for as long as he lived.

Pausing rarely from the rigorous life he had created for himself, the time came when such a pace could not be kept up indefinitely. He retired from Parliament in the spring of 1865. By May of that year he was shown around the flower show at Crystal Palace in a wheelchair, but left early. He died as the sun broke through the clouds on the morning of 8 June 1865, and was buried at Edensor. He was 61 years old.

Nobody could suggest that Sir Joseph Paxton had not lived his life to the full. Whether that life was as happy as it could have been in his later years is open to doubt. On the altar of high ambition, contentment is often sacrificed.

One thing is not in doubt: those forty years between 1818 and 1858 were among the most exciting in the development of the house and the gardens at Chatsworth, thanks to the genius of three men whose vision and energy created a masterpiece: the Bachelor Duke, Sir Jeffry Wyatville and Sir Joseph Paxton.

Now Sir Joseph Paxton, this vignette from the 1850s shows a man in his forties whose reputation was made. But at what price?

CHAPTER 12

DEBORAH DEVONSHIRE

> OUR GARDEN IS AN INHIBITING PLACE TO GO OUT WITH A TROWEL.
> IT COVERS A HUNDRED AND FIVE ACRES AND IS CONTAINED BY A WALL
> ONE AND THREE-QUARTER MILES LONG, AND THIS IN TURN IS
> SURROUNDED BY A THOUSAND ACRES OF PARKLAND ENCOMPASSED
> BY NEARLY TEN MILES OF DEER FENCE.
> *The Garden at Chatsworth*, Deborah Devonshire, 1999

I FIRST ENCOUNTERED DEBORAH, DUCHESS OF DEVONSHIRE – MARRIED to the 11th Duke – sometime in the early 1980s. I was sent to interview her for a magazine. We met at the Devonshire's London house in Chesterfield Street, where I was let in by the black-coated butler. (It was what I would have called a jacket, until I was informed sometime later by the Duke that he wore a coat: only potatoes had jackets.)

I was seated in front of a warming log fire in a very tasteful but cosy drawing room. I took copious longhand notes about the Duchess's taste in gardening and was warmed by coffee and biscuits, as well as by the fire and the pleasant manner of my hostess. What I will never forget are her parting words, delivered from the front door as she saw me off down the street. 'Don't forget; I like them tortured!'

She was referring to her passion for pleached avenues of trees. It is unlikely that the lady who walked past me on the pavement at that moment realised to what the remark referred. She offered me a look of profound unease.

Sometime later I travelled to Chatsworth to make a radio programme about the garden, and sat with the Duchess in her estate car while we waited for a technician to sort out some problem with the sound. I noticed that the carpets were covered in mud and the seats were quite chewed – by dogs. Not for this Duchess ermine and diamonds – though both were worn when the occasion demanded. She was far more comfortable in tweed skirts, hand-knitted cardigans bought at country fairs, a shepherd's crook to walk with and a sense of humour that was never far from the surface. Over the years that followed we became good friends. I would call Andrew, her husband, 'Duke' and the Duchess 'Your Grace', until one evening at a carol concert in Ripon Cathedral she turned to me and said, 'Alan, I wish you would use my Christian name.'

Deborah and Andrew at Edensor House where they lived between 1946 and 1959. Andrew inherited the dukedom in 1950, but it would be almost a decade before they moved into 'the big house'.

The six Mitford sisters and their brother Tom. Debo is third from the left in rather fetching jodhpurs and gaiters.

'I was waiting to be asked,' I replied sheepishly.

'Well, you have been.'

And from then on it was Debo.

The youngest of the Mitford sisters – children of the 2nd Baron Redesdale – she was a part of one of the most documented and commented upon families of the twentieth century. Her eldest sister was the novelist Nancy, born in 1904, followed by Pamela (b. 1907). Then came a brother, Tom (b. 1909), killed in action during the Second World War, then Diana (b. 1910), who married the leader of the British Union of Fascists, Oswald Mosley. Unity (b. 1914), enjoyed a friendship

DEBORAH DEVONSHIRE

with Hitler, which caused an understandable scandal, and Jessica (b. 1917) was a professed communist. Deborah – known as 'Debo' – was born in 1920; the youngest of the family and teasingly known to her sister Nancy as 'Nine' (mental age of …). Her autobiography is entitled *Wait for Me!*

She married Andrew, the tall and rather gangly younger son of the 10th Duke of Devonshire, in 1941, and when Andrew's elder brother William, Marquis of Hartington, was killed in action in 1944, it became clear that one day she would become Duchess of Devonshire.

That she professed she had never read a book was a state of affairs that most of those who knew her took with a pinch of salt, for she was a skilled writer. Her memoirs, book reviews and assorted writings, including those documenting the house and garden at Chatsworth, testify to a ready wit and a naturally felicitous turn of phrase. (She would have found that statement very pretentious.)

Above all, Deborah, Duchess of Devonshire was a generous and thoughtful hostess, as well as being astonishingly good company. She took her role seriously but not herself, took Chatsworth by the scruff of its neck when Andrew inherited the title in 1950, and several years later, they moved into a house that had been unoccupied for many years, in the face of crippling death duties.

It is due to both the 11th Duke and his Duchess that the estate not only survived such financial vicissitudes, but that it was improved beyond all measure by dint of their hard work and inspiration. In 1981, Andrew established the Chatsworth House Trust, a registered charity that looks after the house, collections, garden, woodlands and park for the benefit of everyone.

The garden and the estate were made more welcoming to the general public, who were regarded not as a necessary evil but as folk who had a right to share the good fortune of the owners when it came to enjoying days out –

Lucian Freud's portrait of Debo – *Woman in a White Shirt* – painted in 1958–61. It is only fair to say that it is not admired by every visitor.

CHATSWORTH

walking among the woodland, dining in the restaurant or café and even, on hot summer days, paddling in the Cascade.

They set about modernising the house, which was, among other things, singularly lacking in bathrooms. They built up relationships with craftsmen and artists: Lucian Freud – their first houseguest – became a close friend. He decorated one bathroom wall with paintings of cyclamen (although it was never finished) and painted Debo's portrait. It divides opinion. She once overheard one female visitor saying to another: 'That was the old Duchess. It was painted just before she died.'

The portrait of her painted by Pietro Annigoni is much kinder; much more 'Italian Romantic'. I asked her once about the sitting. 'All I can remember,' she said, 'is that he kept breaking off to ring his mistresses.'

Among Debo's initiatives, aside from her writings, were the creation of the Farm Shop, the Orangery Shop and the furniture makers 'Chatsworth Carpenters'. She also instigated a model farm where children could meet animals face to face.

She planted twin rows of her beloved pleached limes on either side of the South

Debo with Lucian Freud, photographed by David Dawson. Lucian was the very first houseguest at Chatsworth after Debo and Andrew moved in. He became a close friend.

Lawn – now removed, since they had grown so bulky that they were obscuring the view of Brown's parkland – and the Serpentine Hedge. The floor plan of Chiswick House, picked out in golden box around the circular pond (taking the place of the dome) on the west side of the house, was Debo's idea, too, though it eventually succumbed to waterlogging and had to be grubbed out.

The only contribution she made to the garden of which I am not a fan was the Cottage Garden on the slope above the Salisbury Lawns. It seems to me quite out of scale with the garden and is jarring in its twee-ness. Debo loved it, but then, as her son remarked, 'She only ever wanted a cottage garden, and when she moved to the Old Vicarage she created one.' The Chatsworth Cottage Garden remains – for now.

Two of her books, *The Garden at Chatsworth* and *Chatsworth: The House*, demonstrate her knowledge and love of the property that she would come to call home for more than half a century. Read them and you will be astonished at the depth of knowledge they demonstrate. Remember, too, that aside from Chatsworth there were other houses and estates to manage: Bolton Abbey in Yorkshire and Lismore in County Waterford, Ireland, as well as the Cavendish Hotel in Baslow and the Devonshire Arms at Bolton Abbey, both of which demonstrated her impeccable taste, encouraged and guided by another friend, the designer David Mlinaric.

On one occasion, in conversation with the 11th Duke in 1998, he asked what I thought about the redecoration of the then Lord Chancellor's apartments in Parliament – the subject of much criticism when Derry Irvine had ordered specially printed Pugin wallpaper. I offered the opinion that as the rooms had been designed by Augustus Pugin, it seemed to me that they warranted being refurbished in the appropriate manner. I then reminded the Duke that one MP had asked, 'Why couldn't the Lord Chancellor buy his wallpaper from B&Q?', to which Irvine had responded, 'What's B&Q?' The Duke laughed heartily, then paused before asking me, 'What *is* B&Q?'

Deborah Cavendish, Duchess of Devonshire, painted by Pietro Annigoni in 1954 when Debo was in her thirties.

On another occasion he took me to one of his greenhouses to give me a lily – *Pamianthe peruviana* – to take home. There were about a dozen potfuls of them on the bench and it took a degree of sorting before the Duke found one he thought suitable. I knew exactly what he was looking for. I would have done the same myself. He didn't want to give me the worst one but neither did he want to give me the best. He found a middling one – I was very happy …

After Andrew died at the age of 84 in 2004, Debo made the decision to move to the Old Vicarage in Edensor, to make way for the current Duke and Duchess. It was refurbished and redesigned with a little help from her designer contacts and became a welcoming haven for friends. 'The Old Vic' she called it.

Her life, seemingly one of grandeur and with royal connections, was not without its challenges. Andrew was an alcoholic; a Devonshire family trait that brought them to breaking point in the 1980s. Debo vacated Chatsworth. The shock of her absence finally rammed the message home. Andrew renounced alcohol for good. His infidelities she learned to live with; his drinking she could not.

There were also family tragedies. Three of her six children died shortly after birth. My wife and I walked around the churchyard at Edensor with her one day, looking at the grave of Kathleen 'Kick' Kennedy, sister of the late President of the United States, who had married William, her brother-in-law, who was killed in the war. Kathleen herself died in a plane crash in 1948. Then we came upon the graves of the children she had lost. We looked at one after the other. 'So many …' she said wistfully. 'So many …'

She would not allow herself to be sad for long. Dinner in the House (the sobriquet always given to Chatsworth itself) would be around a lavishly decorated table, awash with silver and flowers or, as it was on one particularly special occasion, with live chicks, nestled in moss and straw in a silver basket. Another time, tiny piglets were introduced, though they were removed before the meal began. Drinks around a roaring fire would follow before we would slope off to bed, more often than not exhausted from laughing.

The hospitality continued in later years at the Old Vic. The table setting might have been less elaborate, and the company smaller – often just Debo, my wife and myself – but she would still drift down the stairs of what she referred to as 'my

Deborah Devonshire in her study in the 1970s, surrounded by dark-green slubbed silk walls, favourite books, paintings, ceramics of elephants and dogs and the ever present basket of post.

semi' (the handsome stone-built house had been divided in two some years before) in a billowing Oscar de la Renta gown and three strands of pearls, plus a sparkling insect brooch studded with jewels.

The King – then the Prince of Wales – was a special friend. To see him approach Debo, kiss her on both cheeks and then take her hands while she went into a deep, old-fashioned curtsey was a moving reminder of the courtesies of yesteryear. Like us, he enjoyed her hospitality and her sense of humour.

Her life had been one of privilege, but she never shunned hard work, as the current health of the Chatsworth Estate shows. Debo's tastes were eclectic: she was a fan of Elvis Presley, cottage gardens and Buff Cochin hens. Her lifetime's experiences were many and varied: while visiting Munich with her mother and sister Unity in 1937, she had tea with Adolf Hitler and noted, in the bathroom, the initials AH on his brushes.

The Queen appointed Debo a Dame Commander of the Royal Victorian Order in 1999, for her work with the Royal Collections Trust.

Towards the end of her life, Debo's faculties began to fade and the end was quiet and gentle, the power of speech having deserted her. She died at the Old Vic on 24th September 2014 at the age of 94, having been looked after by her butler Henry Coleman, who had joined the household staff in 1963, and her loyal secretary, Helen Marchant, who, with her dog – Debo loved dogs – was a constant presence.

Her children Emma, Sophia and Peregrine – known as Stoker, the 12th Duke of Devonshire – along with numerous grandchildren and great-grandchildren survive her.

On our last stay at the house she was becoming physically frail, but remained mentally sharp as a tack. She had broken a tooth. She had had an operation on her eye. We said goodbye to her sitting on the bottom of her bed. Propped up on pillows, with her black eye patch and a missing tooth, she tilted her head on one side and laughed. 'Oh dear!' she said. 'I look like a pirate.'

She was one of the most delightful people I have ever met.

Debo and Andrew in the West Garden in 1998 by Gary Rogers. A marriage that was not without its challenges, it nevertheless resulted in the survival of one of England's finest houses and estates.

CHAPTER 13

ARCADIA

> WE DESCEND WITH THE BROOK THROUGH A REGION OF
> CHESTNUTS, OAKS, AND THE HARDY CLASS OF FOREST TREES,
> WHERE SEEDLING RHODODENDRONS ARE BEGINNING TO
> SPRING UP OF THEIR OWN ACCORD.
> *Handbook of Chatsworth*, 6th Duke of Devonshire, 1844–5

Those 'seedling rhododendrons' – the wild *Rhododendron ponticum*, regarded as a weed species and now banned from being planted in the wild – would, 150 years later, become a thicket of thunderous greenery, swamping everything beneath them and turning a great swathe of land on the eastern slopes of the garden into an otherwise sterile wilderness. This included part of Arcadia's 15 acres, which is towered over by mature trees planted by the 6th Duke as part of his famed Arboretum.

Trees and shrubs need managing, even in the largest of gardens. When they are planted they are small and make little dramatic impact. Over the years they grow – slowly or rapidly, never at the same rate as one another. A moment comes when their scale seems to be absolutely right; not only that but their relative size means that they complement one another, as well as the landscape. As trees grow at different rates, so too do shrubs, and that combination, which for a few years seemed perfect, will begin to dissolve over time and the view will change. When trees and shrubs expand, so their canopies begin to overlap, light penetration is reduced and the understorey – the ground flora – changes.

When the umbrella of leaves and branches above grows denser, the plants beneath them that were once happy begin to struggle. They grow tall and spindly, reaching for the sun. When they fail to find it they wither and die; only those adapted to heavy shade will remain – ivy and a few ferns – the rest of the woodland floor will be bare, aside from spring flowers such as bluebells and wood anemones, which can bloom before the deciduous canopy returns and whose food-storing bulbs or rhizomes will allow them to stay alive underground for the rest of the year.

This is what happened in Chatsworth's Arboretum. Trees and long-lived shrubs such as rhododendrons that were planted by Joseph Paxton and the 6th

The Rabbit Glade of Arcadia in June (previous spread) has been transformed from a dingy shrubbery into a flower-filled cascade of planting.

The Bog Garden (opposite) in its rich summery livery of shuttlecock fern (Onoclea struthiopteris), the fluffy pink cockades of the meadowsweet Filipendula rubra 'Venusta' and the darker-purple betony Betonica officinalis 'Hummelo'.

CHATSWORTH

Duke were, a century and a half later, responsible for the demise of many other plants that simply could not compete with their vigour or the deep shade that was cast by their foliage – especially that of the wild rhododendron, which had seeded itself everywhere and found conditions very much to its liking.

In 2015, it was decided that something needed to be done. Here was an opportunity, as much as a problem: a chance to create an area that would inspire rather than oppress. The name 'Arcadia' was chosen: 'An image or idea of life in the countryside that is believed to be perfect', according to the *Cambridge Dictionary*.

Leading garden designer Tom Stuart-Smith was charged with coming up with an overall plan in consultation with the 12th Duke and Duchess:

They were keen to open up vistas and walks but very anxious not to disturb the unruffled backdrop that Arcadia provides in views from the park. No budget has ever been mentioned but I have always been conscious that we are working within quite tightly defined limits.

More than a quarter of a million plants were used, and each of the glades has its own theme. Head of Gardens and Landscape, Steve Porter, and his team of twenty-eight full-time staff, including 2 trainees and also 80 volunteers, worked with Tom Stuart-Smith over the following years to transform the landscape, which is now far from dreary and provides interest and spectacle at every turn.

The operation was undertaken as sustainably as possible: the final phase, involving 40,000 plants within the Hundred Steps Glade, was 100 per cent peat free and 95 per cent plastic free, with most plants being open-field grown and transported to the site bare rooted.

Arcadia is well named. With the establishment of the new plantings there is a great feeling of calmness and refreshment, coupled with vibrant growth that is positively invigorating. The two feelings might seem to be at the opposite ends of the spectrum, but plants have the capacity to engender in the onlooker both exhilaration and tranquillity, the combination of which can lead to a feeling of wellbeing. While a settled and mature planting scheme might seem to be less eventful and lacking in incident, such a plantation is not necessarily conducive to

The Rabbit Glade in September looking down towards the Maze borders. Late-summer perennial asters such as *Eurybia x herveyi* 'Twilight' and *Eurybia divaricata*, the white wood aster, are interwoven with ground-covering *Heuchera villosa* 'Autumn Bride'.

ARCADIA

feelings of calm; quite the opposite – the image of stagnation is stultifying and dreary, even depressing. I doubt that any visitor will level that accusation at Arcadia.

When it comes to the plants themselves, we all have our individual preferences. I asked Tom if the Duke and Duchess had mentioned anything they particularly liked:

White in almost any plant. Big, generous flowers: Loderi rhododendrons, Prunus incisa, *subtle flowers – not too double or cultivated looking. Big groups, natural sweeps, just the occasional plant that someone else might not have.*

And dislikes?

Bright yellows and oranges. Pig holly (which I think is a term of abuse given to a scrappy, bent holly bush) and sarcococca. The Duchess doesn't like ferns! That said, the brief was remarkably free, but by osmosis I soon got to know what were the likes and dislikes.

So does Tom go away and operate alone?

Almost from the outset I've had the help of Emily Assheton in my studio who has been really good. Doing all the dirty work and keeping me on the straight and narrow.

And the main aim of the planting?

I thought the big challenge was to make Chatsworth a horticultural destination; to bring a level of detail that begins to be a counterpoint to the extraordinary setting and to create a more hidden landscape worthy of the name Arcadia. Somewhere timeless and separate – with such an engrossing character that you are at times quite lost in the world – in a good way.

The big contrast is the spatial one between the woodland walks and the bigger glades, two of which give views out into the landscape. The Bog Garden is obviously distinctive in its use of plants with gunnera, rodgersia, and lythrum and other moisture-loving species and a sense of being in a lushly planted bowl. I think it's

The gigantic leaves of *Gunnera manicata* relish the damp conditions of the Bog Garden, along with a mixture of perennials such as the pink-flowered *Eutrochium maculatum* (formerly *Eupatorium*) 'Riesenschirm', *Lobelia* x *speciosa* 'Tania', *Cenolophium fischeri*, *Eurybia* x *herveyi*, *Bistorta amplexicaulis* 'Taurus' ('Blotau') and *Betonica officinalis* 'Hummelo'.

CHATSWORTH

The Hundred Steps Glade (*left*) is almost as dramatic looking upwards as downwards – *Euphorbia heyneana* subsp. *heyneana* and *Euphorbia epithymoides* providing splashes of acid yellow among the dusky pinks of *Eurybia* x *herveyi*, *Geranium* PATRICIA ('Brempat') and *Liatris spicata*.

Sunset in September (*opposite*) when late summer perennial asters carpet the view that leads the eye down towards the Maze.

ARCADIA

at its best in late summer. The only problem here is the massed planting of Primula pulverulenta, *which is just too messy for too long after flowering. We are working on it! That's the other good thing about working on this for a good stint – you get a chance to rectify your mistakes.*

The Rabbit Glade is in a way the most naturalistic – we over-seeded the planting with primulas and violas – and the shape of it is more irregular. This planting is probably best in early summer with euphorbias, Iris sibirica, *astrantias and the like.*

The Hundred Steps Glade is mid-to-late summer. Very strong on pinks, cerise and white. It seems to be the driest of the glades.

It is also hugely spectacular – among those pinks that Tom mentions is *Geranium* PATRICIA ('Brempat') whose 75-cm-high domes of finely cut leaves are studded with almost luminous magenta-pink flowers right the way through the summer. The display moved me to order some for my own garden. You may well do the same. I love the way Tom has restricted his palette of plants – using large numbers of relatively few species and varieties, in deference to the expansiveness of the terrain. The overall feeling is of lushness and generosity, with large drifts of plants all of one variety, rather than lots of smaller groups that would lead to a more bitty, less restful and less spectacular effect.

Tom is pleased with the way things are progressing, though the fact that planting had to be accomplished through a mulch of 15cm of composted green waste (since the soil below was intractable shale and clay, and to offer some kind of weed control) has had a varied effect on the plants:

This has given absurd growth with some species, for example Lamium orvala *and* Campanula lactiflora, *but it's not so suitable for more touchy woodlanders, so things like trillium, uvularia, sanguinaria and erythronium have struggled.*

This new planting will be monitored – successes and failures taken note of, and the mixture adjusted over the years as some plants thrive and others dwindle. However much we espouse the dictum 'right plant, right place', sometimes it is only by experimenting that we discover what will grow and what will not in a particular spot. We can check the soil conditions, monitor the light levels and the degree of exposure of a particular site, and base our plant choice on what we

In September, Japanese anemones and persicaria help the Hundred Steps Glade to fray seamlessly into the surrounding woodland.

The woodland walk between the Bog Garden and the Rabbit Glade in autumn (*above*), with ferns and grasses forming a soft counterpoint to Laura Ellen Bacon's 'Natural Course' dry stone walling sculpture.

The young tree at the centre of the photo (*opposite*) is *Nyssa sylvatica*, renowned for its gloriously glossy autumn colour.

think will thrive. Even then we cannot always predict the outcome, but that is the nature of gardening, whether in a pocket-handkerchief plot, or the 15 acres that comprise Arcadia.

At the moment, there is delight to be had in watching this youthful part of the woodland establishing itself and captivating visitors, who are suddenly aware of a new and interesting part of the garden that, with its meandering paths, simply begs to be explored. Like Paxton's plantings for the 6th Duke, it will grow and change over the years, but, with constant monitoring and adjustment, there is no reason why Arcadia should not live up to Tom Stuart-Smith's aspirations and be a go-to destination for garden visitors in the decades to come.

CHAPTER 14

TOM STUART-SMITH AND DAN PEARSON

The scale and vision of successive dukes and their designers
is what is so astounding – and the way the vast sweep
of the valley is all included in the setting of the house.
Tom Stuart-Smith

For the 12th Duke and Duchess, to choose two of the country's leading garden designers to make their contribution to the Chatsworth landscape was only fitting, bearing in mind their predecessors. From London and Wise, who were commissioned by the 1st Duke, to William Kent, Lancelot Brown and Joseph Paxton, successive Dukes of Devonshire have been inspired in their choices. Both Pearson and Stuart-Smith are regarded within the world of garden and landscape design as masters of their art.

Tom qualified from the University of Manchester in 1984 and, after working with landscape designers Hal Moggridge and Elizabeth Banks, set up his own business in 1998. From Broughton Grange in Oxfordshire and Mount St John in Yorkshire, to the new RHS Garden Bridgewater, near Salford, Manchester, and commissions in Europe, the USA and the Caribbean, his experience is wide ranging. A new garden on the approach to Windsor Castle was commissioned by the Royal Household to mark the Golden Jubilee of Queen Elizabeth II. Tom has won eight gold medals for gardens designed at the Chelsea Flower Show.

When asked about his style, he describes it as:

An expansive naturalism. I work quite contextually. I see my role as trying to articulate what is remarkable about a place and then to accentuate – even distil it – so that the experience of that place can potentially be quite intense.

This ethos is borne out should you visit any of Tom's commissions, from the two-acre garden surrounding the RHS Glasshouse at Wisley, to his work with that great exponent of prairie planting, Piet Oudolf, at Trentham Gardens in Staffordshire, where they were responsible, along with Nigel Dunnett, for collaborating on the redesign of the famous Italian garden.

I find it impossible to gaze on one of Tom's designs and not be moved by its sensitivity to the situation in which it is located. He has a knack of capturing the

Tom Stuart-Smith (*left*) in his own garden, surrounded by his signature style of planting – a rich mixture of textures and colours carefully combined to complement the specific location.

Dan Pearson (*right*) at Chelsea Flower Show in 2015. His gold medal-winning Laurent-Perrier Chatsworth Garden, inspired by the Trout Stream and Paxton's Rock Garden, also won 'Best in Show'.

atmosphere of a place and intensifying it. The senses are heightened, and the experience enhanced, not only by the visual effect, but also by the fact that such artistry is backed by an in-depth knowledge of plants and their individual requirements. Lesser garden designers and landscape architects may shoe-horn in a particular plant for visual effect, regardless of its suitability to the habitat. Tom is aware of the vital importance of both criteria.

It is clear that he derives much pleasure from the challenges that are presented to him, but what does he regard as the most important facets of his work?

I sometimes think that projects are like tables with three legs. All have to be in place for the table to stand and the stronger they are the better.

The people: 'This has to be the most important of all. You can't work with or for people whose values you don't share.'

The place: 'A place that has qualities and a strong narrative as well as a connection to its people.'

The resources: 'I suppose this slightly goes without saying.'

The fact that the work at Chatsworth is ongoing, and not simply a quick one-off job, has made the project especially exciting and fulfilling for Tom, and it's clear that the chance to work on Joseph Paxton's Rock Garden, to re-establish the original concept and even to enhance it, have given this landscape architect, whose work is revered the world over, a unique chance to flex his designer muscles on the sort of landscape that is unlikely to be commissioned ever again.

The Chatsworth Estate combines agriculture, horticulture and forestry, but it also champions country pursuits from fly fishing to sheepdog trials. Here are the game-keeping staff, pictured around 1904.

There can be no doubt that he has risen to the challenge both in the softer, more sylvan plantings of Arcadia and in the drama of the Rock Garden, where a totally different experience is on offer for the visitor. His work continues in devising replanting schemes for the Ravine, the area around the Grotto Pond and towards the Pinetum.

Any designer would find it enormously challenging to work on such well-known and cherished terrain as that at Chatsworth, and to do so, moreover, in conjunction with an existing team. The artistic temperament is, after all, a fragile thing, and a facility imbued with an excess of sensitivity. Is it hard in such a situation, working with others who might not quite understand your devices and desires?

Steve and his team have been absolutely marvellous and I could not have done it without them. I do care enormously about this one. It's been such a fabulous opportunity and a wonderful experience.

Dan Pearson arrived to undertake his commission at Chatsworth a few years before Tom, and the area known as the Trout Stream (see page 199)— two miles from beginning to end – was replanted and re-established along the lower part of its length from autumn 2015.

Forestry and woodland management has always played an important role at Chatsworth. In the eighteenth and nineteenth centuries, with 170 fireplaces to fuel, timber on the estate also contributed to the warmth of the family. Here are the woodmen of Chatsworth in around 1900.

Once swallowed up by the undergrowth, it is now a glistening ribbon that reflects Dan's naturalistic style; a style that is highly regarded, as demonstrated by the gold medal and award of 'Best in Show' when a garden inspired by the Trout Stream was exhibited at Chelsea Flower Show in 2015.

The involvement with this project was not Dan's first visit to the estate:

I'd been to Chatsworth before when visiting friends in the north. I knew of the Brownian landscapes surrounding the gardens but was interested to see the scale of Paxton's ingenuity and intervention. When I first went it felt like a garden from a previously grand era which, through the sheer demands of scale, had lost a layer of horticultural intimacy.

Dan's interest in landscapes began early:

I was a keen gardener as a child but I always knew I wanted to make places with plants. My first commission aged 17 was to design a garden for Frances Mossman in London. After finishing studies at Wisley and Kew I later went on to make Home Farm (Frances's next home) in the mid-eighties. I was able to experiment there with large-scale naturalistic planting that had been inspired by journeys I'd made overseas to study plants in the wild.

At the turn of the century the Chatsworth gardening staff numbered around 70 – a figure which would be reduced dramatically as the century progressed. Here are nineteen of the estate's gardeners in around 1900 – all of them men, and all but two wearing what appears to be a regulation flat cap!

It was these trips that not only inspired, but informed Dan's style of planting:

My work is driven by sense of place. It comes out of the place, its essence and what grows there and might favour the conditions. It is important to 'read' the site carefully to reveal its nuance to enable the mood to be heightened or tapped into. It is an intuitive process that is backed up with practicalities, appropriate choices and good horticulture. I always aim for people to be able to feel the mood of a place and find their way around it intuitively and to feel restored by being there.

And the most important considerations when approaching a project?

To do only as much as you need to, to reveal the best of somewhere. To have a clear idea of the outcome and to think long-term and responsibly. To not be afraid of making changes if that is what is needed. To be quiet and bold in equal measure. To work well in a team and to share a vision. Very few gardens are ever made by just one person.

This last remark is reflected in Dan's appreciation of Steve Porter and the gardeners at Chatsworth. His achievements are, he emphasises, a demonstration of 'the power of teamwork'.

Looking at the newly restored Rock Garden, Arcadia and the Trout Stream, the 12th Duke and Duchess must feel reassured that out of the comprehensive array of available landscaping talent this country has to offer, they made the right choices.

The garden and landscape team in 2023 – a mixture of men and women who are augmented by a healthy contingent of volunteers, most of whom who work a day or half a day per week. Only a couple of flat caps between them …

CHAPTER 15
THE ROCK GARDEN

> IN THE AUTUMN OF 1842 THERE WAS NOT A SINGLE STONE
> IN THESE PARTS ... THE SPIRIT OF SOME DRUID SEEMS TO ANIMATE
> MR PAXTON IN THESE BULKY REMOVALS.
> *Handbook of Chatsworth,* 6th Duke of Devonshire, 1844–5

Perhaps the ghost of 'some Druid' animated Tom Stuart-Smith in his renovation of the Rock Garden in 2018. Purists prefer this term to the more vernacular 'Rockery', and that is how the 6th Duke refers to it in his handbook, though common usage within the garden here resulted in it being referred to as 'the Rockery' for more than a century. Nowadays the more legitimate term is in use, due, no doubt, to the fact that the term 'rockery' encompasses those monstrosities that the great Yorkshire rock gardener and plant collector Reginald Farrer called 'dogs' graves and plum puddings'.

Joseph Paxton was equally opinionated when it came to the construction of rock gardens. In his *Magazine of Botany* he declares:

> ... *no subject in the gardening profession [calls] for a more vigorous exercise of skill and talent ... It is here that those who have studied from nature, frequented her most savage territories and drunk in with avidity their inspiring influence ... is vividly manifest.*

His own plea for caution did not prevent him from creating a dramatic and, in some cases, melodramatic landscape, redolent, in parts, of The Grand Canyon, rather than the Swiss Alps, whose terrain inspired him when he travelled there with the 6th Duke.

At Dobb Edge, on the ridge to the north of the Hunting Tower, he found the gritstone he wanted in some disused quarry workings. With horses, carts, possibly a steam engine and crane, along with human muscle power, these massive monoliths were transported and manoeuvred into position, some of them to create towering columns. The tallest of these, at 14 metres, was named after the Duke of Wellington, and a stream was diverted to cascade over its sheer face.

There were narrow passages between artfully positioned walls of boulders, along with stream-fed pools and swathes of naturalistic planting using shrubs

The Rock Garden (*previous spread*), redesigned by Tom Stuart-Smith, is now even more spectacular than it was when constructed by Paxton in the mid-19th century.

The Wellington Rock today (*opposite*) bordered by the gigantic leaves of the Brazilian native *Gunnera manicata*, which enjoys the moisture-retentive earth at the foot of the gently trickling waterfall.

CHATSWORTH

and alpine plants. The *Gardener's Chronicle* described it as the most extensive and ambitious rock garden made by the hand of man.

The *Art Journal* of 1851 was equally enthusiastic:

[H]ere, Art has been triumphant; the rocks which have been all brought hither are so skillfully combined, so richly clad in mosses, so luxuriantly covered in heather, so judiciously based with ferns and water plants, that you move among, or beside them, in rare delight at the sudden change which transports you from trim parterres to the utmost wildness of natural beauty.

But it is fair to say that it was not universally admired. At about the same time The Horticulturist, and Journal of Rural Art and Rural Taste was less impressed:

The Chatsworth Rockery is but an unsuccessful attempt to impress the mind by an imitation of nature ... [no] person of refined taste and correct judgment, can view these costly monstrosities of vanity and uselessness, without regarding them as a repetition of the vanity of the eastern monarchs ...

You will not be surprised to hear that the editor of that magazine felt the need to add his own two-pennyworth to soften the blow:

[W]e must differ from our correspondent ... time and vegetation have so completely harmonised it with the high hills of Derbyshire, which rise behind it, and of which it now seems a spur, that we venture to say that nine strangers out of ten would walk through it in full belief that it was part of a natural rocky pass in the grounds ...

Tom Stuart-Smith is unequivocal: 'The Rock Garden is the craziest bit of hard landscaping ever made anywhere, I think. It is an heroic piece of landscape creation.'

Paxton's creation could be ridden through in a horse-drawn carriage; today the 12th Duke's electric buggy might follow the same route, but it is on foot that the Rock Garden is most dramatically appreciated. While the planting might soften the overall impact, Paxton – using here the common term – was of the opinion that: 'All the vegetation ... which accompanies an extensive Rockery should be subordinate to it.'

The Rock Garden in June with hardy geraniums, irises and frothy thalictrums flanking the winding path that tempts the visitor to explore.

THE ROCK GARDEN

When the rocks are as big as those at Chatsworth, such a state of affairs is easily accomplished.

The stream that runs through the Rock Garden is, at one point, channelled through narrow boulders to emulate a feature of the Devonshire's Bolton Abbey estate in Yorkshire – the Strid – a notoriously fast-moving cataract that claimed the life of William de Romilly in 1154. Just 'one stride' wide it was; though nine centuries later, the gap has widened to around 2 metres. The waters run fast and deep here, and as twenty-year-old William attempted to leap across the narrow channel, his dog – a greyhound according to my junior-school teacher at Ilkley, just down the road from Bolton Abbey – held back. William lost his footing and perished in the rapids below, thus breaking the heart of his mother, Alice (he was her only son) and removing himself as a contender for the Scottish crown. He is known as 'the Lost Boy of Egremont'.

The 'Strid' at Chatsworth is not nearly so threatening. The ground around it was originally planted with bilberries, crowberries and other moorland plants brought to Chatsworth from the moors above Bolton Abbey.

Over the succeeding 150 years, many of the plants established by Paxton and his successors had become too invasive or grown too large. Areas of rock had subsided and become unstable. Parts of the Rock Garden were still spectacular thanks to their scale, but the whole creation was in need of restoration and repair, which began on a small scale on the upper reaches of the garden in 2002.

But a lot can happen in a garden in twenty years. Rampant plants take over, others dwindle and disappear, until the overview is nothing like what was originally intended. Tom Stuart-Smith took the bull by the horns with a wholesale redevelopment and replanting in 2018, which is now complete.

He was originally called in to relandscape the part of the garden known as Arcadia (see page 149):

But after a day walking around with Steve Porter [Head of Gardens and Landscape] and the Duke and Duchess, I said that I thought the Rock Garden was actually the elephant in the room. So, after a modest intake of breath, they sort of agreed!

The Strid Pond in October, proving that even as the year winds to a close, the newly relandscaped Rock Garden can still inspire.

CHATSWORTH

Tom understood that the original aim of the 6th Duke and his head gardener, Joseph Paxton, was not to create something that was particularly true to nature:

It was conceived more as a piece of scene-making than gardening, and had heathers, cotoneasters and lots of other plants we might think of as dull. Subsequent generations added and subtracted so that by 2018 it was a bit of a tired jumble.

I thought the rock work and Strid were wonderful but most of the planting and the overall character and atmosphere was much too polite and tired. Not immersive at all.

I asked Tom what his intentions were:

To make the arrival experience as you come into the garden from the surrounding areas much more dramatic so you really know you are in a separate world. Then to plant the whole thing with great drifts of flowers and shrubs with paths through it, so you have a very close experience.

It was done in four phases. For the rock stacks, the gritstone from the original quarry was not available so we used limestone from a quarry also on the estate. I was a bit anxious this would read badly. But it's fine and interesting because of the fossils in the rock.

Tom has also added more rocks – six towering monoliths that herald the entrance to the garden. He planted a small range of graceful trees to hold it all together: *Zelkova serrata*, *Prunus x yedoensis*, *Acer palmatum*, *Cercidiphyllum japonicum*, and quite a few specimens of a tree both the Duke and the Duchess love: the Chinese dogwood, *Cornus kousa*. There are relatively few shrubs – mainly the deciduous white-flowered *Rhododendron* 'Daviesii', glorious in spring.

On the lower moisture-retentive slopes you'll find large, repeated drifts of *Iris sibirica*, *Heuchera villosa*, white astrantia, persicaria, *Veronicastrum*, rodgersia, *Ligusticopsis wallichiana*, *Hakonechloa*, *Actaea simplex* 'Prichard's Giant', along with masses of bulbs. The key theme, right the way through, has been to use plants in generous drifts to avoid a spotty effect, which would look overly busy and bitty on such a large scale.

The Strid Pond in 1935 (*opposite top*) when it was still planted with bilberries, crowberries and other moorland plants brought in from Bolton Abbey.

The Rocking Stone and Turnstile in the Rock Garden, around 1900 (*opposite below left*). Tom has added more monoliths to enhance the spectacle.

The Wellington Rock (*opposite below right*) – named after the Iron Duke, it is the tallest of all the monoliths at around 14 metres.

THE ROCK GARDEN

New rock stacks (*opposite*) emerge from the welter of foliage, true to the spirit of Paxton's muscular creation.

In July (*right*), the Rock Garden exhibits far more botanical interest than did its predecessor, where dreary shrubs had obliterated much of the stonework.

CHATSWORTH

Higher up, where conditions are drier, are planted *Cistus, Indigofera, Salvia nemorosa, Sesleria autumnalis, Origanum, Scabiosa columbaria* and *Paeonia tenuifolia*. Throughout, plants have been chosen for their suitability to the prevailing conditions, following the wise gardener's dictum of 'right plant, right place.'

It has been, for Tom Stuart-Smith, a labour of love:

I really can't think of any other project I've ever done that has been so engrossing and pleasurable. This has had so much to do with Steve and his team and above all the generosity and enthusiasm of Stoker and Amanda.

At the suggestion of Duchess Amanda, the bridge across the water was dispensed with. It enabled visitors to take a shortcut, but it also deprived them of the full exploratory experience. Its removal also opened up spectacular views.

The resulting restoration has not only highlighted and emphasised Paxton's spectacular construction, but has also broadened its appeal: it is a great place for children to explore the paths and outcrops – to leap from stone to stone without taking the same risks as William de Romilly – and for gardeners and plantsmen to admire its botanical riches.

The planting might need to be adjusted and tempered over the years – the introduction of the invasively seeding daisy *Erigeron karvinskianus* might give rise to sighs on the part of those gardeners tasked with curbing its rampancy, but when in bloom it makes delightful foaming cascades over and between the rocky crevices.

One thing is certain: the 'elephant in the room' is no longer an embarrassment, but a destination likely to draw gasps of admiration thanks to its sheer scale, and sighs of pleasure at the richness and artfulness of the new planting. The Rock Garden or Rockery – call it what you will; after all, Paxton used both terms – may have slumbered for the better part of a century, but it is now wide awake and ready to impress.

On a foggy morning the Rock Garden is particularly atmospheric; Japanese maples add to the stature of the planting.

CHAPTER 16
ROYALTY AND CHATSWORTH

IT WAS TO HAVE PRIVATE TALKS WITH UNCLE HAROLD* THAT THE PRINCE OF WALES CAME TO STAY IN JUNE 1984. WHAT UNCLE HAROLD TOLD HIM I DO NOT KNOW, BUT THEY MADE GOOD FRIENDS AND THE PRINCE FELT HIS TIME WAS WELL SPENT. HE REMINDED ME RECENTLY THAT HE HAD ASKED FOR A READING LIST TO FILL THE GAPS IN HIS KNOWLEDGE, AND THAT ANDREW AND UNCLE HAROLD HAD SCOURED THE BOOKSHELVES TO PRODUCE ONE. HE SAYS IT IS INVALUABLE TO HIM STILL. THEREAFTER THE PRINCE STAYED AT CHATSWORTH WHENEVER HE HAD AN OFFICIAL ENGAGEMENT NEARBY ...
Wait For Me! Deborah Devonshire, 2010

I HAVE WITNESSED AT FIRST HAND THE WARM, EVEN LOVING, RELATIONship between Deborah Devonshire and the then Prince of Wales, now King Charles III. It was a connection cemented in March 1988. Holidaying in the ski resort of Klosters, the Prince's skiing party were overtaken by an avalanche. The Prince narrowly escaped death, but one of his friends – a former Equerry to the Queen, Major Hugh Lindsay, aged 34 – lost his life. The Prince returned home shocked and deeply affected.

Debo sprang into action:

I talked to Andrew and we decided I should ring up the Prince's private secretary and say how pleased we should be if the Prince would come to Chatsworth to do just what he liked – walk, talk, be with us or stay alone – and to our delight he accepted. It was during those days of slow recovery from shock and the death of his friend that I got to know him. Our friendship has lasted through good times and bad for both of us, and I value it more than I can say.

Having stayed with the then Prince of Wales at Sandringham one summer weekend, along with Debo, I can vouch for the closeness of their bond and the easy rapport between them.

Since the days of Mary, Queen of Scots and her exile here (see page 96), Chatsworth has hosted many 'royalties'. Queen Elizabeth the Queen Mother stayed here several times as Duchess of York, but never returned thereafter; the

*Harold Macmillan, former Prime Minister, was married to Lady Dorothy Cavendish, who was Andrew Devonshire's aunt.

A royal house party at Chatsworth. King Edward VII and Queen Alexandra were regular guests of the 8th Duke of Devonshire and his wife, Duchess Louise.

reason is easy to understand. Her last visit was on the eve of the abdication when, in Debo's words:

… she and the Duke of York had been acutely aware of the profound change about to take place in their lives. This association with this troubled time went so deep that, in spite of many invitations, she never came to stay at Chatsworth with us.

Queen Victoria's enthusiasm for the garden and the estate has already been touched upon (page 117). She came here both before and after her marriage, latterly marvelling at the genius of Joseph Paxton's many accomplishments. George Anson, private secretary to Prince Albert, added his own remarks after their joint visit in 1843:

Today the Queen leaves this magnificent place after a soujourn [sic] of three nights. The Prince is much struck with it, & pronounces it the finest place he has yet seen belonging to any subject of the Queen. The Duke of Devonshire has been much pleased with the visit & has entered into everything with the greatest spirit & spared no expense or trouble to ensure the visit going off well, & he has succeeded admirably.

Queen Elizabeth II was also an occasional visitor – particularly when the present Duke held the post of Her Majesty's Representative at Ascot between 1997 and 2011. In 2005, when the new stand was being constructed at the Berkshire racecourse,

A tree was planted in the West Garden to commemorate the occasion of the Queen's visit in 1968 (*above*).

The Princess Royal with the 12th Duke and Duchess in 2018 (*opposite*), along with the Lord-Lieutenant of Derbyshire, William Tucker and his wife Jill, and Vice Admiral Sir Timothy Laurence.

Prime Minister Harold Macmillan, 'Uncle Harold', (*above, second from the left*) with the 11th Duke and Duchess, Peregrine Hartington (who would become the 12th Duke) and his younger sister Lady Sophia Cavendish.

Royal Ascot moved to York and the Queen, the Duke of Edinburgh and the Princess Royal stayed with the Devonshires on their estate at Bolton Abbey – journeying to York each day by helicopter and returning in the evening.

I had been asked to present one of the trophies – being both a friend of the Devonshires and also a Yorkshireman. So it was that I found myself one evening sitting at dinner in the company of the Queen, the Duke of Edinburgh and the Princess Royal.

My father, a plumber, had undertaken much of the restoration work at Bolton Hall, where we were dining and where the royal family were staying. (My wife and I were billeted at the Devonshires' former home, nearby Beamsley Hall, but joined

the royal party for dinner.) I turned to the Princess Royal and explained to her that my father had been responsible for putting the lead on the roof above us. She directed at me that well-known raised eyebrow, along with a wry smile, and said, 'Well, thank goodness he didn't take it off.' I assured her that he did not, in spite of the fact that someone else had perpetrated that felony a few years after Dad's handiwork had been completed.

Princess Margaret was probably unaware, on a visit to Chatsworth in November 1963, of the previous incumbent of her room. The family, along with Cabinet members of Her Majesty's Government, were returning from the funeral of President Kennedy in the United States. Fog prevented them from landing at London Airport, so the plane put down at Manchester, and Deborah Devonshire offered a room for the night to those who wanted to stay. Some decided that they must, at all costs, make for London. The Prime Minister, Sir Alec Douglas-Home, accepted the offer, though, and was shown to the room the Princess was due to inhabit the following day. Thoughtfully, the Prime Minister suggested to Deborah that 'if he crept into bed and lay very still she would not have to change the sheets …'

Having married into the family, Prime Minister Harold Macmillan was a frequent visitor to Bolton Abbey for the shooting and to Chatsworth. My favourite story is of him, aged nearly 90, wandering the corridors of the house and murmuring to himself, 'You have to throw a double six to get out of this place.'

The friendship of the late Queen and the present Duchess goes back a long way. Amanda Heywood-Lonsdale, as the Duchess was before her marriage, remembers Princess Elizabeth, as she then was, staying with her parents when she – Amanda – was a little girl of six or seven. Early one bright morning, her pony escaped from the paddock and could be heard whinnying loudly under the Princess's bedroom window. Amanda recalls tiptoeing down the stairs and leading the pony away, wearing only her pyjamas and a pair of wellies. The Princess did not stir, and the pyjamas were not remarked upon at breakfast.

Prince Philip of Greece, as he was before his marriage to Princess Elizabeth, served on HMS *Wallace* under Amanda's father, Commander Edward Heywood-Lonsdale, having been informed by the Prince's uncle, Lord Louis Mountbatten, 'I have a nephew for you to look after.' Subsequently, the Duke of Edinburgh came

to Chatsworth regularly, most recently to meet twenty-five local charities in the Painted Hall, to stay for lunch and enjoy that easy familiarity that must come as a blessed relief to someone used to making polite conversation over a lifetime of public service.

And so the friendships continue down the generations: the King, when Prince of Wales, visited Chatsworth in 2015 to meet local farmers at an event organised by the Prince's Countryside Fund and – keen gardener that he is – took the opportunity to look at the newly landscaped Trout Stream.

Diana, Princess of Wales, visited Derbyshire on many occasions; most memorable for Chatsworth were the Barnardo's garden party in July 1986, attended by 8,000 guests, during which she took tea by the Ring Pond, and the Festival of National Parks in September 1987 when wellington boots were the prerequisite for a muddy tour of the park.

Prince William – now the Prince of Wales – had a rather more hands-on experience. After graduating from university in 2005, he undertook a number of work experience placements. He came to the house for two weeks and moved around various different departments, spending a few days in the bookings office, making sausages in the Farm Shop butchery, assisting the joiners in the house with some temporary stage construction, and joining in the 'Friday fish and chips lunch' with the house maintenance team. He lived in the Hunting Tower (his detective was billeted 'round the back') and worked alongside the garden and estate

The Queen and the 12th Duke of Devonshire at Chatsworth in 2014 (*above*). This was one of many visits the Queen made over the years when she met staff and inspected the ongoing restoration work, as well as chatting with search and rescue teams, Peak District Park Rangers, air ambulance crew and members of Derbyshire voluntary and charity organisations, before enjoying a private lunch.

Diana, Princess of Wales (*opposite*) enjoyed a number of visits to Chatsworth in the 1980s. She also supported local charity initiatives.

staff who got on with him well. So much so that on the last day, he was asked to dig a hole for a tree that he would plant as a memento of his visit. He began to dig. He paused. His workmates shook their heads. 'Not deep enough.' His workmates found it difficult to keep a straight face. Only then did the penny drop. The hole was backfilled until it was perhaps 45cm deep, and the oak sapling was planted with a suitably inscribed spade, also used by his mother to plant her tree back in 1986. The technique is to be recommended. I saw the tree on a recent visit. It was grown from an acorn taken from a tree planted on the estate by Queen Victoria nearly two centuries ago, and is now a strapping specimen 5 or 6 metres high. It is unlabelled, but fondly watched over by the gardening staff.

The hosting of 'royalties' will no doubt continue, but then, as Queen Victoria discovered, when it comes to the quality of innovation, decoration and cultivation, not to mention hospitality, comfort, friendliness – and a wry sense of humour – the people of Chatsworth are in a league of their own.

CHAPTER 17

THE ARBORETUM AND PINETUM

THAT IS THE DOUGLAS PINE, THE PRIDE OF CALIFORNIA: IN 1829 IT CAME DOWN IN MR PAXTON'S HAT, AND IN 1845 IT IS 35 FT HIGH.
Handbook of Chatsworth, 6th Duke of Devonshire, 1844–5

Leave the formal areas around the house and journey upwards to the right of the Cascade, and you will discover that almost the entire garden from thereon is an arboretum – a collection of trees – the understorey varying according to the aspect of the land and the shade cast by the overhanging canopy. At its southern extremity is the Pinetum, a collection of coniferous plants begun in the 1820s that was in full swing by 1835, when streams were diverted to improve the aesthetic appearance. The trees themselves were planted according to their scientific order, including over 1,670 species and varieties. Wood felled from the site was sold to finance the replanting.

The 6th Duke was an avid tree collector and played his part in sponsoring plant-collecting expeditions across the world, in those Victorian days when 'collecting' was all the rage – from minerals to statuary, books to paintings and, in the Duke's case, all of the above, though one of his greatest pleasures came from amassing a collection of plants, both hardy and tropical.

So thrilled was he at the arrival of a rare tropical specimen – *Amherstia nobilis*, the Pride of Burma – from the East India Company, that he had the plant positioned in the Painted Hall, and a breakfast table laid alongside it so that he might feast his eyes upon his new acquisition while he took his morning repast. Joseph Paxton was then summoned to its presence and was introduced to the new tree, and its fellow additions to the Chatsworth plant collection, one by one.

Many of these would have been plants for the Great Stove – the Great Conservatory – since they were too tender to survive outdoors in the chilly Derbyshire winters.

Many of the original conifers planted by Paxton and the 6th Duke survive in the Pinetum. The Douglas fir (which the Duke called the Douglas pine) is still growing, though its top is occasionally blown out by strong winds, and it has not reached the Duke's hoped-for 200 ft.

The Arboretum in autumn (*previous spread*); a vibrant confection of reds, yellows and oranges thanks to acers, liquidambars and other brilliantly colouring deciduous trees.

Under the boughs of an ancient oak tree (*opposite*) a carpet of bluebells erupts in the Pinetum in April and May.

CHATSWORTH

A monkey-puzzle tree – *Araucaria araucana* – was planted by Paxton, and used to stand like some strange and gigantic candelabra on a landing halfway down the Hundred Steps, which were installed later in the 1980s. Beloved of the Victorians, it was an acquired taste, and specimens still in the Pinetum today are a reminder of the avidity of those Victorian plant collectors who seemed to prize oddity every bit as much as beauty.

Of the hardwood (deciduous) trees that surround the Pinetum, a few are worth noting, though their precise history has been lost in the mists of time. Look out for venerable oaks, some of them only recently uncovered, and their august stature revealed, having been swamped by those two thugs *Rhododendron ponticum* and seedling holly. The Duchess herself took part in the clearance of the undergrowth (after the fashion of King George V's widowed Queen Mary, who busied herself at Badminton during the Second World War, hacking down ivy from the trees on the Beaufort estate). Ivy is welcomed at Chatsworth, due to its hospitality to a range of wildlife, birds and insects, provided its location does not threaten the survival of other plants; *Rhododendron ponticum*, and what the current Duke and Duchess refer to as 'pig holly', are not.

Due to its acting as a host for the fungus-like organism *Phytophthora ramorum*, a disease that causes 'sudden oak death', government grants have been made available to encourage landowners to grub out the wild rhododendron and help to control the spread of this virulent and deadly disease. The Devonshires miss its glorious spring display of vibrant mauve flowers, but know that its eradication is essential for the health of other trees and shrubs on the estate.

The newly uncovered oaks are far older than those that were planted by Paxton. Some of them would have been here when Bess of Hardwick held sway – possibly even longer. There are oaks in Windsor Great Park that were 200 years old when William the Conqueror invaded these islands in 1066. Those at Chatsworth are not quite so ancient, but it is clear from their girth and general demeanour that they are in excess of 500 years old.

Do not underestimate the importance of *Quercus robur*, the oak tree in the British landscape. According to the Woodland Trust, 2,300 species of wildlife are supported by the oak; 326 species depend upon it for their very survival,

The site of the Great Conservatory with the Maze at its centre, surrounded by the Arboretum, as the shadows lengthen and autumn colour begins to flush the landscape.

THE ARBORETUM AND PINETUM

and 229 species are rarely found on trees other than oak. It remains a vital source of food, shelter and protection for an astonishing number of creatures.

Throughout the Arboretum, the understorey has been cleared in many areas to let in light and to open up views that had long since disappeared. 'Crown lifting' (the removal of the lower branches of trees) is practiced judiciously and regularly to ensure the health and elegance of the trees in question, as well as the provision of better growing conditions for the smaller trees and shrubs that surround them. The work is ongoing, and a walk through the Arboretum will reveal the extent of the clearance and replanting.

Keen plantspeople will find labels to sate their curiosity in the Pinetum, others to whom Latin is a foreign language will find more solace in the views between the towering trunks; in the elegant Chinese dogwoods (*Cornus kousa* varieties) that have been added by the 12th Duke and Duchess, and in the ever-changing patterns of light that play across the softly rolling waves of woodland grasses. In spring, the startling azure carpets of native bluebells, which rejoice under the botanical name of *Hyacinthoides non-scripta*, seem to shimmer in the sun.

There is a secret pond up here in the Arboretum – Morton Pond. I call it secret, only because few folk seem to venture this far. Those who do can enjoy the tranquillity and admire the towering form of the giant redwood, *Sequoiadendron giganteum*, with its soft, fire-resistant bark. I always think of it as nature's asbestos – though it is far less toxic and much kinder to the touch. The tree was grown from seed in 1955 by a former Head Gardener here, Jim Link, who served under the 11th Duke and Duchess. He planted it when he was a boy. I love its old name of *Wellingtonia*, bestowed in honour of the Iron Duke who knew Chatsworth well. The name was given to the tree on its introduction to Britain from North America in 1853 by the botanist John Lindley, but was declared void a year later since it had already been given to another plant. It would be given all kinds of names subsequently, until *Sequoiadendron* was decided on as late as 1939.

New plantings will continue over the years, making sure that the Arboretum and Pinetum are not simply a museum of arboricultural curiosities, but a handsome, vigorous and ever-evolving collection of woody plants that enjoy the conditions to be found here in the Derbyshire Dales.

If you seek a tranquil spot in the garden at Chatsworth, head up the hillside to the south east where you will find Morton Pond, and few other visitors to disturb your reverie beneath the canopy of oak and beech trees.

CHATSWORTH

On the streamside between Morton Pond and the Grotto (*right*), an ancient specimen of *Rhododendron calophytum* is a majestic sight in spring.

Other examples of this spectacular species (*opposite*) add to the March spectacle, contrasting with the rugged outline of boulders above the Grotto Pond.

THE ARBORETUM AND PINETUM

The Trout Stream

Dan Pearson began redesigning, editing and improving the Trout Stream area in 2015. This meandering stream – it covers two miles in total, from its source on the East Moor – was originally diverted around 1835 by Joseph Paxton at the behest of the 6th Duke. At that time, no doubt, it looked pretty and 'Arcadian' as it made its way down through what would then have been a planting scheme of relatively new introductions to English gardens. Time had masked its earlier beauty and the rhododendrons, amongst other species, had had their way, so almost two centuries on, it was cleared of unwanted undergrowth and seedling trees and returned to its sylvan beauty.

I asked Dan how the project began:

Originally we were asked to make a garden for the Chelsea Flower Show which celebrated the partnership between Chatsworth and the champagne house Laurent-Perrier. I spent time at Chatsworth to try and find a moment in the garden that would translate in scale to the flower show. The long-neglected Trout Stream in the

The Trout Stream in June (*opposite*), redesigned and replanted by Dan Pearson in 2015. It is especially luxuriant in spring (*above*) with buttercups and lady's smock or cuckoo flower (*Cardamine pratensis*) at the water's edge.

CHATSWORTH

upper reaches of the garden provided a perfect narrative and for the process to be circular in terms of energies and resources. We would restore the Trout Stream by bringing the Chelsea show garden back to Chatsworth. We made the brief work so that the two projects became one. This was important.

We wanted to reinvigorate the Trout Stream and use the already good bones of the vegetation and the stream itself as a backbone. It was an exercise in subtlety, firstly editing unwanted saplings and undergrowth to let the light into newly opened glades; to throw light onto the water and to provide us with the right conditions into which a new layer of woody plants could be added for the future: Stewartia, hydrangea, magnolia and other flowering material that would suit the conditions.

We had been inspired by the monumental rock stacks in the nearby Rock Garden for Chelsea and assembled two as focal points near the first circular pool of water. They provided gravity and the water their reflection. Two bridges from the show garden were placed to engage with the water, and suggest a path that would loop back over the second small pool to engage the other side of the stream, where previously it had slipped by to one side of the path only. We added a robust perennial and bulb layer amongst the meadow grasses and managed the meadows for diversity. The planting follows the water and highlights its passage through the garden.

The 'Laurent-Perrier Chatsworth Garden' at Chelsea Flower Show in 2015, inspired by the Trout Stream, won a Royal Horticultural Society gold medal and was judged 'Best in Show'. Its manifestation at Chelsea had a huge impact. Gardener and writer Mary Keen admitted that she had been moved to tears. I confess, myself, to having experienced the same emotion. Anna Pavord remarked that Dan 'pulled off the most difficult trick of all: to make the made look not made.' Plantswoman Tania Compton found it 'breathtaking'.

It really was the most magical creation, and the plants and rocks that went into its construction were, as planned, brought back to Chatsworth and established in their long-term home.

Dan is clearly pleased with the result:

The restored Trout Stream has become a quiet place of focus in the garden, a subtle experience that sits gently in its setting.

In early autumn, Japanese maples give the Trout Stream a second season of interest, with their autumn colours of butter yellow, vibrant amber or fiery scarlet.

THE ARBORETUM AND PINETUM

While the extreme naturalism of this garden area has been retained and developed, in the perennial plants strong, vibrant colour has been used subtly and playfully to create a heightened sense of nature, drawing attention to the fact that, although seemingly wild, this is a man-made environment.

Even for those not well versed in the intricacies of garden design, there is much to admire here: deftly placed drifts of irises and primulas erupt through the woodland grasses, along with wild strawberry and white ragged robin and meadow cranesbill. Shrubs like *Halesia* and *Enkianthus* add height and structure, while maintaining that vital feeling of calm that Dan sought.

The visitor experience was well to the fore in Dan's thinking at Chatsworth, every bit as much as it was at the flower show:

The installation of new footbridges and new seating have made the Trout Stream and Arboretum more accessible and enjoyable for visitors, while a specially commissioned sculpture by David Nash forms a focal point to the scheme.

Like Tom Stuart-Smith, Dan is ready to acknowledge the help and encouragement of Steve Porter and the gardening staff of Chatsworth:

A semi-wild planting scheme of this kind requires extremely sensitive management and its continued success and development is testament to the skill of the Chatsworth Gardens team.

Conner Grove

To the west of the Bamboo Walk, on the lower slopes of the Arboretum, you will come across a parliament of busts – a latter-day 'Temple of Worthies', like that in the gardens at Stowe. Sculpted by Angela Conner, there are thirteen of them in all – close friends and members of the family: Queen Elizabeth II, King Charles III, Harold Macmillan, Lady Emma Tennant, Sir Tom Stoppard, Sir Roy Strong, Lucian Freud, Sir Patrick Leigh Fermor, Lord Rothschild, Sir John Betjeman, Andrew, 11th Duke of Devonshire, Deborah, Duchess of Devonshire and the Earl of Burlington. The Grove was opened in 2011. Imagine the conversations held between them when everyone has gone home …

Camassias provide a vibrant springtime carpet for 'Oculus Oak' – a sculpture by David Nash installed in 2015.

CHAPTER 18

THE 12TH DUKE AND DUCHESS OF DEVONSHIRE

THE OVERRIDING IMPRESSION OF LIVING AT CHATSWORTH IS ONE OF PEACE. THE HOUSE IS ENTIRELY BENIGN, THE VIEWS ARE WONDERFULLY CALM, AND A SENSE OF OPTIMISM PREVAILS. WE ARE CONSTANTLY REMINDED OF THE MANY LAYERS OF TIME AND HISTORY, WHICH SOMETIMES REVEAL THEMSELVES QUITE UNPREDICTABLY.

Chatsworth, Arcadia, Now, John-Paul Stonard,
foreword by the Duke and Duchess of Devonshire, 2021, Particular Books

W<small>HEN A FAMILY INHERITS A HOUSE FROM A PREVIOUS GENERATION</small> it is time for change. Furniture is sold off; rooms are redecorated and the garden is relandscaped to suit the needs of the new family and the tastes of the day. When the residence – and its surrounding lands – comprise what is usually referred to as a 'stately home', the situation is rather different. The words 'custodianship' and 'history' are a heavy burden under which to make your own mark and to live your life as you would choose. No one wants to live in a house that is frozen in time, as if it were a museum, or preserved like some treasured comestible in aspic. Each house, however stately, should be allowed to reflect the tastes and predilections of its new owners who will, themselves, one day be a valid part of its rich history. The difficulty lies in combining the legacy of the past with the aspirations and acquisitions of the present day.

We have all been to historic houses where nothing has been allowed to change since the time that the National Trust or English Heritage, or whichever body has the responsibility for its future, has decided is the one that most reflects its importance. Such houses are then equipped with 'interpretation boards' to explain the reasoning behind their existence and to help 'contextualise' them. My spirits – and those of many others I suspect – sink at the very prospect of such a sterile approach. All too often such measures are both stultifying and patronising. For students of a particular period of history they may be valuable source material. But to live in?

There is an additional problem when it comes to preserving gardens: the two words are impossible companions. You can furnish a room with Georgian furniture and decorate it appropriately. You can then preserve it exactly as it is for future

Stoker and Amanda – Peregrine Cavendish, Marquess of Hartington, and Amanda Heywood-Lonsdale – on their wedding day in June 1967.

THE 12TH DUKE AND DUCHESS OF DEVONSHIRE

generations with, perhaps, the odd lick of paint every fifty years. You cannot do that with a garden. By its very nature it grows: the scale changes. Trees, as in the Pinetum at Chatsworth, may last for hundreds of years, but beds and borders, shrubs and perennials do not. Rock gardens become overgrown; landscapes erode, earth becomes impoverished. Gardens move and gardeners must move with them, which results in an ever-changing picture, unless you are to settle for a stagnant cypher of what once was a vibrant living tapestry.

It is something of which the current Duke and Duchess of Devonshire are well aware. Both respect the work of earlier generations – ducal and horticultural – but realise the need to reinvigorate tired planting schemes and to make their own quite legitimate mark on the landscape for their own pleasure, and for the enjoyment of visitors now and in the future. Such actions effectively prevent the garden and the estate from becoming stuck in a time-warp.

It is an easy trap to fall into: assuming that anything historic must be of value, and that anything new and innovative is to be discouraged. Had our own predecessors felt the same way, we would still be gazing out of our windows at a swamp or a wilderness.

Stoker and Amanda Devonshire – while acknowledging the accomplishments of London and Wise, Lancelot 'Capability' Brown and Sir Joseph Paxton, and their immediate predecessors Andrew and Deborah Devonshire – have not rested on these august laurels. They have not been timid. Instead, they have taken hold of the garden and the estate, breathed new life into historic features, added to them and pointed the Chatsworth landscape firmly towards the future.

You may not find that everything they do accords with your own taste, but what is undeniable is that they have given both the house and the garden a far greater relevance to the twenty-first century, without 'mucking up' the legacy of those who came before.

Were they daunted by the prospect when they took over the house and the estate in 2004? Says the Duke:

We were so timid. We had no experience of such a large landscape. Beamsley Hall [near Bolton Abbey in Yorkshire] where we lived before had 2.5 acres, but no landscape

One of two bridges over the Trout Stream – part of Dan Pearson's Gold Medal-winning Laurent-Perrier Chelsea Flower Show Garden commissioned by the Duke and Duchess of Devonshire in 2015 and subsequently installed at Chatsworth.

– just fields. We were unprepared for the scale. We were hugely influenced by my mother who – like my father – was dead against outside help. It took us ten years to realise that we were not good at 'big planting'. That said, we have never regretted the loss of any tree that was cut down.

When we cleared the Ravine of Rhododendron ponticum we thought we'd get the Gardens Team to make a plan. 'Think about what you want' we said. But it didn't work at all, simply because of the scale. Eventually we realised we needed help. I wrote to about six landscape designers and eventually we settled on Dan Pearson and Tom Stuart-Smith. Without them we simply could not have managed.

Dan's work can be seen in the Trout Stream project (see page 199); Tom's work after the Rock Garden (page 169) and Arcadia (page 149) is ongoing, and he will soon be tackling additional planting in the Ravine and towards the Pinetum.

Michael Leonard (b. 1933) painted these engaging portraits of Stoker and Amanda with their budgerigar George in 1981.

The Duke says, with a wry grin: 'When I am working alongside Tom I am a better gardener.' The Duchess, too, admits to originally planting on too small a scale, and both found it helpful to visit some of Tom's previous commissions to see his designs and plantings at Mount St John in Yorkshire and Broughton Grange in Oxfordshire. Both gardens fired their imaginations. They love, too, their own garden at Lismore, in County Waterford, Ireland, and the gardens of Newby Hall in Yorkshire. Whether one's own garden is large or small, visiting others for inspiration is always worthwhile.

CHATSWORTH

A key factor in the subsequent development of the garden and estate was the influence of the late John Sales, Head of Gardens for the National Trust for 30 years. John's intervention at Chatsworth in 2006 – by invitation – encouraged the restructuring and strengthening of the teams, and the appointment in 2011 of Steve Porter (hitherto the second in command to Head Gardener Ian Webster) as Head of Gardens and Landscape. John also offered invaluable practical advice on planting and landscaping. The Duke is effusive in his praise:

Without John's input we would have floundered. He was a godsend. We mourn his loss and are happy that 130 different varieties of snowdrop from his collection have been planted here at Chatsworth. It will be a reminder of a man to whom we are hugely grateful. We realised the kind of help we needed and John pointed us in the right direction – he was the cement between the old and the new. We now have the equivalent of 28 full-time staff in the garden, a landscape team of seven, and around 80 garden volunteers. My father [Andrew, 11th Duke of Devonshire] would never ask people to work for nothing and would not ask for grants, in spite of Chatsworth being a charity. We have learned that with the garden now 20 per cent bigger than it was, thanks to the rhododendron clearance, we need more help.

There is pride at Chatsworth in the fact that many of its gardens and estate staff have worked here for many years – up to fifty years in some cases – and that others who trained here have gone on to take charge of gardens and estates elsewhere. There are always two trainees in place, for a year at a time, all of whom

The 12th Duke and Duchess of Devonshire and Max in front of the newly restored house.

become ambassadors for Chatsworth and whose input during their time here is acknowledged and valued.

The fact that what in most organisations would be called the HR (human resources) department, is at Chatsworth referred to as the 'People Team', shows how much the 12th Duke and Duchess value the input of those who work here, whether as paid employees or as volunteers.

The restoration of the house was carried out under the guidance of the architect Peter Inskip – who also advised on the simplification of the landscape, and plantings immediately surrounding the house. The production of a management plan for the park, as well as the review of priorities and development within the garden, combined to establish a new direction and energy for the garden and estate, and to recognise the importance of connecting it to the surrounding landscape.

The legacy of the 12th Duke and Duchess – aside from the creation of Arcadia, the revitalisation of the Rock Garden and a host of other gardening projects – will be the integration of the workforce at Chatsworth, the ability of departments to liaise with one another and the acknowledgement that enlisting the help of people with the necessary expertise is not a sign of weakness, but a recognition of what is needed to effectively manage a 105-acre garden and an extensive landscape that is healthy, inspirational and forward looking. As the responsibility passes to the next generation in William and Laura Burlington, the 12th Duke and Duchess have every right to feel proud of what they – and those in whom they have put their trust – have achieved.

Chatsworth Country Fair is an annual celebration of all things rural – and that includes vintage cars. Alan Titchmarsh drives his 1929 4½ litre Bentley into the arena. His wife Alison sits beside him, with Stoker and Amanda as back-seat passengers.

CHAPTER 19

THE RAVINE

> GRANNY EVIE'S LOVE OF GARDENING EVENTUALLY SPURRED HER ON TO CREATE SOMETHING NEW IN THE 1930S. SHE CHOSE THE RAVINE, THE STEEP BANKS OF A LITTLE STREAM WHICH FLOWS OUT OF THE GROTTO POND. THERE SHE MADE WHAT MUST HAVE BEEN A VERY PRETTY WILD GARDEN IN THE FASHION OF THAT TIME. SHE WAS PLEASED WITH HER CREATION AND TOOK ALL AND SUNDRY TO SEE IT.
> *The Garden at Chatsworth*, Deborah Devonshire, 1999

Deborah Devonshire's use of the past tense speaks volumes. Fifty years after the Ravine had been planted with all manner of woodland beauties by Duchess Evelyn, wife of the 9th Duke, Victor, the intervention of the Second World War had seen it languish and become swamped by seedling trees and wild rhododendrons. These interlopers smothered and usurped much of the original planting, including choice specimens acquired as a result of investing in the plant-collecting expeditions of that intrepid adventurer Frank Kingdon-Ward on his sorties in Tibet, China, Burma and India.

Born in Manchester in 1885, and at the height of his plant-collecting powers in the 1930s, it was Kingdon-Ward who brought back the first viable seed of the Himalayan blue poppy, *Meconopsis betonicifolia* (discovered by the French missionary and botanist Père Delavay in 1886), along with *Primula florindae* (named after his first wife Florinda) and the gloriously elegant *Lilium mackliniae*, named for his second wife, Jean Macklin. The yellow-flowered *Rhododendron wardii* carries his own name.

The catalogue of plants that Kingdon-Ward introduced to British gardens is long and distinguished. Botanical exploration took him to the wilder areas of the Himalayas where he survived numerous accidents – falling off a cliff, being speared by bamboo, being crushed by a falling tree, getting totally lost in unchartered terrain and living through an earthquake. His occasional arrests and incarcerations can be explained by the fact that he also acted as a spy for the British India Office. He appears to have had more lives than your average cat.

Kingdon-Ward would send a round-robin to those who had subscribed to his expeditions (their funds ensuring that he could cover his expenses and,

A bridge in the Ravine (previous spread), offering a wonderful view down the valley in June, at the height of its luxuriance.

New deciduous azaleas are still being added to augment the planting scheme begun by Duchess Evelyn during the first half of the twentieth century (opposite). They create a startling sight in spring.

in turn, his backers would have access to seeds and bulbs that other keen gardeners would covet). One such communiqué received at Chatsworth includes the following:

40 marches from the railhead at Myitkyina. 6000' above sea level … a queer mixture of plants – six species of rhododendrons grow around the camp. One, a fine tree, is already in bloom. Shrubs of all kinds, crowded with berries, abound.

As well as seeds, bulbs and fragments of plants were brought back and distributed to those investors eagerly awaiting their share of the booty. Of his twenty-five books, *The Land of the Blue Poppy* (1913) and *Plant Hunting on the Edge of the World* (1930) have particularly evocative titles.

To this day there remains a degree of mystery and magic surrounding plants of Himalayan origin, due, in no small measure, to the inaccessibility not only of the terrain in which they grow but of the countries themselves. The sheer variety of plant material and their uniqueness to that particular area of the globe gives them an added frisson. The great delight is that the majority of them are well suited to being grown in the UK – not least in Derbyshire.

To Frank Kingdon-Ward, the gardens at Chatsworth – and all across the British Isles – owe a debt of gratitude. Over a period of almost fifty years, from the turn of the century until 1958, he undertook more than two dozen plant-collecting expeditions, which yielded many of the choice plants we cherish in our gardens today. How lucky was Duchess Evelyn to be in there at the start of things, and for her and her head gardener J. G. Weston to see at first-hand plants that had never before been grown in these islands. The botanical treasures themselves must have felt very much at home in the sheltered confines of the Ravine.

The 'wild style' of gardening that Duchess Evelyn loved was promoted towards the end of the nineteenth and the beginning of the twentieth centuries by William Robinson, of Gravetye Manor in Sussex, as an antidote to the bright, formal bedding schemes beloved of so many Victorian gardeners. I suspect it created every bit as much of a stir as the prospect of 'rewilding' does today, though both Robinson and that other early twentieth-century 'high priestess' of

Candelabra primulas and rodgersias in the Ravine in June – very much in the 'wild style' of gardening beloved of Duchess Evelyn.

THE RAVINE

Camassias and crab apple blossom (*right*) at the top of the Ravine in April, a time of year when nature is at its most ebullient.

The top of the Ravine, near the Trough Waterfall, (*opposite*) has been replanted with evergreen rhododendrons and deciduous azaleas famed for their late spring and early summer brilliance.

gardening, Gertrude Jekyll, were accomplished gardeners who realised that such a scheme involved every bit as much management and skill in cultivation as more formal styles.

In its heyday the Ravine had been a 'must see' in spring, with its banks of rhododendrons, azaleas, carpets of candelabra primulas, followed by voluptuous lilies. Fifty years of relatively little intervention since its inception meant that by the 1980s it needed attention. A foray was made into the undergrowth. *Rhododendron ponticum* – that rampant scourge of woodland and host of the dreaded water mould disease *Phytophthora ramorum* was grubbed out, along with unwanted seedling trees that were undermining the banks. The original stone paths were uncovered, and some of the choice rhododendrons that were of a strong constitution emerged from the gloom.

At the top of the stream, where it leaves the Grotto Pond, you will find the Trough Waterfall: a curious feature constructed in 1997, where the pond's overflow tumbles through a series of thirteen stacked stone troughs, down a narrow rill and onwards into the Ravine. Children love to follow it. So does this grown-up.

Another thirty years would pass after the 1980s clearance before a more comprehensive restoration of the Ravine was undertaken in 2013. The stream was cleared of debris, cascades restored and the rivulet dammed at intervals to create small pools that offer sparkling reflections. A path crosses and recrosses the stream at intervals to make for a more enjoyable walk, with views across the water and away into the canopy of trees to right and left. Sunlight – once so lacking – now slants through the tree canopy at intervals, and the pools sparkle and shimmer beneath the heaven-bound parasol of leaves. Poetic? A touch, but then this is a magical place on a fine spring day – a time when the Ravine once more looks its best. The banks of the stream have been planted up with primulas, astilbe, dogwood and the gloriously fragrant, yellow-flowered deciduous *Rhododendron luteum* (*Azalea lutea*). In autumn there is spectacle of a different kind, when the leaves of the deciduous azaleas turn scarlet and crimson.

Over the next few years, Tom Stuart-Smith will be supervising the addition of more perennials along the streamside and more rhododendrons supplied by Britain's leading grower of 'rhodies', David Millais. David's expertise is unique,

The Trough Waterfall – thirteen troughs in all – was constructed in 1997 and intercepts water from the Grotto Pond, sending it on its way down through the Ravine.

THE RAVINE

and his Surrey nursery has the most comprehensive collection of species and varieties in the United Kingdom.

Being in the farthest reaches of the garden, the Ravine is not the most frequented of spots. If you want to savour the peace of Chatsworth – especially on a bright spring day, or when the first chill of autumn has turned the leaves to shades of ochre, amber, raw sienna and the more vibrant tones on the water colourist's palette, wander along there and drink in the atmosphere, reflecting for a moment on the courage and expertise of those plant collectors of the early-twentieth century, who made the world of difference to this and so many other British gardens.

And say thank you, too, to Granny Evie and Victor, the 9th Duke of Devonshire, who gave the likes of Frank Kingdon-Ward the funds to make it possible.

Watching the changing pattern of leaves, flowers and colours through the year is a good reason to make frequent visits to Chatsworth. Only then can you see how features such as the Ravine change their livery from early summer, to the season of mists in November (*opposite and above*).

Chatsworth v. Bolton Abbey.

CHAPTER 20
CHATSWORTH CRICKET CLUB

When we had come on the terrace the Duke wished us to plant two trees down under the terrace. So we did, I planted an oak and Mamma a Spanish chesnut [sic]. After that we went upon the terrace again and went up a platform which had been arranged with carpets, to view the cricket match below; the Buxton band playing 'God save the King' and the people hurraying and others under tents looked very pretty.

Journal, Queen Victoria (then Princess Victoria; aged 13), 20th October, 1832

There is nothing quite so relaxing, quite so British, as watching a cricket match on a sunny summer's afternoon, where the partaking of a good tea is regarded by many as being of equal importance to the outcome of the match (unless you are playing, and even then the refreshments are still a highlight).

To play cricket at Chatsworth is to enjoy the 'Summer Game' in the finest of settings. It is a tradition that has been upheld here for at least 200 years, as Princess Victoria's journal testifies. That particular match was played in front of 300 invited guests. Today, anyone can watch.

Few clubs are blessed with such a glorious location, or such a picture-postcard-worthy pavilion, as the one on the estate. It was built in 1911 and has a steeply pitched thatched roof. Six snow-white pillars support the eaves above the veranda, providing the perfect shelter for those who like to be as near to the tea and cakes as possible, and protected from the occasional summer shower. The surrounding poplar trees act like gnomons on a sundial, casting their shadows across the pitch in the early evening sun.

Many of the players for the Chatsworth team come from the house, the garden, the wider estate and its surrounding villages – Edensor, Baslow, Beeley and Pilsley.

The first recorded match after Princess Victoria's visit was in 1833 when Joseph Paxton led a team of gardeners against members of the household staff. The gardeners won the two-innings match by five wickets. (You will forgive my satisfaction at the outcome.)

Although these are the earliest recorded matches, it is highly likely that cricket

Chatsworth v Bolton Abbey *c.* 1910, when the employees' cricketing skills were as important as their chosen trades.

A cricket match in 1964. The pitch boasts one of the finest views in England, with the house and the Emperor Fountain in the background.

was played at Chatsworth around 100 years before, since there is a record of the Dukes of Devonshire and Richmond, along with the Earl of Albemarle, being involved in a match at Hyde Park in London with 100 guineas at stake.

In 1777, the famous Duchess Georgiana, wife of the 5th Duke, was critical of the Duke of Dorset's facility with the cricket bat. Gambler that Georgiana was, it is highly likely that her interest stretched to cricket which, at that time, attracted royalty, nobility and gentry, not only to watch the matches but to wager large sums of money on their outcome.

The following century, the 6th Duke's diary carries an entry dated 13 September 1842: 'Grand Cricketing – Chatsworth Victorious.' Successive Dukes have been equally supportive of cricket, even if, on occasion, the behaviour of some of those present has been less than gentlemanly. Declining to leave the wicket when called

CHATSWORTH CRICKET CLUB

'out' is … just not cricket. In August 1876 the police were called to the ground. A blacksmith, Mr George Hill, was arrested for being drunk and refusing to quit. He was given the choice of paying ten shillings, or facing 14 days behind bars. History does not record whether he was a Chatsworth player, a member of the opposing team, or a spectator enjoying his day out, nor, sadly, is it known which option he took.

Until 1911, the club was situated much nearer the house, to the northwest of Queen Mary's Bower, but the 9th Duke, Victor, decided to relocate it to what was part of the old golf course, and the pavilion was built at a cost of £385.

Beautiful as the setting was, with a new club formed at nearby Baslow, within a few years it became hard to find good cricketers on the estate, with the result that in the recruitment of estate tradesmen, sporting prowess became a distinct advantage, as the advert in a local newspaper indicates:

WANTED
Plumber for estate maintenance work. Must be a good wicket-keeper.

By the 1970s, the club was once again in a healthy condition, with celebrity teams coming up from London to play the 11th Duke of Devonshire's XI, and there were even occasional visits from touring sides.

There are times when the weather will wreak havoc with the pitch. It was flooded in 1989 and again in 2019. But this is Britain. And this is Chatsworth. It will take more than a shower or two – or a waterlogged pitch – to dent the spirit of those who enjoy the summer game, and since 2002, a Chatsworth Ladies XI has livened things up.

Even the MCC fielded a side here in 2012. They won, but then they would, wouldn't they? Is it time for tea?

The girls of Penrhos School (*left*) walk over the cricket field during World War II. As a school for evacuees, Chatsworth boasted ample opportunity for country walks.

Chatsworth v Lord Hartington's XI, 1965 (*above*). Lord Hartington, who became the 12th Duke of Devonshire, is 6th from the right in the front row.

CHAPTER 21

THE MAZE

> THE CONSERVATORY LEFT A BIG PLOT TO BE TIDIED UP AND
> PLANNED ANEW. GRANNY EVIE PLANTED A DOUBLE ROW OF CRAB
> APPLES ON THE LAWN SURROUNDING THE WALLS IN THE 1920S.
> WE THOUGHT THEM OUT OF SCALE WITH THEIR SURROUNDINGS
> AND CUT THEM DOWN. IMAGINE MY FEELINGS WHEN
> THE MAN WIELDING THE AXE TOLD ME THAT IT WAS
> HE WHO PLANTED THEM THIRTY YEARS EARLIER.
> *The Garden at Chatsworth*, Deborah Devonshire, 1999

Professional gardeners tend to be a philosophical bunch. I suspect that the chap who felled Granny Evie's crab apples gave a shrug and did as he was bid by the new Duchess without much of a backward glance.

You can see Deborah Devonshire's point: the area occupied by the Great Conservatory is vast and something more in keeping with its scale was needed. The lawns surrounding it were left unadorned – a simple picture frame for the low walls that supported the structure, which were allowed to remain as a lasting memorial to its grandeur.

Within the confines of these walls – at either end – were planted-up beds and borders of flowers whose identities have changed over the years. The earth here has sustained Michaelmas daisies (late flowering and subject to frosts when just coming into bloom), lupins (bright but short-lived in early summer) and dahlias (again, good until the frosts) as well as a wide range of perennials, grasses, bulbs and half-hardies, bedded out each year after the last frost (rather more reliable and certainly more in tune with twenty-first-century gardening practices).

But what to do with the large central portion? In the early years of the twentieth century it was decided to construct two tennis courts, side by side. According to Duchess Deborah, her husband Andrew remembered changing into his white flannels in the dark recesses on either side of the entrance arches.

Alas, the fact that many of the heating pipes were subterranean meant that as they cracked, collapsed and perished the ground subsided, so the playing surface became ever more uneven, leading not only to frustrating tennis matches but also

The Maze in November (previous spread), seen from the Hundred Steps as the trees begin to shed their russet foliage across the valley in the Brownian parkland.

The flower beds at either end of the Maze (opposite) have hosted everything from dahlias and lupins to Michaelmas daisies over the years. Here they boast a mixture of sub-tropical plants in September.

CHATSWORTH

to the real possibility of injury – from sprained ankles to broken legs. The tennis courts were abandoned, then broken up, and in 1962 they were replaced with a maze.

One of the great delights in writing about a garden of national importance is that records are kept of progress and statistics. How else would we know that 1,209 English yews were needed to complete the design, or that the then Comptroller (financial controller), Denis Fisher, designed the pattern?

I suppose you need someone with that kind of mindset to work out the intricacies of a pattern every bit as complex as the columns in an account book – as Denis Fisher would have been used to doing in those days before computerisation. The labyrinth is sufficiently tantalising to offer a taxing puzzle to those who are brave or foolhardy enough to enter its portals.

At first the paths were made of grass, but they soon began to wear, and the more muddy they became, the easier it was to work out the way to the centre. The grass was eventually replaced with rammed hardcore topped by gravel, so that visitors' feet remained dry in wet weather (for which countless parents will have been grateful).

When you do get there you will find a tiered 'wedding cake' arrangement of dry stone walling built by Carl Hardman, Chairman of the Derbyshire Branch of the Dry Stone Walling Association. Carl's work is on view elsewhere in the garden and he comes here every year for the country fair, along with his DSWA members, to create a new feature alongside the River Derwent in front of an admiring audience. Once you reach the 'wedding cake', stop to admire the precise craftsmanship such a structure entails before you work out how to retrace your steps and get out again.

The yews were planted when they were 45cm high and they are clipped at a height of 2 metres – tall enough to prevent all but the loftiest of folk from seeing over them and divining a way to the centre.

While not all of Granny Evie's innovations have been banished, the crab apple trees have bitten the dust and the sixteen urns that decorated the corners of the Great Conservatory garden have been returned to the four turrets of the Belvedere at the north end of Wyatville's extension to the house. Duchess Evelyn's dislike of all things Victorian had led her to remove them and place

A bird's eye view of the Maze in June, with the sub-tropical beds to the right newly planted now that danger of frost is past. Memorise the pattern to find your way in – and out!

THE MAZE

them here where, presumably, she found them less offensive. (She might have loathed Victoriana but, like many of her generation, she could not bear to throw anything away.)

The gardener who was charged with chopping down Granny Evie's crab apples (I became so used to Debo talking about Granny Evie, it now seems overly formal to refer to her as 'Duchess Evelyn, wife of the 9th Duke', which I really should) personifies something that still pertains at Chatsworth to this day – members of staff who remain in post for a long time.

It is clear that the relationship between the family and those who work for them is highly prized on both sides. There is a genuine feeling of mutual loyalty, which can result in especially long years of service. I remember Debo telling me how, in 1963, Andrew gave a party for people who had worked on the Derbyshire estate for 25 years or more: 175 people came, of whom 52 had completed 40 years or more. This comforting tradition of long service continues – between 2000–2022, a total of 376 people completed ten years, 83 had clocked up 25 years and 25 members of staff had spent 40 years on the estate. Six had been employed here for 50 years. Some of the roles have changed significantly in that time, but staff loyalty remains at a remarkable level.

New enterprises have developed over the years, such as the Farmyard & Adventure Playground. The Farm Shop and Chatsworth Kitchen, at Peak Village in Rowsley, have supplemented the traditional ways of supporting an estate; and there are departments and roles that did not exist in the 1950s, including Health & Safety, Learning & Engagement, Sustainability and Nature Conservation.

Tourism is a sizeable proportion of national income now, and Chatsworth has responded, developing services to meet the requirements of visitors, including the Carriage House Restaurant, the Farm Shop Café, and all-important retail opportunities.

Duchess Evelyn (*opposite*), seen here in 1892 with the 9th Duke, Victor, loathed all things Victorian and banished the urns from Wyattville's Belvedere to the corners of the garden. They have since been returned to the house.

Two tennis courts were laid on the lawned area within the former Great Conservatory site. This image shows a Penrhos girls' match during World War Two (*right*).

At the opposite end of the Maze from the sub-tropical borders is a series of beds designed and planted by Tom Stuart-Smith (*above*), creating quite a different mood, here with *Eutrochium* and *Ligusticopsis wallichiana*.

Around the outer wall of the Maze (*opposite*), herbaceous peonies bloom in May and June. It is a relatively short season of flowering, but hugely spectacular.

Not surprisingly, the number of staff employed outdoors at Chatsworth has changed dramatically over the years. Granny Evie was once asked by a visitor, 'How many gardeners are necessary to keep the park so beautiful?' She replied: 'We used to have seventy but we now manage with forty. We have to be economical.'

Today there are fewer still full-time gardening staff, but they are augmented with around 80 volunteers who each contribute, on average, a day or half a day per week. The volunteers enjoy their engagement with a garden they love, and their service allows for a level of gardening excellence that would otherwise be extremely hard to achieve.

But that is the other thing about Chatsworth – the sense of ownership that the locals feel when it comes to their 'stately home'. Talk to the folk of Bakewell and Buxton, Chesterfield and Matlock, as well as the nearby villages of Rowsley, Edensor, Pilsley and Beeley and you will discover an enormous amount of pride in the 'Palace of the Peaks'. It is a focal point of their lives, not just because of its size and grandeur, but because of the jobs it supports, the events that it organises, the country pursuits that it champions, and the responsibility that everyone who lives and works on the estate feels they owe to the landscape.

Life itself is a bit of a maze for all of us, but there is no confusion when it comes to the aims of the Devonshires at Chatsworth: to be responsible custodians of this part of Derbyshire and to ensure that it is handed on in good heart to those who come after.

CHAPTER 22

ART EXHIBITIONS IN THE GARDENS

> I LIKE THE MORE ABSTRACT THINGS. I DON'T ALWAYS LIKE WHAT
> STOKER LIKES. I'M NOT SO KEEN ON HIS CERAMICS, FOR INSTANCE.
> Duchess Amanda, in conversation

This is borne out by the choice of artworks in the house – a Sean Scully abstract painting will hang close to an eighteenth-century swagger portrait by John Singer Sargent; a colourful sculpture by Michael Craig-Martin, or a landscape by David Hockney will be positioned opposite a Rembrandt. The tastes of the Duke and Duchess do not always differ – they both have a preference for contemporary rather than historic works, and they choose much of the artwork in both house and garden together, be it paintings, furniture or sculpture. The Duke's ceramics – modern pots by Japanese artists, by Edmund de Waal (author of *The Hare With Amber Eyes*), or the vibrantly coloured tulip-shaped vases by the Australian Pippin Drysdale – occupy many surfaces in the house, while larger sculptural works have a place in the garden.

What the current Duchess of Devonshire also likes are dogs; something that was clearly evident in the celebratory exhibition entitled *The Dog* at Chatsworth in 2019:

I have lived with and loved dogs for as long as I can remember; they are an integral part of my life. Every day I see the importance of dogs reflected on the walls of Chatsworth, in generations of family pictures and in the particularly rich collection of portraits of dogs who were much treasured. Wherever one looks dogs appear – in letters, jewellery, sculpture, ceramics, books, tapestries, drawings and on painted ceilings – there is such a long and enduring legacy of dog ownership in the Devonshire family.

A dog bed is tucked beneath a gilded William Kent side table in the dining room and its incumbents follow the Duchess around. At the time of writing, two Jack Russell terriers – Max and Quince – are seldom far from her heels.

The Dog exhibition was a huge success, and while most of the artworks were displayed in the house, the towering *Dog Scaffolding Sculpture* by Ben Long made a huge impact on the South Lawn.

Michael Craig-Martin's *High Heel (Pink)*, 2013 by the Grotto Pond, with Barry Flanagan's *Drummer*, 2004 in the distance – art works to surprise and to amuse are scattered throughout the garden.

CHATSWORTH

The Duchess's success as an owner of gundogs is well-known nationally as well as locally, something she shares with the late Queen Elizabeth II, so it is not surprising that Her Majesty came for lunch and paid a private visit to view the exhibition.

For thirteen years, beginning in 2006, Chatsworth hosted a series of exhibitions, in collaboration with the auction house Sotheby's, entitled *Beyond Limits*. Huge sculptures – many of them abstract in form – were positioned around the garden, set off – or certainly made to stand out – by their immediate surroundings. Twenty or so of these works of art made up each exhibition and they were offered for sale for to those whose tastes – and pockets – they suited.

Robert Indiana's now famous *LOVE* graced – or marred – the Cascade, depending on your point of view, and work by artists as diverse as Damien Hirst and Barry Flanagan would take visitors by surprise as they rounded a corner and came face to face with each dramatic work of art.

The inaugural *Beyond Limits* exhibition was not without controversy. Many visitors come to Chatsworth to enjoy what amounts to a calming oasis in an increasingly frenetic world. The imposition of some dramatic piece of modern sculpture on a verdant stretch of greensward, where once buttercups and daisies offered the only dramatic counterpoint, was quite literally shocking. The enjoyment of 'peace and quiet and open air' is not taken lightly by the Duke and Duchess, who recognise the value of Chatsworth's atmosphere to visitors in search of solace. But they also enjoy giving exposure to artists who seek to inspire and to enliven the landscape with their work. Balancing the two points of view has always been a challenge, but then, as the Duke says: 'Watching a grandchild explain to a grandparent about a sculpture, having been here on a school visit, is a great delight. I love it!'

What is irrefutable is the increase in visitor numbers during such exhibitions – up by 40,000 during the 2022 exhibition *Radical Horizons – The Art of Burning Man*. Entrance to this exhibition – arranged across the landscape and mostly shipped to the UK from Nevada's Black Rock Desert – was free, and I heard more than a handful of favourable comments from the locals and visitors from across the UK about the dramatic spectacle it offered.

ART EXHIBITIONS IN THE GARDENS

Chatsworth was one of the first private houses to host outdoor sculpture exhibitions. Now, those who are regular visitors and who might, in those early years, have been upset or annoyed by the imposition of 'a carbuncle on the face of a much-loved friend' will ask: 'What have you got for us this year?'

The current Duke and Duchess are not the first generation to have introduced contemporary sculpture to the landscape – that distinction belongs to the 11th Duke and Duchess who installed Dame Elisabeth Frink's *War Horse* at the southern end of the Canal Pond in 1991. I love this robust sculpture, but I always wondered why it had been positioned with its bottom towards the house. Perhaps it enjoyed the view out across the landscape. Now it has been moved and resides, rather fittingly, in the quadrangle of the Stables.

This love of contemporary art and sculpture shared by the 12th Duke and Duchess had its beginnings early on in their lives. The Duke says:

Amanda's mum had a very contemporary home with stark walls painted black and white, very modern furniture and paintings by Francis Bacon. I'd never been in a sitting room without a fireplace before.

When I was younger, Lucian Freud was coming to stay at Chatsworth but we had friends who hated his work. Both Amanda and I woke up to contemporary art at around the same time. Although our tastes sometimes differ, we often share a love of a particular object or painting.

Back in the nineteenth century, when the Bachelor Duke employed Sir Jeffry Wyatville and Sir Joseph Paxton to make their own architectural and artistic marks on the garden and the landscape, there would doubtless have been detractors who were appalled at their temerity on messing with the *status quo*. That these sentiments are still expressed on occasion today, reminds us that only by pushing the boundaries can we enhance our experience of art in the landscape. Some installations will be more felicitous than others, but until we experiment with them, how will we know? And the nature of landscape is often forgiving.

CHAPTER 23

SCULPTURE

> WHEN YOU ARE AT CHATSWORTH TRY COUNTING THE URNS.
> Sir John Betjeman, quoted by Deborah Devonshire in *The Garden at Chatsworth*, 1999

There are a lot of urns at Chatsworth, and those on the roof of the house had their finials gilded during 2018's major refurbishment. Dating from the eighteenth century, they now sparkle in the sunlight, as befits a house of such grandeur and elegance.

Contemporary sculpture is the predilection of the current Duke and Duchess, while more classical tastes were enjoyed by their predecessors. That said, when Bess of Hardwick presided over her newly built Hardwick Hall in 1597, she had the parapets of the house decorated with her initials – 'ES' for Elizabeth Shrewsbury. They remain on that house today as a reminder of her local omnipotence. At Chatsworth, Queen Mary's Bower, a portion of balustrade on the west terrace and the Hunting Tower are her legacy, but subsequent occupants of the house have left their mark over the centuries when it comes to sculpture as well as architecture.

Indoors, the Sculpture Gallery features the work of that Italian neoclassical master Antonio Canova, including one of his greatest works, *The Sleeping Endymion*. Touring Italy in 1819, the 6th Duke visited Canova's studio in Rome and was so entranced by what he saw that over the next few years he acquired many of the sculptor's finest works and brought them back to Chatsworth. The two became firm friends. Canova was, wrote the Duke, 'The most talented, the most simple, and most noble-minded of mankind.' To Canova, the Duke was '*gentile, generosita dell' animo*'. Chatsworth also has a framed exhibit of a few of Canova's tools, given to the Bachelor Duke by Lady Abercorn when she visited the sculptor's studio shortly after his death in 1822; a gesture which must have delighted the Duke.

It would not be the last time that an artist's equipment was treasured at Chatsworth. Lucian Freud left a box of paints and brushes behind, having painted some cyclamen on the wall of one of the bathrooms in 1959.

Canova's monumental works in shimmering marble are on view in the Sculpture Gallery today. (Nearby, you will also find a more recent bust of

Classical statues in the Rose Garden (*previous spread*), collected by earlier Dukes of Devonshire, act as focal points at the ends of paths and vistas.

There is something innately pleasing about the juxtaposition of a formal classical urn (*opposite*) with the relaxed feel of cornfield wild flowers.

CHATSWORTH

Fitzwilliam Darcy, used in the 2005 film of *Pride and Prejudice*. Matthew Macfadyen was the model, and for £75 you can buy a small copy to take home. My wife has so far restrained herself.)

In the garden, classical sculptures vie with contemporary works of art for your attention. It is no idle boast to say that there will be something to suit all tastes.

As well as being the focus of a temporary exhibition in 2012, Barry Flanagan, the man who sculpted hares, has several sculptures at Chatsworth that always fill me with joy. His *Leaping Hare on Curly Bell* resides in the Inner Court and can be viewed from the windows of the house by visitors as they walk round. Another – *Drummer, 2004* – can be found north of the Grotto Pond. Flanagan is an artist admired by both the Duke and the Duchess, as the Duke confesses in the handbook *Director's Choice: Chatsworth*. The *Drummer, 2004* was a memorable purchase:

In 2004 I sold a two-year-old thoroughbred colt for what, for me, was a great deal of money. As this was a windfall, I had no hesitation in reinvesting part of it in this sculpture. Amanda loved the piece, and we knew we wanted it at Chatsworth.

Like me, Flanagan's hares lift the Duke's spirits:

I smile every time I see it, and it reminds me how lucky we are to live at Chatsworth and how even luckier we are to have been able to acquire new things to go with the myriad old things.

The 'old things' are too numerous to mention in detail. Like Sir John Betjeman's urns, statues gaze coyly or impassively atop columns and plinths. A bust of the Bachelor Duke (he, more than anyone, must feature somewhere) sits at the top of a column he acquired from the Temple of Poseidon at Cape Sounion in Greece. From that vantage point he gazes down the full length of the Serpentine Hedge, looking favourably, one hopes, upon the work of his successors.

Carl Hardman, the skilful dry stone waller who built the 'wedding cake' in the centre of the Maze (see page 232), has created *Wedgwood: Emergence* (so called as it was created for RHS Chatsworth and sponsored by Wedgwood) – a sinuous dry stone wall installation in the Arboretum whose limestone and

Drummer, 2004 by Barry Flanagan (1941–2009) is one of a number of his 'hare' statues positioned throughout the garden. Each one raises a smile.

sandstone sections are divided in two by a massive shard of plate glass. Laura Ellen Bacon is a wizard with woven willow. Her creations appear from time to time, wrapped around tree trunks or slithering along walls and over buildings.

Along with her love of dogs, Amanda Devonshire is a passionate horsewoman, which explains – if explanation were necessary – why the work of one of this country's finest equestrian sculptors – Nic Fiddian-Green – has prime position at the end of the Canal Pond. Originally inspired by the Parthenon Frieze, Nic has gone on to create a series of exquisite and powerful sculptures of horses and horse's heads. You might have seen the monumental one at the top of Park Lane in London. The head at Chatsworth is awesome and perfectly positioned.

An earlier example of an equine statue is that of Dame Elisabeth Frink's *War Horse*, acquired by Duchess Deborah in 1991 and now situated in the stable yard. It is positioned to gaze wistfully through the archway at the landscape and green fields beyond the river.

Mozart wrote his *Musical Joke* in 1787. Chatsworth had its own watery joke almost a century earlier, when Mr Ibeck was responsible for the creation of the Willow Tree Fountain in 1695. A year later the intrepid Celia Fiennes, a single woman who travelled around England on horseback, visited Chatsworth and wrote:

… all of a sudden by turning a sluice it raines from each leafe and from the branches like a shower, it being made of brass and pipes to each leafe but in appearance is exactly like willow.

It still does, though the current tree, which stands on the northern edge of the Rock Garden, replaced the original in the nineteenth century, having been made for the 6th Duke by a Mr Bower of Chesterfield. It still surprises unsuspecting visitors and delighted the thirteen-year-old Princess Victoria when she visited Chatsworth in 1832. She called it the 'squirting tree'. At least one instance when the future Queen Victoria *was* amused.

The 6th Duke – the Bachelor Duke, in a drawing by Bathe – was an inveterate collector who was responsible for most of Chatsworth's neoclassical sculpture collection.

Of one thing you can be certain; each season at Chatsworth will bring refreshing changes to the landscape: not just in the form of new plantings, but also in artistic acquisitions. As the 12th Duke and Duchess move out of the main house to make way for Lord Burlington and his family, there will be opportunities for a new generation to make their artistic mark on Chatsworth's garden and estate. What are their tastes? Only time will tell, but the locals will be looking on with interest …

This photograph of 1899 shows the Willow Tree Fountain, which surprised and delighted many visitors, including Celia Fiennes.

CHATSWORTH

Walking Madonna (right) by Dame Elisabeth Frink (1930–1993) who was a great friend of Debo for many years, until her untimely death.

Sir Richard Long's linear sculpture *Cornwall Slate Line* (opposite), dating from 1990, runs parallel to the Canal Pond.

CHAPTER 24

SHOWS AND FAIRS

IT'S LIFE-CHANGING.
A prominent London lawyer, having watched the ferret racing
at Chatsworth Country Fair

On 1 April 1949, the 6th Marquis of Bath threw open his doors at Longleat in Wiltshire to the public. It was, he claimed, 'The first house ever to be opened to the public on a thorough-going commercial basis.' Seventeen years later, in 1966, he would go even further down the road of commercialisation and open 'the first drive-through safari park outside Africa'. Now families could motor through the British countryside and gaze from the windows of their Austin 1100 (the most popular family car of the time) on the 'lions of Longleat'. Almost half a million visitors came during that first year, contributing enormously to the Marquis' coffers and consequently to the upkeep of an Elizabethan palace.

Following the Second World War, those grand country houses that had survived the privations of the last six years, and the consequent loss of staff, had another battle on their hands and a simple question to answer: how could they afford to survive? Opening to the public was the obvious way of garnering revenue, but simply inviting people into the house was unlikely to prove a long-term solution. Britain's stately homes looked for other more durable ways to make themselves attractive to the visiting public and to keep them coming back – with everything from safari parks and elaborate aviaries, to funfairs and adventure playgrounds.

Chatsworth was no exception, and following punitive death duties levied on the sudden demise of the 10th Duke of Devonshire in 1950 (which took more than twenty years to pay off and resulted, among other things, in the handing over of Hardwick Hall to the National Trust) the 11th Duke of Devonshire needed to create a variety of income streams to make ends meet and to maintain the fabric and the estate of a large and important house that was, in this part of Derbyshire, one of the largest local employers.

Andrew and Deborah Devonshire knuckled down and over the course of the next fifty years turned the Chatsworth Estate into a healthy going concern. It took innovation and determination, inspiration and perspiration.

Christmas at Chatsworth is celebrated not only in the house, but also outdoors. Here Wyatville's North Entrance arch positively sparkles at twilight.

It involved the creation of a farm shop, of tasteful merchandising, attractive exhibitions and a host of other initiatives, many of which took place in the gardens and on the estate, whose beauty and ease of access were great assets.

It comes as a relief to those who regard the commercialisation of a country estate as a necessary evil, to observe how the Devonshires have managed things. Not for them the safari park or the funfair – aside from that which pops up annually for a single weekend when the country fair is in full swing. Instead, they have concentrated on events that either form an intrinsic part of the countryside, or offer only a temporary transformation of the landscape. As the 12th Duke puts it:

You can't muck up the countryside for too long. If there are too many events, with marquees and roadways that scar the landscape, then the very things which we and the locals cherish the most – the views and the peacefulness of the gardens and the riverside – are sacrificed.

So it is that the calendar of events at Chatsworth (which closes its doors and the gates to its gardens only between the months of January and March) are carefully arranged, so that for the majority of the time the estate can show off its beauty untrammelled by too much in the way of tentage and all-weather roadways.

A series of talks, tours and workshops runs through the first three months of the year; offering small groups the opportunity for behind-the-scenes access to parts of the house and garden for sketching and painting, guided walks in the

The Country Fair at the beginning of September (*above*) is a lively celebration of all things rural, from ferrets and fly fishing to vintage cars and lurcher racing.

Early in the morning at the Country Fair, hot-air balloons take to the skies (*left*) offering glorious views of the 'Palace of the Peaks' and its surrounding countryside.

Members of the Derbyshire DSWA at the Country Fair (*opposite*). Their final creation usually stays in place until the following year's event.

SHOWS AND FAIRS

park and Stand Wood, rural craft courses from wreath-making and willow weaving to dry stone walling, and illustrated talks on recent developments in the garden or house. The visitor season begins in March with a preview day for the Friends of Chatsworth, then the house, garden, Farmyard and Adventure Playground re-open for all.

The events programme encompasses a variety of attractions suitable for a country estate in the heart of the British countryside: including the annual International Horse Trials and the Chatsworth Country Fair; outdoor theatre and cinema in the garden; bonfire and fireworks in November; a myriad of workshops and walks for children and the not-so-young; and Christmas festivities from November to early January. In addition, there are classic car rallies; pony club meets and gundog trials; a small number of charity fund-raising walks, runs and rides; the Derbyshire Charity Clay Shoot; as well as amateur dramatic performances in the theatre and charity concerts and receptions in the Carriage House.

Many of these events last a single day, others a maximum of three days, with only the Christmas Market and garden illuminations being on site for longer. They occupy a total of around sixty days of the year, only about a third of which fall between the months of June and August, when the majority of visitors will come to enjoy the gardens and estate for their intrinsic beauty. They will not be distracted by acres of canvas and metal tracks.

The Horse Trials in May attract a loyal following and, along with events such as the National Fox Terrier meet in July, they contribute to Chatsworth's devotion and championing of country pursuits along with the horse and the dog, two of Amanda Devonshire's abiding passions.

The first Country Fair was held on two days in 1981 when 50,000 visitors flocked to the park. Now spread over three days, around 70,000 come to enjoy

everything from gun-dog trials and lurcher racing to archery and clay pigeon shooting, ferret racing and displays of vintage cars and commercial vehicles. There are 100 food outlets and 350 trade stands, and a central arena that offers everything from dare-devil motor cyclists to the King's Troop Royal Horse Artillery or the Musical Ride of the Household Cavalry, along with birds of prey demonstrations and the Pony Club Mounted Games. There are displays of dry stone walling and stick making, and cooks and chefs like Dame Mary Berry and James Martin will hold audiences enthralled with their presentations which – in a live setting – are even more amusing than they are on television. As 'a day out for the whole family' it has few rivals and the setting – to the north and west of the house, running down to the river – makes it especially enjoyable.

As winter approaches, so the Christmas Market appears with those timber chalets we have all become used to in towns and cities across the land. They may have started life in Germany, but they are now as frequent in the UK as they are in Bavaria, selling their glühwein and stollen, their Christmas decorations and their festive stocking fillers.

It is now that the house will be decorated for the festive season – an annual tradition since 2001 that has a new theme each year, but which never fails to impress the visitors. Chatsworth is a beautiful house at the best of times, and when the artistic flair of the Yuletide decorators comes into play it is nothing less than entrancing.

The garden, too, has an illuminated route where visitors can admire the grandeur of the trees, the electric 'fireflies' that seem to glitter along the Bamboo Walk and the Rock Garden that, by night, is every bit as magical as something from *Harry Potter* – its sheer rock faces and waterfalls shimmering in the floodlights.

When the Christmas festivities draw to a close, so the house, the garden – and their residents and staff – have a couple of months to catch their breath and get ready for the spring opening. Winter offers a chance to get ahead with pruning and the repairing of pathways, with the cutting back of perennials and the manuring and mulching of beds and borders in the Kitchen and Cutting Garden.

There are Muscat grapevines to be pruned and the entire garden and estate to be readied for another season of visitors.

 I suspect the gardeners and the landscape team rather like the winter months. It might be cold or it might be wet, but they can enjoy their surroundings and have a moment to themselves. There's time to watch the icicles that form on the rocks beside the stream; time to get on with a job without interruption. Oh, they will always be polite, but as everyone connected to the land knows, there is something very special about having it all to yourself.

Hundreds of Christmas lights decorate the Cascade, each waterfall shimmering and the Cascade House glowing against the darkened trees.

CHAPTER 25

THE KITCHEN AND CUTTING GARDEN

According to the 1905 list of greenhouses, the Kitchen Garden must have been more like a glass village than the accepted idea for such a piece of ground with a few rows of vegetables and soft fruit. Thirty-three glazed buildings were described separately as 'fruit' and 'plants', plus the Lily House, a propagating house and thirteen others all covering 30,239 square feet, or just under seven tenths of an acre.

The Garden at Chatsworth, Deborah Devonshire, 1999

At the turn of the century this 'glass village' as Duchess Deborah describes it, would have had no shortage of gardening staff to keep it in shape, but during the two World Wars that followed, things changed. Staff numbers were drastically reduced and economies needed to be made, not only in terms of overall finance, but also in manpower, so this area (near Paxton's former house at Barbrook), was abandoned for growing. However, during the Second World War, paddocks near the Stables, originally grazing for the horses, were used as allotments – part of the 'Dig for Victory' campaign – and in the early 1990s, this whole area, some 2.5 acres, was formally laid out as a new kitchen garden.

It was Deborah Devonshire who initiated the return of the earth to growing fruit and vegetables: 'There were three reasons why I yearned to grow vegetables. Greed was one. Another was for their own intrinsic beauty and the third was to make something out of nearly nothing.' In the early 1990s, along with her then Head Gardener Jim Link, that is exactly what Debo did.

The site slopes to the west and as such is a good place to grow fruit and vegetables – cold air will run down the valley rather than accumulating and creating a frost pocket, and land that slopes to the west or the south is always, by virtue of its orientation and the path of the sun, warmer than land that slopes to the east or the north.

Four glasshouses, side by side, run north–south on the northern side of the garden. They were built by the long-established firm of Foster and Pearson in 1910, and, like so many glasshouses of the time, they have timber roofs and brick-built sides – a combination that ensures good light penetration as well as

The Kitchen and Cutting Garden (previous spread) at the height of its productivity in July, on the rising ground behind the clock tower of James Paine's stable block.

Dahlias and cosmos for cutting grow alongside vegetables and fruits (opposite) – including pears trained over archways for dramatic effect.

CHATSWORTH

effective insulation. They would originally have been built as 'forcing houses', to bring on early crops such as tomatoes, cucumbers and melons. Today they allow for propagation and the growing on of tender subjects, as well as growing flowers for cutting in the raised beds, whose sides are around 45cm high and built of brick and stone. The earth within them is as rich as you would expect in a garden that has no shortage of compost-making facilities.

These greenhouses take me back to my apprenticeship in a parks department nursery during the 1960s when, to my astonishment, I was given three of them – Victorian in origin – to look after. Until then, all my greenhouse gardening had been undertaken in our Yorkshire back garden in small structures made from scrap timber (my dad worked for a plumbing and carpentry firm) and polythene. On my first day at work, having been led into the first of the trio of glasshouses that were joined to one another and told 'these are yours', I thought I had died and gone to heaven. There is still a great deal of romance, for me, in Victorian greenhouses, with their brass doorknobs and water tanks sunk into the earth below the staging and fed by downpipes linked to the gutters. As you enter these venerable structures, notice the cathedral-like atmosphere: the silence broken only by the gentle drip-drip of water from the gravel-covered staging into the sunken reservoirs below.

There is one difference between the glasshouses at Chatsworth and the ones in which I underwent my apprenticeship: the finials on the Chatsworth glasshouses are gilded. Says the Duke: 'I didn't feel I could gild the finials on the urns of the house without giving the gardeners a bit of their own.' He smiles and adds: 'I like a bit of bling.'

A great range of flowers, fruits and vegetables grow inside the greenhouses, and one of them is home to a family of elegantly leggy cats – good mousers all, and happy to sneak inside through their own little tunnel when the weather turns foul.

Within the well-manured beds of the garden grow a wide range of vegetables for the house and the restaurant. This is no purely decorative addition to the Chatsworth Estate – it pulls its weight in terms of economy, but it is still a kitchen gardener's dream – partially walled and beautifully maintained.

Venerable glasshouses from the early 1900s have their own embellishment of gilded finials – the Duke not wanting to deprive his gardeners of their own bit of 'bling'.

THE KITCHEN AND CUTTING GARDEN

As I walk round on a grey January day, one of the gardeners is hard-pruning an apple tree in the centre of a bed, 'If it gets too large it casts too much shade,' he says, by way of defence, while another is adding manure to enrich the earth where beetroot and potatoes, squashes and salad crops, onions and celery will grow. Edible flowers such as borage, violas and nasturtiums are added to the mix, along with herbs like French tarragon, lemon verbena and numerous varieties of mint. I pass a row of terracotta seakale forcing pots, mounded up with well-rotted manure – 'Amanda loves seakale,' murmurs the Duke. I am less sure that he loves it himself.

In a raised bed alongside one of the greenhouses, and across the way against another small brick wall, grow lusty blueberry bushes – several dozen of them. There are figs planted here as well as the more customary apples, pears and plums.

Produce is delivered fresh to the house and the restaurant in the stables, but crops are also grown for making beers, spirits, chutneys and candles, all of which are offered for sale to visitors.

Due to its close proximity to the Stick Yard (see page 270) the Kitchen and Cutting Garden is also used by the Learning and Engagement Team, whose groups find its contents well-suited to understanding not only where food comes from, but also of its health benefits – both mental and physical – when it is home-grown.

I can think of no finer sight in summer than a well-tended kitchen garden. Is it a male thing, do you think, this pleasure derived from seeing healthy crops growing in well-ordered rows? The froth of carrot foliage contrasting with the spiky uniformity of onion leaves; the elephantine leaves of Savoy cabbages opening their vast rosettes, alongside the neatly mounded earth of the far-reaching rows of potatoes. Pea vines scramble up linear forests of twiggy pea sticks, and scarlet runners dangle their pods from tent-like rows of beanpoles. It is all so fecund and so promising; who would not feel better for a walk among plants that sustain us, body and soul, and repay our ministrations with nourishment? That's how it always strikes me at any rate.

Picturesque though the garden is – and delightful to walk through when it is

Even in the Kitchen and Cutting Garden, moss-covered dry stone walls and views of the distant rolling dales make sure there is no mistaking the fact that you are in Derbyshire.

CHATSWORTH

at the height of its productive powers from May through to September – there is one ugly building in the southwestern corner. It was built in the late 1960s, originally as a boiler house, and remains in situ, in spite of its ugliness. Its walls are of corrugated steel – not so sympathetic to the eye as the 'corrugated iron' of the late-nineteenth and early-twentieth centuries, which now has a kind of rustic charm. How long it will survive I know not, but as the 12th Duke remarks: 'My mother said it should stay simply to remind us of the follies of 1960s architecture.' That it most certainly does.

Turn away from it and enjoy instead the intrinsic beauty of the well-ordered rows of fruit and vegetable crops. And do try – as you marvel at the sight of a gloriously Beatrix-Potter-cum-Peter-Rabbit style kitchen garden – not to turn green with envy.

The Cutting Garden

Around a third of the Kitchen Garden is devoted to growing flowers and foliage that can be used by Chatsworth's floristry team. Inside the building just across from the ugly 1960s barn, they create arrangements for the various rooms of the house, putting together collections of plants in bowls, making floral displays and bouquets for the farm shop and for weddings and events. This additional income stream is useful, but so too is the skill of the florists in keeping the house well dressed with fresh flowers and plants that remind visitors of the benefits of bringing the outside in.

Flowers for cutting are grown right through the year, from the daffodils, narcissi and tulips of spring, through summer-flowering perennials to the dahlias of high summer and the chrysanthemums of autumn.

Cut flowers in the house reflect the changing seasons and are a reminder of the pleasures of gardening in a cool, temperate climate, where seasonality ensures that the displays are ever-changing.

The Cutting Garden in July forms part of the Kitchen Garden, and provides cut flowers and foliage for the floristry team throughout much of the year.

THE KITCHEN AND CUTTING GARDEN

Even in autumn (*opposite and left*) the Kitchen and Cutting Garden offers flowers for cutting – whether they are seedheads or the branching purple candelabra of *Verbena bonariensis*.

CHAPTER 26

THE LEARNING CENTRE

> What's really great about it is that it's inter-generational — we have grandparents as well as small children.
> Gill Hart, Chatsworth's Head of Learning and Engagement

The 'Stick Yard' they call it. Go there and you will discover a strange open-sided building with a fenced off area at its core. Within that enclosure is the old water-powered saw from the 1880s that was used in former times to cut up timber – with estate staff making sticks to keep the 170 fireplaces at Chatsworth fuelled. Today it is one of two areas within the gardens that have been given over to education and learning, and the increasing numbers of participants each year is proof of its value to local communities.

I have, if not a vested interest, then a sense of proprietorial pride in those parts of Chatsworth that are devoted to 'outreach' – a rather clumsy word, but admittedly more concise than 'spreading the word'. On 5 April 2005, at the invitation of Deborah Devonshire, I opened the Oak Barn in the Farmyard – a learning hub intended to give local schoolchildren in particular an understanding of how man, land and animals can work together. The Oak Barn still flourishes, as do the 'Stick Yard' – developed in 2015 – and its companion venue 'The Old Potting Shed', which has been up and running since it was opened by the Princess Royal in 2018.

The Old Potting Shed is a flexible space, that looks like a state of the art conference suite that can be adapted for art classes for schools and for adults. It can even be turned into a theatre space for up to sixty people. Here you can learn to 'draw from nature' as well as enjoy the intricacies of print making.

Not only do schoolchildren benefit from the study of nature in both the Stick Yard and The Old Potting Shed, but teachers, too, find this a conducive venue for what is now known as 'Continuing Professional Development', or CPD if you are a fan of acronyms.

It is vital that we get across to teachers and those who devise the National Curriculum not only the importance of the great outdoors in all our lives, but the need to imbue succeeding generations with an understanding of how it works. Only then will we foster a true love of nature and a willingness to participate in the future of our landscape and the forms of life that depend upon it.

THE LEARNING CENTRE

Gill agrees:

Teachers like to know that our workshops link with the National Curriculum and a visit will support class work. It's hard to get out of school, so we offer short CPD courses in local schools from 3.30 to 5pm. We do this to encourage teachers to come here though – and they love it. Chatsworth is known as a visitor attraction but not necessarily as a learning destination. This outreach has really helped.

The Chatsworth Learning and Engagement Team works closely with the Peak District National Park and also partners with the University of Derby to identify communities that would benefit from such outreach, many that are, for one reason or another, hidden from view.

These learning spaces serve different audiences with a range of needs: from teachers who meet their incoming pupils here before they start secondary school; to families who enjoy autism-friendly workshops; to art and nature experiences for people with dementia.

'Chicks in Schools' involved sending young chicks to schools where pupils would monitor their development – linking together maths, science and animal welfare. The early years gardening club – 'Little Pips' – for children aged between two and five years has been regularly oversubscribed.

Gill and her team have discovered that they can help support schools with an understanding of how nature works. Their dedication to 'environmental literacy' and 'nature connectedness' is plain to see, and over the years to come their great zeal will ensure that more and more children and adults, pupils and teachers, discover, through learning at Chatsworth, a greater understanding and love of nature that will stand them, and the planet, in good stead through the coming generations. Their noble endeavours deserve everyone's support.

The Old Potting Shed is now a part of Chatsworth's well-used Learning Centre, offering a range of facilities and classes to teachers, adults and children.

CHAPTER 27

THE TWENTY-FIRST CENTURY

I AM GRATIFIED BY YOUR WISH OF KNOWING SOMETHING
ABOUT CHATSWORTH – AS IT IS IN MY OCCUPATION,
AND AS IT WAS IN MY RECOLLECTIONS.
The 6th Duke of Devonshire to Countess Granville in his
Handbook of Chatsworth, 1844–5

The subtitle of this book about Chatsworth – *The Gardens and the People Who Made Them* – demonstrates that gardens are dependent upon people, not only for their creation, but also for their continued welfare and development. The requirements and predilections of civilisation change over the centuries when it comes to the landscape that surrounds their dwellings, but never in the history of mankind have they changed so rapidly or dramatically as in the last century.

When Bess of Hardwick chose this part of Derbyshire in which to sink the roots of the Cavendish family in 1549, she could have had no inkling as to how, almost five hundred years later, the world would have changed. She might have been comforted by the fact that the landscape in this part of the Derwent Valley has never been in better heart. She would still recognise the hills and the valleys. She may even have enjoyed the shade provided by some of the oak trees that tower above the parkland today, or gazed from her Hunting Tower with a nod of approval. Other aspects of civilisation would have been less comforting. The relative speed of change would have astonished her.

Out of the knots and parterres of Elizabethan England grew the formal French- and Dutch-influenced gardens of the seventeenth century. These were swept away and replaced by the Arcadian landscapes of the eighteenth and early nineteenth centuries, which were easier on the eye and certainly less demanding of labour.

The Victorian era saw not only an influx of plant material from all over the globe, but also advances in engineering that would keep tropical specimens alive in heated palaces of glass – ensuring their survival in the British winter.

In 1750, Britain had a population of seven million – 90 per cent of whom lived in the countryside and worked on the land. That would change over the next 100 years with the Industrial Revolution, but labour would remain cheap

The late afternoon sunshine highlights the recently completed restoration work, undertaken to safeguard the fabric of 'The House' for the next century.

CHATSWORTH

and plentiful. Then as the twentieth century dawned, two World Wars would wreak havoc with the nation's equilibrium and 90 per cent of the population would gravitate to towns and cities, factories and workshops, soon-to-be depleted themselves, as advances in technology sent workers in search of a more comfortable life in offices.

The 'White Heat of Technology' referred to by Prime Minister Harold Wilson in his speech of 1963 was, on reflection, lukewarm compared with what would happen in the twenty-first century, when every single life would not only involve 'high tech' but become entirely dependent upon it.

And while all this was going on, the countryside – the hills and the dales of Yorkshire and Derbyshire, the moors of Scotland and Wales, the lakes of Cumberland and Westmorland, the rugged coastline of Cornwall – would remain as a constant reminder of a heritage that seemed not nearly so evanescent as the whims and fancies of twenty-first-century generations who had taken them for granted.

Then came the awareness of global warming and climate change – a wake-up call that galvanised a younger generation who criticised their forebears for forgetting about the really important things in life: the seeming constants of sea and sky, hill and dale, mountain and coastline, which, in reality, could only survive long-term if man's deleterious influence on the environment was acknowledged and curtailed.

All the while, those who loved and cared about the natural world were doing their bit as custodians of those small pieces of landscape we call gardens: tiny patches outside cottages and terraced houses; half an acre around a detached villa. Smallholdings and wildflower meadows gained traction. On larger country estates, new ways were being found to cherish the landscape and remember the vital part it plays in health, not only of the land itself, but of those who are its custodians. Looking after a piece of earth – however small – nourishes us both physically and mentally; a fact that was brought home to us during the Covid pandemic of the 2020s.

If clouds have silver linings, then perhaps the silver lining of the pervasive Coronavirus was the wake-up call that reminded us not to squander our natural

THE TWENTY-FIRST CENTURY

resources, but to cherish them. It is not enough to rant and protest and march against the warming of the planet; we must all become involved – on our own patches of earth – to make a difference. The single bee that visits the flower in your window box matters every bit as much as all the other bees that hopefully someone else is looking after. If we all do our bit, we *can* make a difference.

Grand houses and estates like Chatsworth had for centuries stood proud in the landscape as beacons of power and achievement. They were local employers – hopefully benevolent and caring about the local population, but a constant reminder of who was the boss. By the twentieth century that power and influence had been heavily eroded, and in order to justify their existence the owners and chatelaines of such estates had to adjust not only their way of thinking, but also their way of managing their house and their land.

Thankfully, in most cases, the adjustments were not cynical manoeuvres but a real and genuine awakening. *Noblesse oblige*, it used to be called: 'nobility has its obligations'. Duke and marquis, earl and viscount needed to look hard at the way in which their estates were managed, both to survive and to engage responsibly with current accepted methods of land management. To those who really did care about the landscape in their charge, this new state of affairs presented a challenge that had to be risen to for all the right reasons.

The Chatsworth Estate is a shining example of successful and responsible twenty-first-century land management. It also recognises the need to spread the word; to demonstrate the vital importance of the British countryside and its contribution to our very survival. Whether you are at the Learning Centre or the Country Fair, walking through Arcadia or sauntering down the azalea-filled Ravine, simply being here demonstrates that moving with the times need not mean neglecting all that went before. Far from it: we can learn by experience what matters, and ensure that, with an eye to the future, we do not make the mistakes we made in the past. There are also times when we can learn from our forebears.

While the majestic man-made features of Chatsworth are impressive, just as much effort goes into the estate's responsibility to the natural world – something that applies to both the wider landscape and to the cultivation of pollen- and nectar-rich flowers which ensure the wellbeing of butterflies and other insect life. Here, a small tortoiseshell butterfly drinks nectar from the dahlia 'Happy Single Juliet'.

CHATSWORTH

To the southern end of the West Garden at Chatsworth, the water from the moorland tarns is not visible, but it nevertheless undertakes an important role. In 1893, turbines were installed below the house where the power of the water flow could be harnessed to generate electricity. By 1936 the National Grid was a more tempting prospect, and the turbines were pensioned off. Fifty years later, thanks to unsurprisingly eye-watering electricity bills in a house with 300 rooms, the turbines were recommissioned and now – when the rainfall is of sufficient volume – they augment the mains supply. Sometimes we neglect the technology of previous generations at our peril.

At Chatsworth, both inside the house and outside in the garden and on the estate, endeavours continue to ensure the sustainability of the landscape. Biomass boilers provide the heating, plastics are avoided wherever possible, water is conserved and resources are not squandered.

New plantations are constantly being established, and the garden and landscape are being nourished in ways that enhance the environment rather than deplete it.

Underlying all this is the determination of each generation of the Devonshires to hand on this estate in even better heart than it was when they became its custodians. From Bess of Hardwick to the ambitious 1st Duke of Devonshire; from the 4th Duke and Lancelot 'Capability' Brown, to the Bachelor Duke and the indefatigable Sir Joseph Paxton. From Andrew and Deborah Devonshire, who inherited an estate that was on its knees and who ensured its survival when all seemed lost, to the 12th Duke and Duchess, Stoker and Amanda Devonshire, who have held the reins since 2004. Their tenure has burnished Chatsworth's reputation and guided it securely through the first quarter of the challenging twenty-first century, embracing change and responding to modern demands without squandering the legacy of their forebears. The Chatsworth Estate, its house and garden, will be handed on to William and Laura Burlington as a vibrant, environmentally responsible and joyous concern. I wish them the very best of good fortune. Good luck to them and the glorious Palace of the Peaks.

Chatsworth bathed in warm early evening light – and seen across the wild-flower-rich meadow: a salutary reminder of the importance of a sympathetic relationship between man and nature.

CHATSWORTH
THE CAVENDISH FAMILY FROM BESS TO STOKER

Bess of Hardwick,
c. 1527–1608

Sir William Cavendish,
1508–1557

1st Earl of Devonshire,
William Cavendish, 1551–1626

Anne Keighley,
d. 1625

2nd Earl of Devonshire,
William Cavendish, 1590–1628

Hon. Christian Bruce,
1595–1675

3rd Earl of Devonshire,
William Cavendish, 1617–1684

Lady Elizabeth Cecil,
1619–1689

4th Earl and 1st Duke of Devonshire, William Cavendish,
1641–1707

Lady Mary Butler,
1646–1710

2nd Duke of Devonshire,
William Cavendish, c. 1672–1729

Hon. Rachel Russell,
1674–1725

THE CAVENDISH FAMILY: FROM BESS TO STOKER

3rd Duke of Devonshire, William Cavendish, 1698–1755

Catherine Hoskins, c. 1700-1777

4th Duke of Devonshire, William Cavendish, 1720–1764

Lady Charlotte Boyle, 1731–1754

5th Duke of Devonshire, William Cavendish, 1748–1811

Lady Georgiana Spencer, 1757–1806

Lady Elizabeth Foster, 1757–1824

6th Duke of Devonshire, William Spencer Cavendish, 1790–1858

7th Duke of Devonshire, William Cavendish, 1808–1891

Lady Blanche Howard, 1812–1840

8th Duke of Devonshire, Spencer Compton Cavendish, 1833–1908

Louise von Alten, 1832–1911

CHATSWORTH

9th Duke of Devonshire,
Victor Cavendish, 1868–1938

Lady Evelyn Fitzmaurice,
1870–1960

10th Duke of Devonshire,
Edward Cavendish, 1895–1950

Lady Mary Cecil,
1895–1988

11th Duke of Devonshire,
Andrew Cavendish, 1920–2004

Hon. Deborah Mitford,
1920–2014

12th Duke of Devonshire,
Peregrine 'Stoker' Cavendish,
b. 1944

Amanda Heywood-Lonsdale,
b. 1944

THE FAMILY TREE

1508–1557 Sir William Cavendish = Bess of Hardwick *c.* 1527–1608

1551–1626 William Cavendish = Anne Keighley *d.* 1625
1st Earl of Devonshire

1590–1628 William Cavendish = Hon. Christian Bruce 1595–1675
2nd Earl of Devonshire

1617–1684 William Cavendish = Lady Elizabeth Cecil 1619–1689
3rd Earl of Devonshire

1641–1707 William Cavendish = Lady Mary Butler 1646–1710
4th Earl and
1st Duke of Devonshire

c. 1672–1729 William Cavendish = Hon. Rachel Russell 1674–1725
2nd Duke of Devonshire

1698–1755 William Cavendish = Catherine Hoskins *c.* 1700–1777
3rd Duke of Devonshire

1720–1764 William Cavendish = Lady Charlotte Boyle 1731–1754
4th Duke of Devonshire

1748–1811 William Cavendish = Lady Georgiana Spencer 1757–1806
5th Duke of Devonshire = (2) Lady Elizabeth Foster 1757–1824

1754–1834 Lord George Cavendish = Lady Elizabeth Compton 1760–1835
1st Earl of Burlington
(second creation)

1790–1858 William Spencer Cavendish
6th Duke of Devonshire

Lady Georgiana Cavendish 1783–1858 = George Howard 1773–1848

1783–1812 William Cavendish = Hon. Louisa O'Callaghan *d.* 1863

1803–1881 Lady Caroline Howard = Rt. Hon. William Lascelles 1798–1851

1812–1840 Lady Blanche Howard = William Cavendish
2nd Earl of Burlington
7th Duke of Devonshire
1808–1891

1838–1920 Emma Lascelles = Lord Edward Cavendish 1838–1891

1833–1908 Spencer Compton Cavendish = Countess Louise von Alten 1832–1911
8th Duke of Devonshire

1868–1938 Victor Cavendish = Lady Evelyn Fitzmaurice 1870–1960
9th Duke of Devonshire

1895–1950 Edward Cavendish = Lady Mary Cecil 1895–1988
10th Duke of Devonshire

1920–2004 Andrew Cavendish = Hon. Deborah Mitford 1920–2014
11th Duke of Devonshire

1917–1944 William Cavendish = Kathleen Kennedy 1920–1948

b. 1944 Peregrine Cavendish = Amanda Heywood-Lonsdale *b.* 1944
12th Duke of Devonshire

b. 1969 William Cavendish = Laura Montagu *b.* 1972
Earl of Burlington

b. 2009 Lady Maud Cavendish *b.* 2010 James Cavendish *b.* 2013 Lady Elinor Cavendish

CHATSWORTH
ACKNOWLEDGEMENTS

My thanks, first and foremost, to the 12th Duke and Duchess of Devonshire for being rash enough to ask me to write this book. They have become, over the years, staunch and valued friends whose patience, hospitality and good humour seem to know no bounds. The Derbyshire locals will know exactly what I mean. The Earl and Countess of Burlington have also been kindness itself whenever I broached the subject of their taking over the house and, eventually, the garden and the estate. Their devotion to its future is reassuring.

Jonathan Buckley is one of this country's greatest garden photographers and I've had the pleasure of working with him on several occasions. His talent is matched only by his companionability. Without his unerring eye, this book would be all the poorer, and without the encouragement and wisdom of my editor Lorna Russell, my own input would not have been nearly so enjoyable.

Helen Marchant has been her usual efficient self as a reliable go-between. Steve Porter, the Head of Gardens and Landscape at Chatsworth, is a mine of information on all things horticultural at the 'Palace of the Peaks', both current and historic, and answered my many questions on 'who, what, where and when?' in relation to the gardens and the landscape in his charge. Alice Martin, Fran Baker, Faye Tuffrey, Alex Hodby, Charles Noble and Ian Else furnished me with assorted facts and figures relating to the garden and estate for which I am hugely grateful. Gill Hart, Head of Learning and Engagement, brought me up to speed with Chatsworth's comprehensive and ever-developing programme of outreach and education, and both Tom Stuart-Smith and Dan Pearson shared their enthusiasm and enjoyment at playing a part in the ongoing story of one of the country's greatest landscapes.

ACKNOWLEDGEMENTS

Every bit as important as these living contributors to my knowledge of Chatsworth and its rich history, are the many authors whose books feature on my shelves. As a curious, if not especially academic lad, I started collecting books in my teens. The addiction has not declined with the years. They now number more than 5,000 and take up a ridiculous amount of space in the Hampshire barn where I write. Many of them relate to botany and the history of gardens and gardening. Others are devoted to art and architecture. I have biographies of houses and of the people who built them and created the gardens that surround them. Most of these volumes – some of them dating back to the seventeenth and eighteenth centuries – are old friends and have been my constant companions for more than fifty years. It has been a delight to consult them – and the minds of those who wrote them – rather than having to rely solely on that modern helpmate, the internet. I have produced, since I began writing for a living back in the 1970s, more than seventy books. I cannot recall a single one that has given me more pleasure than this one.

<div style="text-align: center;">

ALAN TITCHMARSH
Hampshire 2023

</div>

BIBLIOGRAPHY

A History of Chatsworth, Francis Thompson, 1949, Country Life.

A Thing in Disguise: The Visionary Life of Joseph Paxton, Kate Colquhoun, 2003, Fourth Estate.

Britannia Illustrata, Johannes Kip and Leonard Knyff, 1714, Joseph Smith.

Capability Brown: Designing English Landscapes and Gardens, John Phibbs, 2016, Rizzoli.

Chatsworth: The House, The Duchess of Devonshire, 2002, Frances Lincoln.

Decimus Burton – Gentleman Architect, Paul A. Rabbitts, 2021, Lund Humphries.

Devices and Desires: Bess of Hardwick and the Building of Elizabethan England, Kate Hubbard, 2018, Chatto and Windus.

Director's Choice: Chatsworth, The Duke and Duchess of Devonshire, 2013, Scala.

Georgiana, Duchess of Devonshire, Amanda Foreman, 1998, Harper Collins.

In Tearing Haste: Letters between Deborah Devonshire and Patrick Leigh Fermor, Edited by Charlotte Mosley, 2008, John Murray.

James Paine, Peter Leach, 1988, Zwemmer.

Joseph Paxton, John Anthony, 1973, Shire Publications.

Magazine of Botany, Joseph Paxton, 1834–49, Orr and Smith.

Plans, Elevations and Sections, of Noblemen and Gentlemen's Houses, James Paine, 1767, London, Printed for the Author.

Pride and Prejudice, Jane Austen, 1813, Smith Egerton.

Sir Jeffry Wyatville, Derek Linstrum, 1972, Clarendon Press.

The Account Book of Lancelot Brown, c. 1760–82, Library of the Royal Horticultural Society.

The Bachelor Duke, James Lees-Milne, 1991, John Murray.

The English River, Alan Titchmarsh, 1993, Jarrold.

The Garden at Chatsworth, The Duchess of Devonshire, 1999, Frances Lincoln.

The Illustrated Journeys of Celia Fiennes, Edited by Christopher Morris, 1982, Webb and Bower.

The Omnipotent Magician: Lancelot 'Capability' Brown, 1716–1783, Jane Brown, 2011, Chatto and Windus.

The Sixth Duke of Devonshire's Handbook of Chatsworth, 1844–5, Edited and with an introduction by John Martin Robinson, 2020, The Roxburghe Club.

The Temple of Flora, or Garden of Nature, Robert Thornton (originally 1810–12), 1951, for Collins by George M. Rainbird and Ruari McLean.

The Wyatts: An Architectural Dynasty, John Martin Robinson, 1979, Oxford University Press.

Wait For Me! Memoirs of the Youngest Mitford Sister, Deborah Devonshire, 2010, John Murray.

Windsor Castle in the History of the Nation, A.L. Rowse, 1974, Weidenfeld and Nicolson.

ARTICLES

Anna Pavord: 'Dan Pearson conjured up drama on the Chelsea Flower Show's triangle site', Anna Pavord, *Independent* (May 2015)

Chelsea Flower Show: highlights from the gardens, Stephen Lacey, *Daily Telegraph* (May 2015)

How stately home tourism saved the aristocracy in the 1950s, Adrian Tinniswood, *House & Garden* (February 2022)

INDEX

Note: page numbers in bold refer to information contained in captions.

1st Duke's Greenhouse *see* Old Greenhouse

Abercorn, Lady 245
Aboretum 132
acer 174, **178**, **191**, **200**
Adam, Robert 108
Adam brothers 90, 91, 108
Albemarle, Earl of 226
Albert, Prince 117, **118**, 133, 182
Alexandra, Queen **181**
All Saints Church, Derby 47
Alnwick Castle 88
Amhersita nobilis **191**
angel's trumpet (*Brugmansia*) 127
Anne, Queen 17
Anne, Princess Royal 182, 184–5, 270
Annigoni, Pietro 140, **141**
Anson, George 182
apple 262–5
Aqueduct 82, **83**
Arboretum 149–50, 191–203, **191**–**2**, 246–8
Arcadia 12, 22, 149–58, **149**, 163, 165, 173, 208, 210, 275
 Hundred Steps Glade 150, **154**, **157**, 157, 192, 231
 Rabbit Glade 149, **150**, 157
Archer, Thomas 39, 73, **73**
Armstrong, John 108
art exhibitions 239–41, **239**
Ashopton 28
Assheton, Emily 153
Aster × herveyi 153, **154**
astrantia 157, 174
Audias, Monsieur 51
Austen, Jane 17, 18, 27
autumn crocus (*Colchicum autumnale*) 11

azalea 215, 219, 220, 275
Azalea Dell 219

Bacon, Francis 241
Bacon, Laura Ellen **158**, 248
Badminton House 108
Bamboo Walk 203, 256
banana, dwarf (*Musa acuminata*) 128
Banks, Elizabeth 161
Barbrook **118**
Barley, Robert 41–2
Baslow 28, 34, 104, 141, 225, 227
Bath, 6th Marquis of 253
Bath, Lady 108
Bathe 248
Batoni, Pompeo 22
Battlesden Park 132
Baugniet, Charles-Louis **111**
BBC radio 17
Beamsley Hall 184–5, 207–8
Beaufort estate 192
Bedford, 6th Duke of 108
beech (*Fagus sylvatica*) 11, 60, 99, **195**
Beeley 225, 236
Belvedere 110–11, 232, **235**
Belvoir Castle 66
Berry, Dame Mary 256
Bess of Hardwick 22, 28, 33–4, **34**, 41–7, **41**–**2**, **45**, 47, 54–9, 95–6, **95**, **100**, 192, 245, 273, 276, **278**
Betjeman, Sir John 203, 245, 246
Betonica officinalis 'Hummelo' 153
Beyond Limits (exhibition) 240
bilberry 173, **174**
Bistorta amplexicaulis 'Taurus' ('Blotau') 153
Blake, William 18
Blanche's Vase **51**, 110
Blenheim Palace 17, 64
bluebell (*Hyacinthoides non-scripta*) 149, **191**, 195
Bog Garden 153

Bolton Abbey 141, 173, **174**, 185
Bolton Abbey Cricket Club 225
Bolton Hall 184
'bouncing bomb' 28
Bowling Green 100
box 38, 51, 111
 golden 59, **60**, 141
Boyle, Richard, 3rd Earl of Burlington 59, **60**, 87, 88
Brailsford, Samuel 74
bridges 66, **67**, 87, 89, 108
Bridgman, Charles 64
Briggs, Henry Perronet **131**
Britannia Illustrata 52, **52**
Broad Walk **51**, 60, 100, 110, 111
Broadlands 64
Brompton Park 51
Brown (née Wayet), Bridget 'Biddy' 69
Brown, Jane 66
Brown, Lancelot 'Capability' 17, 27, 30, 33, 38, 59–60, 63–9, **63**, 73, **73**–**4**, 90, 95–6, 141, 161, 207, 276
'Brownian' landscapes 28, 33, 164, 231
Buckley, Jonathan 13
Burghley 45
Burton, Decimus 117–18, **117**, 121
butterfly, small tortoiseshell 275

cactus, night-flowering (*Epiphyllum oxypetalum*) 127–8, **128**
Calton Lees 18, 66, 89, 99
camassia **95**, 203, 219
Cambridge, Richard Owen 63
Camellia 11, 122
 C. reticulata 'Captain Rawes' 100, 121
Campbell, Thomas 60
Canal Pond 34–8, **37**, 60, 73–4, 78, 79–81, 85, 248, **250**
Canova, Antonio 245
carbon capture 30, 33

Carriage House 255
Cascade 12, 21, 37, 38, 52, 73–4, **74**, 79, 140, 191, 240, **257**
Cascade House 73, **74**
Cascade Pond 85
Case *see* Conservative Wall
Cavendish (née Heywood-Lonsdale), Amanda, Duchess of Devonshire 18, 20, 22, 59, 95, 143, 150, 153, 161, 165, 173, 174, 178, 182, 184–5, 192, 195, 205–10, **205**, **207**, 210, 227, 239–41, 245, 246, 248, 249, 255, 265, 276
Cavendish, Andrew, 11th Duke of Devonshire 11, 18, 20–2, 46, 59, 137, **137**, 139–43, **144**, 181, 184, 195, 203, 207–8, 211, 227, 231, 241, 253, 276
Cavendish (née Howard), Lady Blanche, Countess of Burlington **51**, 110, **111**, 279
Cavendish (née Boyle), Charlotte, Marchioness of Hartington 87, **279**
Cavendish (née Mitford), Deborah, Duchess of Devonshire 11, 18, 20–2, 39, **57**, 59–60, **60**, 63, 66–7, 96, 99, 104, **104**, 111, 137–44, **137**–**41**, **143**, 181–2, 184, 185, 195, 203, 207–8, 215, 231, 241, 245, 248, **250**, 253, 261, 266, 270, 276
Cavendish, Lady Dorothy 181
Cavendish, Edward, 10th Duke of Devonshire 139, 253, 280
Cavendish, Emma 144
Cavendish, Evelyn, Duchess of Devonshire 11, 215–16, **215**–**16**, 223, 231–5, **235**, 236
Cavendish, Frances 42
Cavendish, George, 1st Earl of Burlington 38

Cavendish, Georgiana, Duchess of Devonshire 68, 81, **95**–**6**, 96, 99–100, 226, **279**
Cavendish, Henry 45, 47
Cavendish (née Kennedy), Kathleen 'Kick' 143
Cavendish (née Roundell), Laura, Countess of Burlington 13, 20, 210, 276
Cavendish (née Butler), Mary, Duchess of Devonshire 59, **59**, 278
Cavendish, Peregrine ('Stoker'), 12th Duke of Devonshire 18, 20, 22, 59, 95, 143–4, 150, 153, 162, 165, 170, 173–4, 178, 182, 184–5, 186, 192, 195, 205–10, **207**, 209–10, 239–41, 246, 249, 254, 262, 265–6, 276
Cavendish, Sophia 144, 184
Cavendish, Spencer Compton, 8th Duke of Devonshire 59, **181**, 279
Cavendish, Victor, 9th Duke of Devonshire 85, 215, 223, 227, **235**, 280
Cavendish, Sir William 22, 28, 42, 45, 54, **278**
Cavendish, William, 1st Earl of Devonshire 47, **47**, 280
Cavendish, William, 4th Duke of Devonshire 64, 66, 68–9, **68**, 87, 99, 276, **279**
Cavendish, William, 4th Earl and 1st Duke of Devonshire 34, 51, **52**, 54, 59, 74, 79, 85, 100, 122, 127, 161, 276, **278**
Cavendish, William, 5th Duke of Devonshire 68, 81, 96, 226, **279**
Cavendish, William, 7th Duke of Devonshire 51, 182, **279**
Cavendish, William, Earl of Burlington 13, 20, 203, 210, 249, 276

Cavendish, William, Marquess of Hartington 143
Cavendish, William Spencer, 6th Duke of Devonshire ('The Bachelor Duke') 33, **51**, **57**, 60, 74, 79–81, **79**, **82**, 85, 89, 96, 100, 104, **104**, 107–13, **107**, **111**, 117–18, 122, **125**, 128, 131–3, 135, 149–50, 158, 169, 174, 191, 199, 226, 241, 245, 246, 248
Cavendish family 46, 47, 59, 128, 273, 278–80, 281
see also Devonshire family
Cavendish family crest 122
Cavendish Hotel 34, 141
Cenolophium fischeri **153**
Cercidiphyllum japonicum 174
Charles II of France 63
Charles III of England 107, 144, 181, 186, 203
'Chatsworth Blue' 34
'Chatsworth Carpenters' 140
Chatsworth Country Fair 39, 73, 253, **254**, 255–6, 275
Chatsworth Cricket Club 225–7, **225–7**
Chatsworth Estate 33, 39, 42, 73, 95–6, 104, **162**, 262, 275–6
Chatsworth House Trust 20, 139
Chatsworth Manor 28, 42
Chelsea Flower Show 161
'Laurent-Perrier Chatsworth Garden', 2015 **161**, 164, 199–200
Chertsey 91
Chesterfield 27
chestnut 149
sweet 81
Chippendale, Thomas 88
Chiswick House 38, 59, 60, **60**, 117, 131, 132, 141
Christmas **253**, 255, 256, **257**
Cibber, Caius Gabriel 52, **78**, 79, 100
Cibber, Colley 79

climate change 33, 274
Cliveden Conservation **74**
Cobham, Lord 64
Codnor Castle 41
Coleman, Henry 144
Colepeper, Colonel Thomas 54
Compton, Tania 200
conifers 132, 191
Conner, Angela 203
Conner Grove 203
Conran, Jasper 91
Conservative Wall 38, 100, **121**, **121**
cosmos 261
Cottage Garden 141
Cotton, Charles 51, 52
Covid-19 pandemic 274–5
cows 30, 39
crab apple 95, 219, 231–2
Craig-Martin, Michael **239**, **239**
crowberry 173, **174**
'Crown lifting' 195
Crystal Palace 117, **124**, 133, **133**
Cutting Garden 256, 261, **262**, 266, **266**, 269

daffodil **11**, 30
dahlia 231, **231**, 261
'Happy Single Juliet' **275**
daisy, Michaelmas 231, **231**
Darlington, Earl of 88
Darwin, Charles 118
de Romilly, Alice 173
de Romilly, William 173, 178
de Rothschild, Baron Mayer 135
de Waal, Edmund 239
death duties 20, 21–2, 46, 253
deer park 34
Delavay, Pere 215
Derby Cathedral 47
Derbyshire Dales 18, 21, 27, 30, 38, 47, 195
Derwent Hall 28
Derwent, River 27–8, **27**, 33, 38, 46–7, 59, **64**, 67, 73, 77, 89, 95, 232

Derwent village 28
Devonshire Arms 141
Devonshire family 21, 143, 173, 236, 254, 276
see also Cavendish family
Diana, Princess of Wales 96, 99, 186, **186**, 187
Display Greenhouse (Display House) 117, 122, 127–8, **127**
Dobb Edge 169
Dog, The (exhibition) 239
dogwood 220
Chinese (*Cornus kousa*) 174, 195
Dorset, Duke of 226
Douglas-Home, Sir Alec 185
dry stone walling **158**, 232, 246–8, **265**
Dry Stone Walling Association (DSWA) 232, 254
Drysdale, Pippin 239
Dunnett, Nigel 161
Dutens, Louis 99

East India Company 191
East Moor 199
Edensor 18, **18**, 20, 33, 37, 121, 132, 225, 236
Edensor House **137**
Edensor Lodges **113**
Edinburgh Botanic Garden 127
Edward VI 45
Edward VII **181**
electricity generation 276
Elizabeth I 41, **42**, 45, 46, 96, 100
Elizabeth II 144, 161, 182–3, **182**, 185, **186**, 203, 240
Elizabeth, Queen Mother 181–2
Elizabethan Chatsworth 39, 42
Emperor Fountain 38, **64**, 73, 77, 79–81, 85, 131, 132, **226**
Emperor Lake 81, **85**
English Heritage 205
Entrances
Buxton **113**

North 112, 253
Sheffield (Golden Gates) 104, **104**
Environmental Stewardship Scheme 30
Erigeron karvinskianus 178
Eupatorium 236
Euphorbia 157
E. heyneana subsp. *heyneana* **154**
E. spithymoides **154**
Eutrochium maculatum 'Riesenschirm' **153**

fairs 253–7
farm 140, 255
Farm Shop 140, 186, 254
farmland, arable 30
Farrer, Reginald 169
Fermor, Sir Patrick Leigh 59–60, 203
ferns 153
Fiddian-Green, Nic 248
Fiennes, Celia 248, **249**
fir, Douglas 191
First World War 119, 121, 261, 274
Fisher, Denis 60, 122, 232
Flanagan, Barry **239**, 240, 246, **246**
Flora's Temple 100, **100**, **103**, 121
follies 95–104
formal gardens 51–60
Fortescue, Mary 108
Foster and Pearson 261
Freud, Lucian **139**, 140, **140**, 203, 241, 245
Frink, Dame Elisabeth 95, 241, 248, **250**
Frith, Francis 60
fruit 54–9, 261–5, **261**

Gabor, Zsa Zsa 41
Game Larder 104, **104**
game-keepers **162**

gardeners 164, 165, **165**, 208, 231, 261–5
George III 69
George IV 107, 112, 131
George V 192
Geranium 170
G. 'Patricia' ('Brempat') **154**, 157
meadow cranesbill 203
glasshouses 38, **54**, 60, **60**, 117–28, **117**, 122, 127, 132, 143, 261–2, **262**
global warming 33, 274
Glorious Revolution 52
Golden Gates 104, **104**
Granville, Countess 273
grape vines 122–7
'Muscat of Alexandria' 122–7, **125**, 257
Gray, Thomas 67–8
Great Conservatory 17, 99, **103**, 117–21, **117**, **118–19**, 132–3, 191, **192**, 231–2, **235**
Great Exhibition, 1851 117, 133, **133**
Great Fountain 64, 79–81
Great Parterre 51–2, **52**, 59–60, 74
'Great Slope' 37, 79
Great Stove *see* Great Conservatory
Grillet, Monsieur 73, **73**
Grotto 95, 96, **196**
Grotto Pond 12, 81, **81**, **82**, 96, 163, **196**, 215, 220, **220**, **239**, 246
Gunnera 153
G. *manicata* **153**, 169

Hampton Court 52, 63, 69
'Black Hamburgh' grape vine 69
Privy Garden 51
Wilderness House 69
Hardman, Carl 232, 246–8
Hardwick, Elizabeth 41
Hardwick, John 41

INDEX

Hardwick Hall 34, **45**, 46, 135, 245, 253
Hart, Gill 270–1
Hartington, Lord **227**
Hartington, Marquis of 88
Hayter, Sir George **79**
Heath House 88
heating 121, **163**, 270, 276
Henry VIII 42
Het Loo 63
Heywood-Lonsdale, Commander Edward 185
Hill, George 227
Hilton, James 27
Hirst, Damien 240
His Majesty's Stables, New Market 88
Hitler, Adolf 139, 144
Hockney, David 239
Hogarth, William 87
Holland, Nathaniel Dance **63**, 69
holly 51, 59, 192
Holmfirth, Yorkshire 27, 73
Hopton Hall 11
hornbeam 51
Horticultural Society 131, 132
Hubbard, Kate 41
Hudson, Thomas **68**
Huet, Monsieur 51
Hunting Tower 33–4, **34**, 42, 95, **95**, 169, 186–7, 245, 273

Ibeck, Mr 248
Indiana, Robert 240
Industrial Revolution 273–4
Inner Court 246
Inskip, Peter 210
International Horse trials 255
Iris 54, **170**, 203
 I. sibirica 157, 174
Irvine, Derry 141
ivy 192

Jack Pond 12
James I of England 46

James II of England 52, 54
Japanese anemone **157**
Japanese maple (*Acer palmatum*) 174, **178**, **200**
Jekyll, Gertrude 220
Jennings, George 88
Johnson, Wilfred 99
Josephine, Empress 110

Kedleston Hall, Derbyshire 108
Keen, Mary 200
Kempenfelt, Admiral 108
Kennedy, J. F. 185
Kent, Duchess of 133
Kent, William 22, 60, 64, 74, **74**, 161
Kettle, Tilly 88
Kingdom-Ward, Florinda 215
Kingdom-Ward, Frank 215–16, 223
Kingdom-Ward (née Macklin), Jean 215
Kip, Johannes 52, **52**, 60, 67, 122
Kitchen Garden 74, 100, 256, 261–6, **261**, **265–6**, **269**
Klosters 181
Kneller, Sir Godfrey **52**
Knyff, Leonard 52, **52**, 60, 67, 122

lady's smock (*Cardamine pratensis*) **199**
Landscape Interpretation Centre 104
Laurence, Vice Admiral Sir Timothy **182**
Lawrence, Sir Thomas 107
Le Nôtre, André 51, 63
Learning Centre 270–1, **271**, 275
Learning and Engagement Team 265, 271
Leche, Ralph 28
Leopold, King of the Belgians 118
Liatris spicata **154**
library 110

lily 220
 Lilium mackliniae 215
 Pamianthe peruviana 141
Lily House 118, 122, 261
lime 51, 140–1
Lindley, John 128, 195
Lindsay, Major Hugh 181
Link, Bert 60
Link, Jim 195, 261
liquidambar **191**
Lismore 141, 208
livestock 30, 39
Lobelia x *speciosa* 'Tania' **153**
Lockey, Rowland 41
London, George 51, **52**, 161, 205
Long, Ben 239
Long, Richard **250**
Longleat 45, 108, 253
Loraine, Sir William 64
Louis XIV 51
lungwort (pulmonaria) 149
lupin 231, **231**
Luttrell, Henry 100
Luttrell, Narcissus 54
Luttrell's Seat *see* Summer House

Macfadyen, Matthew 246
Macmillan, Harold 181, 184, 185, 203
Malmaison 110
Mansion House, Doncaster 88
Marchant, Helen 144
Margaret, Princess 185
Marlborough, Duke of 17, 64
Martin, James 256
Mary II, Queen 51, 63
Mary, Queen of Scots 33, **42**, 46, 96, **100**, 181
Mary of Teck 192
Maze **17**, **57**, 99, 117, 122, **154**, **192**, 231–6, **231–2**, **236**, 246
Midland Railway 121, 132, 134
Millais, David 220–3
Milliken, Michael 66, 96

Mitford, Tom 138, **138**
Mitford, Unity 138–9, 144
Mitford sisters 138–9, **138**, 144
 see also Cavendish (née Mitford), Deborah
Mlinaric, David 141
Moggridge, Hal 161
monkey puzzle tree (*Araucaria araucana*) 192
monoliths 174, **174**
Morton Pond 81, **82**, 195, **195**, **196**
Mosley, Oswald 138
Mossman, Frances 164
Mountbatten, Lord Louis 185
Moyser, Colonel James 87
Mozart, Wolfgang Amadeus 248

Nadauld, Henri 73, 79
Nash, David 95
 'Oculus Oak' 203, **203**
National Trust 46, 205, 208, 253
Neo-Palladian villa 59
neoclassicism 90–1, 108, 110, 112, **248**
Nether End 28
New Piece Wood 66
New Wardour Castle 91
Newman & Co. 12
Nicholas I, Czar 79–81, 131
Norfolk, Duke of 28
Northumberland, Earl of 88
Nostell Priory 87, 88
Nyssa sylvatica **158**

Oak Barn 270
oak (*Quercus*) 30, 47, 66, 149, 187, **191**, 192–5, **195**
Old Greenhouse 54, 60, **60**, 117, 122, **122**, 127
Old Potting Shed 270, **271**
Old Vicarage, Edensor 141, 143–4
orange trees 51, 110–11
Orangery 110
Orangery Shop 140
orchids 122, **125**

Oudolf, Piet 161
Oxburgh Hall, Norfolk 46
Oxburgh Hangings 46

Paeonia tenuifolia 178
Paine (née Beaumont), Charlotte 88
Paine, James **12**, **27**, 66, **67**, 87–91, **87**, **89–90**, 99, 108, 261
Paine, James (son of James) 88, 90
Paine, Mary 88
Paine (née Jennings), Sarah 88
Paine's Mill 99, **100**
Painted Hall 186, 191
Palladian style 90, 91, 108
Palladio, Andrea 91
Palmerston, Lord 64
Parthenon Frieze 248
Pavord, Anna 200
Paxton, Annie 128
Paxton (née Bown), Sarah 131, 132, 134–5
Paxton, Sir Joseph 33–4, 38, 81, 82, 83, 99–100, 110–11, **113**, 117–18, **117–18**, 121–2, 128, 131–5, **131**, 133–5, 149–50, 158, 161, 182, 191–2, 199, 207, 225, 241, 276
 and the Rock Garden 12, 132, **161**, 162, 169, **169**, 173–4, **177**, 178
Peak District 27, 66
pear **261**, 265
Pearson, Dan 11–12, 22, 161, **161**, 163–5, 199–203, **199**, 208
Penrhos College **78**, **112**, **227**, 235
peony, herbaceous **236**
persicaria 157, 174
Peterhof 131
Philip, Prince, Duke of Edinburgh 184, 185–6
Phytophthora ramorum 12, 192, 220
Pilsley 225, 236

INDEX

Pinetum 132, 163, 191–203, **191**, 207, 208
poppy, Himalayan blue (*Meconopsis betonicifolia*) 215
Porter, Steve 12–13, 150, 163, 165, 173, 178, 203, 208
primrose **149**
Primula 157, **216**
 candelabra 203, 220
 P. florindae 215
 P. pulveruenta 157
Prunus
 P. incisa 153
 P. x yedoensis 174
Pugin, Augustus 141

Quebec 85
Queen Mary's Bower 33, 42, 54, 96, 100, 227, 245

Raby Castle 88
Radical Horizons ... (exhibition) 240
Ravine 12, 22, **96**, 163, 208, 215–23, **215–16**, **219–20**, 223, 275
Redesdale, 2nd Baron 138
redwood, giant (*Sequoiadendron giganteum*) 195
Rembrandt 239
Reynolds, Sir Joshua 87, 90
Rhododendron 220
 Loderi 153
 R. calophytum **196**
 R. 'Daviesii' 174
 R. luteum **219**, 220
 R. ponticum 12, 85, 149–50, 192, 208, 209, 215, 220
 R. wardii 215
Richmond 91
Ring Pond **57**, 60
Robertson, John 34, 121, 132
Robinson, John Martin 107, 110, 113, **113**
Robinson, William 216–20

Rock Garden 132, **161**, 162–3, 165, 169–78, **169–70**, 173–4, **177–8**, 200, 208, 210, 248, 256
 Rocking Stone **174**
 Wellington Rock **169**, **174**
rodgersia 153, 174, **216**
Rogers, Gary **144**
Ronksley Moor 27, 73
Rose Garden 38, **59**, 60, **60**, 122, **245**
Rothschild, Lord 203
Royal Botanic Gardens, Kew 117, 128, 164
Royal George (ship) 108
Royal Horticultural Society (RHS) 200
 Lindley Library 64
Rysbrack, John Michael 60

St Loe, Edward 45
St Loe, Sir William 45
St Peter's Church, Edensor 18
Sales, John 208–9
Salisbury Lawns **51**, **54**, 74, **117**, 141
salmon 73
Sandringham 181
Sandwich, Lord 69
Sargent, John Singer 22, 239
Scott, Sir Gilbert 18
Scully, Sean 239
sculpture 22, 95, **158**, 203, **203**, 239–41, 245–9, **245–6**, 248–50
Sculpture Gallery 22, 110, 245
Sea Horse Fountain **51**, **59**, 78, 79, 100
Second World War 78, 111, **112**, 139, 192, 215, 227, 235, 253, 261, 274
Serpentine Hedge 11, **57**, 60, 122, 141, 246
Sesleria **236**
 S. autumnalis 178
sheep 30, 73
Sheffield Manor 46

shows 253–7
Shrewsbury (née Hardwick), Elizabeth *see* Bess of Hardwick
Siberechts, Jan 34, **52**
Smith, Thomas 64
Smythson, Robert 46, 95
Snake Terrace 122
South Lawn 51, 54, 59–60, 140–1
stables 64, 87, 88–9, **89–91**, 91, 108, 241, **261**
Stand Tower *see* Hunting Tower
Stand Wood 18, 27, 82, 85, 95, 103, 255
Stick Yard 265, 270
Stonard, John-Paul 205
Stoppard, Sir Tom 203
Stowe 64, 203
Strid Pond 57, 173–4, **173–4**
Strong, Sir Roy 203
Stuart-Smith, Tom 11–12, 22, 59, 150, 153–8, 161–3, **161**, 169, **169**, 170, 173–4, **174**, 178, 203, 208, 220–3, **236**
Summer House 100, **103**
Sutherland, Duchess of 118
Swains Greave 27
Swiss Cottage 34

Talbot, George, Earl of Shrewsbury 42, 45–6, 96
Talman, William **39**
Taylor, Joseph 73
Temple Poseidon, Cape Sounion, Greece 246
Tennant, Lady Emma 203
tennis courts 231–2, **235**
thalictrum 170
Thames, River 91
Thompson, Francis 95, 96
Thornton, Robert 128, **128**
Tillemans, Peter 34
Titchmarsh, Alison 143–4, 184, 246
Treasury 42, 46
tree planting 33

Trent, River 28, 73
Triton 52, **52**, 60, 79
Trough Waterfall **96**, 220, **220**
trout 73
Trout Stream 11–12, 100, **161**, 163–4, 165, 186, 199–203, **199–200**, 208
Tucker, Jill **182**
Tucker, William **182**

urns 17, 232, **235**, 245–6, **245**, 262

vegetables 261–2, **261**, 265
Verbena bonariensis **269**
Versailles 51, 63
Victoria 107, 112, 117–18, **118**, 121, 131, 133, 182, 187, 225, 248
Victorian Rock Garden 12, 22
Vinery 122–7, **125**
viola 157, 265
Virgil 100, **103**
visitor loyalty 20–1, 28
volunteers 13, **165**

Walker, John 51
Wallis, Dr Barnes 28
Walpole, Horace 66, 69, 95
Ware, Isaac 87
water lily 60
 giant (*Victoria regia*) **118**, 128, 132
water management 67, 73–85, 173, 276
waterfalls **96**, **169**, 220, **220**
Watson, Samuel **78**
weather records 30
Weber, Bruce **104**
Webster, Ian 12–13, 208
Wellington, Duke of 133, 169, 195
Wentworth House, Yorkshire 17
West Garden 111, 132, **144**, **182**, 276
Westminster Abbey, Cloister Garth 69
Weston, J.G. 216

Whessell, John 42
wild flowers 30, 245
'wild style' 216–20, **216**
William the Conqueror 192
William III 51, 52, 63
William IV 107, 112
William, Marquess of Hartington 139
William, Prince 186–7
Williams, John 128
Willow Tree Fountain 248, **249**
Wilson, Harold 274
Windsor Castle 107, 112
 St George's Chapel 113
 Winchester Tower 112
Windsor Great Park 192
Wingfield, Elizabeth 41
Wingfield Manor 46
Winn, Sir Rowland 87, 88
Wise, Henry 51, **52**, 161, 205
Woburn Abbey 108
Woodland Trust 192
woodmen 163
Wren, Sir Christopher 52
Wyatt, James 108
Wyatt, Joseph 108
Wyatt, Myrtilla 108
Wyatt, Samuel 108
Wyatville, Sir Jeffry 12, 13, 33, 38, **39**, 51, 59, 96, 107–13, **107–8**, **110**, **113**, 132, 135, 232, **235**, 241, 253
Wyatville (née Powell), Sophia 112
Wyatville Lodges **108**

yew 11, 38, 59, 111, 232
 Irish 60

Zelkova serrata 174
Zouch family 41

HUNTING
TOWER

GAME
LARDER

CHATSWORTH

QUEEN MARY'S
BOWER